UPLAND

Best wishes,

Upland – Shropshire's Long Mynd
and the Stiperstones
Published in Great Britain in 2017 by
Graffeg Limited.

Written and photographed by
Andrew Fusek Peters Copyright © 2017.
Designed and produced by Graffeg
Limited copyright © 2017.

Graffeg Limited, 24 Stradey Park
Business Centre, Mwrwg Road,
Llangennech, Llanelli, Carmarthenshire
SA14 8YP Wales UK
Tel 01554 824000 www.graffeg.com

Andrew Fusek Peters is hereby identified
as the author of this work in accordance
with section 77 of the Copyrights,
Designs and Patents Act 1988.

A CIP Catalogue record for this book is
available from the British Library.

ISBN 9781910862681

1 2 3 4 5 6 7 8 9

Photo: James Russell

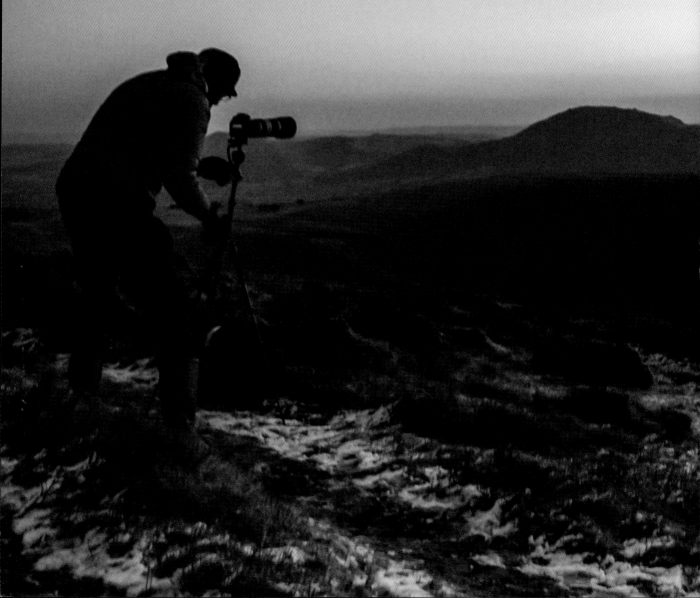

Shropshire's Long Mynd and the Stiperstones
Andrew Fusek Peters

UPLAND

GRAFFEG

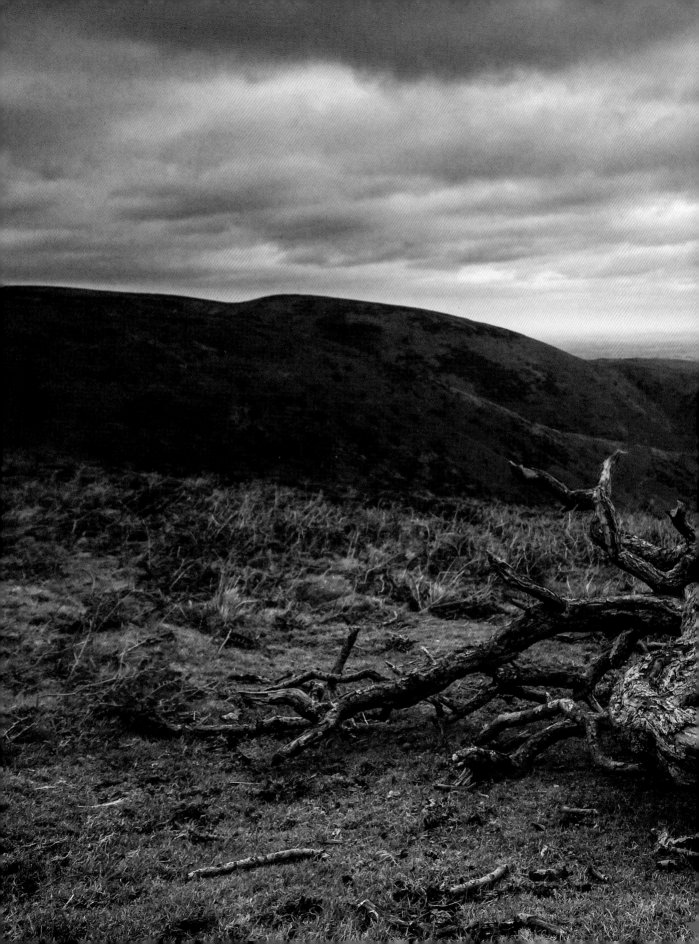

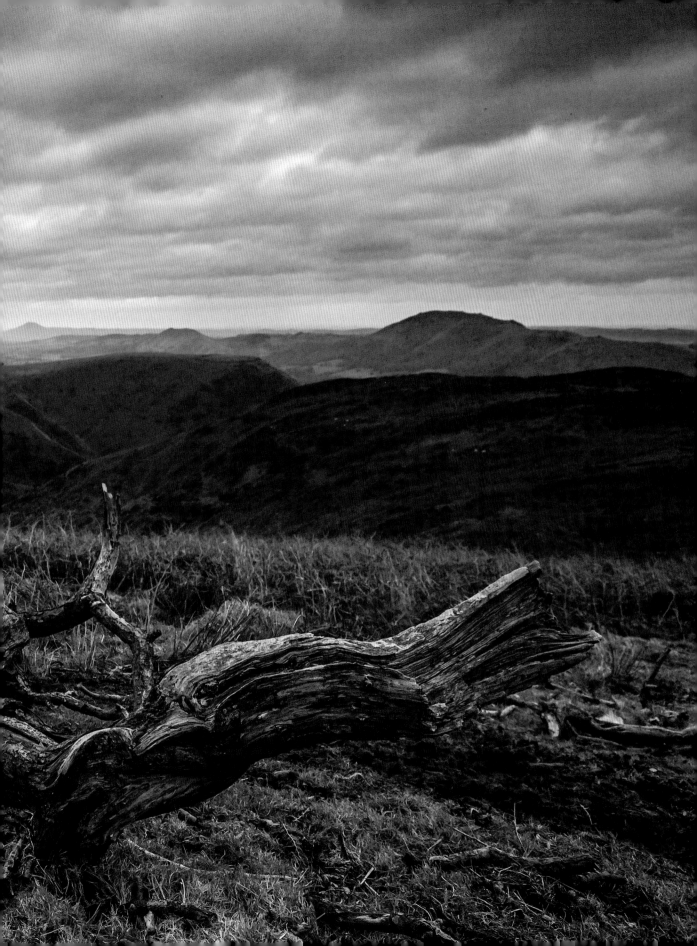

CONTENTS

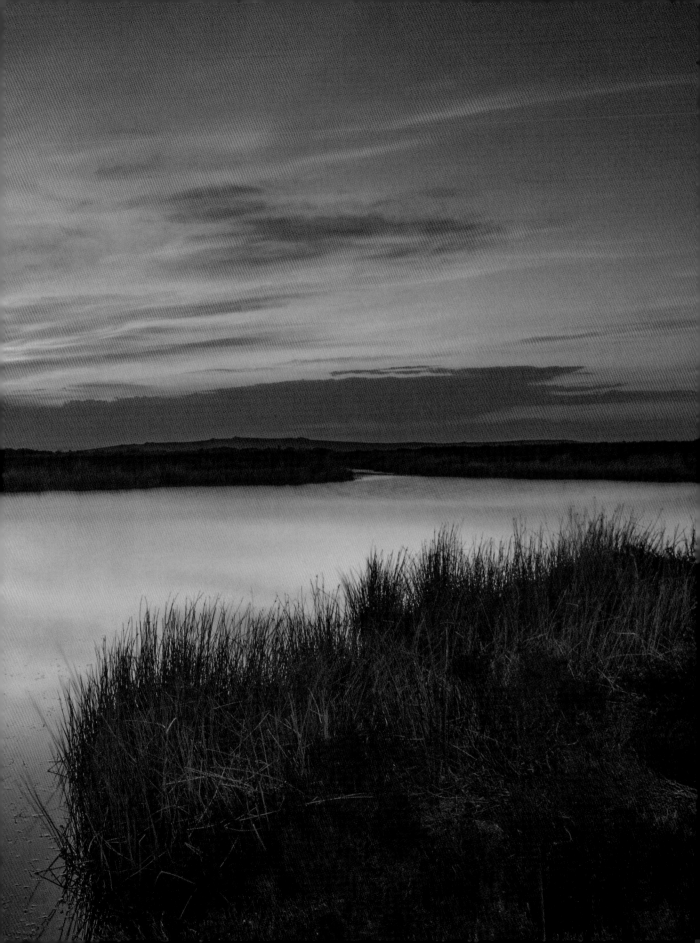

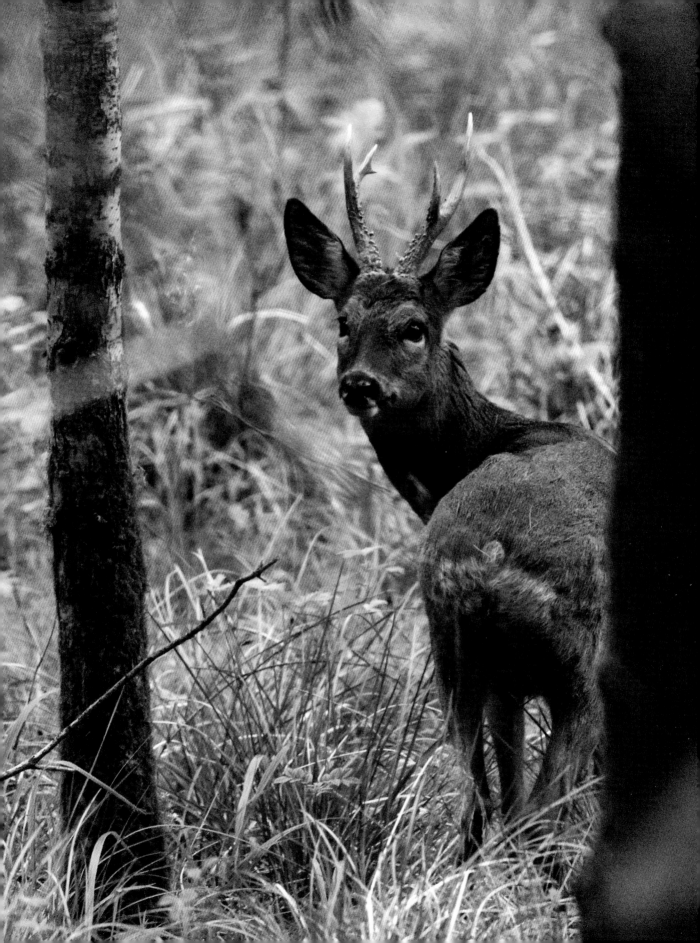

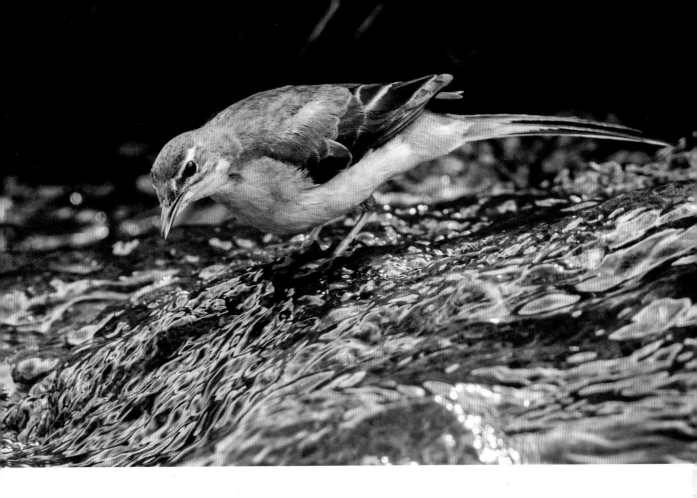

ACKNOWLEDGEMENTS

This book is dedicated to Pete Carty, who has backed me all the way. Thank you. Also, a massive debt of gratitude to Simon Cooter, who has taken me out on numerous Stiperstones safaris and who has kindly passed on a wealth of knowledge. To Sue and Phil Wood & their family – your warmth and hospitality have been humbling and I have felt honoured to walk your land. I am also grateful to Richard Hickman for spreading my pictures out there by creating the awesome slideshows of my work that can be seen at the Carding Mill Valley Tea Room. Thanks to all staff both at Natural England and the National Trust, Andy Spencer and Amber Bicheno for inviting me out for flycatcher ringing and Jennifer for sharing her passion for and adventures with kites. Last but not least, for my forbearing wife Polly who has been encouraging from the start and has put up with my endless absences.

Above: Grey wagtail in the stream at Carding Mill Valley.

Left: Driving back from the Stiperstones with Simon Cooter, I catch this Roe buck at dusk near Linley Big Wood. Simon's shoulder makes an instant tripod to slow my shutter speed to 1/80th second at ISO 25600.

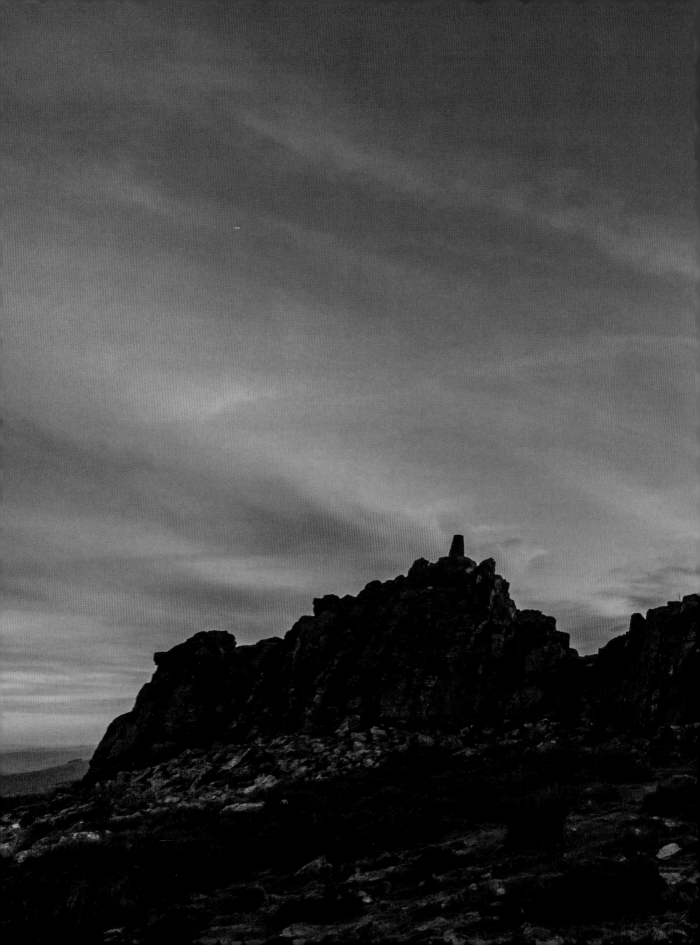

INTRODUCTION

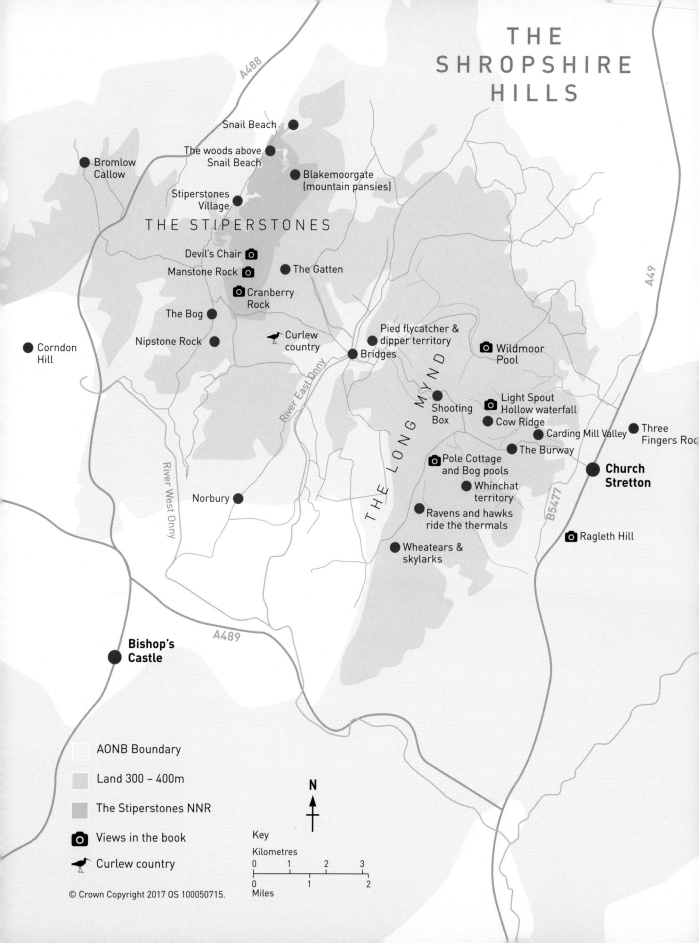

THE SHROPSHIRE HILLS

Snail Beach

The woods above
Snail Beach

Bromlow
Callow

Blakemoorgate
(mountain pansies)

Stiperstones
Village

THE STIPERSTONES

Devil's Chair 📷

Manstone Rock 📷

The Gatten

📷 Cranberry
Rock

The Bog

Pied flycatcher &
dipper territory

Nipstone Rock

Curlew
country

📷 Wildmoor
Pool

Corndon
Hill

Bridges

THE LONG MYND

Shooting
Box

Light Spout
📷 Hollow waterfall

Cow Ridge

Carding Mill Valley

Three
Fingers Rock

The Burway

📷 Pole Cottage
and Bog pools

**Church
Stretton**

Norbury

Whinchat
territory

Ravens and hawks
ride the thermals

📷 Ragleth Hill

Wheatears &
skylarks

River East Onny

River West Onny

A488

A49

B5477

A489

**Bishop's
Castle**

Key

AONB Boundary

Land 300 – 400m

The Stiperstones NNR

📷 Views in the book

🐦 Curlew country

N

Key

Kilometres

0 1 2 3

0 1 2

Miles

© Crown Copyright 2017 OS 100050715.

'The country that lies between the dimpled lands of England and the gaunt purple steeps of Wales – half in Faery and half out of it.' Mary Webb

© Crown Copyright 2017 OS 100050715.

Many years ago, I found myself one freezing February morning standing on top of the Long Mynd in the middle of scratchy, boggy heather wearing nothing but a pair of swimming trunks and leaning on an eight foot surf board.

This undulating leviathan of a ridge had lifted me high enough to make out the silhouette of far Hay Bluff and the Welsh mountains to the west, while the plain of Shrewsbury and the distant protuberance that is the Wrekin spread out behind. Rather closer, a cameraman kept shouting 'one more take, Andy!' as my goosebumps developed their own goosebumps and the crew tried to stop sniggering. The programme, called Heart of the

Country, liked my quirky presenting ways. So here I was, illustrating the fact that 560 million years ago, the Long Mynd was a sea and if you dig down, enormous trilobytes are still to be found.

What I did not know then, was that twenty years later I would be exploring these uplands with a fresh eye and some warm clothes. Far from being a uniformity of brown and muted colours with a six-week-summer-splash of blooming purple heather, the Mynd and that other great raised quartzite ridge of the Stiperstones are bursting with flora and fauna through all the seasons. Throughout my adult life, I had seen these uplands as places to visit, walk through, clear one's mind. Yes, I had seen the

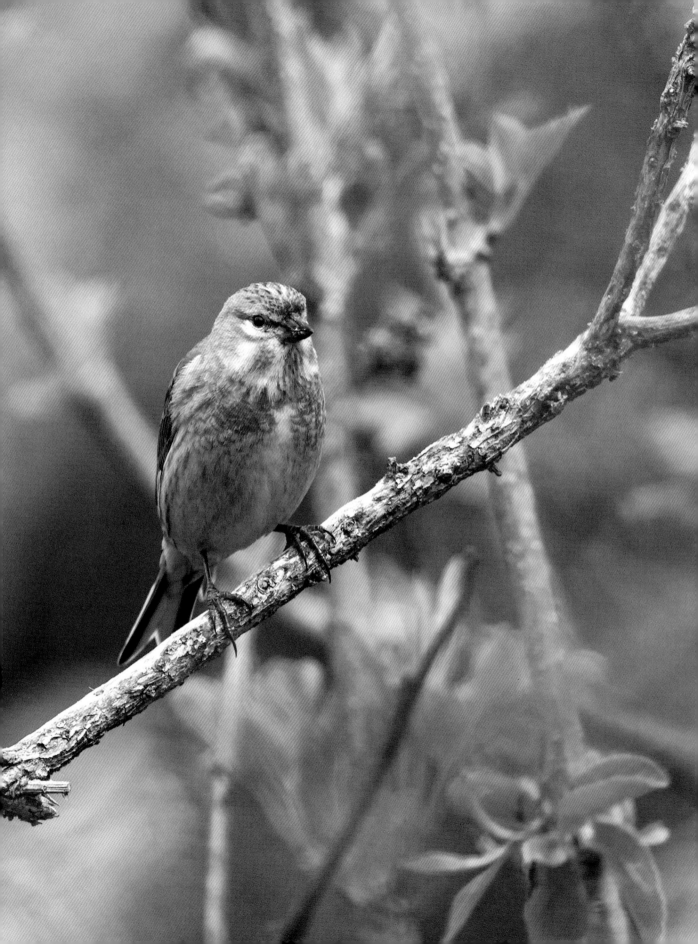

wild ponies that roamed the Mynd, plenty of crows and even the odd raven. But as for other inhabitants and the area they lived in, I was ignorant.

It took a phone call from Pete Carty, Countryside Manager for the National Trust in South Shropshire, to change all that. He rang me two years ago, in December, and asked if I would be interested in a photographic commission. There was a new project called Stepping Stones, that was all about connecting up the Stiperstones, owned by Natural England, and the Long Mynd, in the custodianship of the National Trust. The subsequent photos of Upland began with this commission. I later interviewed Pete to ask him about Stepping Stones and why it is such a profoundly important environmental project.

This is what he said: 'As manager of the Long Mynd I and the team have been looking at changes in wildlife on the Mynd and seen a lot of declining wildlife despite our best efforts. We have linked up with Stiperstones National Nature Reserve and need to think about these two reserves as wildlife parks. What is clear from recent research is that a lot of wildlife lives in those places, but the wildlife in between is in decline and that decline is affecting the species on these two sites. We need to not just think about these nature reserves as islands, but view them in the wider landscape and try to restore wildlife populations over a much wider area by creating corridors and stepping stones across the landscape, so that species can move from one site to another. This is absolutely fundamental for those

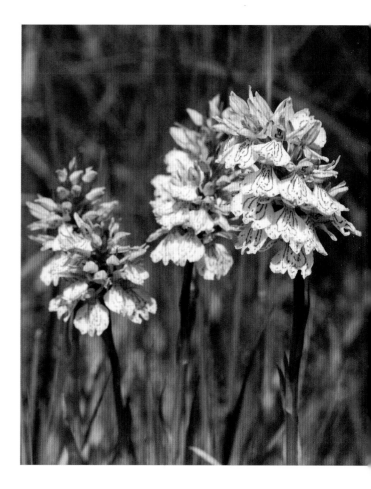

populations to survive. Why is that? If you have your wildlife in rather small islands, it is easy for those populations to be extinguished by fire, famine, disease or a sudden change in land management. If those islands are a long way apart, it is less likely that those species will be able to re-colonise and cross areas where there is very little habitat. Ideally what we need is lots of islands, of smaller nature reserves with corridors like hedgerows, verges, meadows, woodland and stream banks connecting them. The Stepping Stones project is taking a long hard look at wildlife over a large area, collecting data on decline and disappearance of wildlife and coming up with plans to put as much habitat back as possible.'

Pages 10-11: After dusk, the sky above Manstone Rock is on fire.

Left: The male linnet shows off its colours against a backdrop of yellow gorse on the Stiperstones.

Right: The heath spotted-orchid is quite a find on a farm that edges the lower slopes of the Long Mynd.

Pages 16-17: Long Mynd at dawn in August when the heather is in bloom.

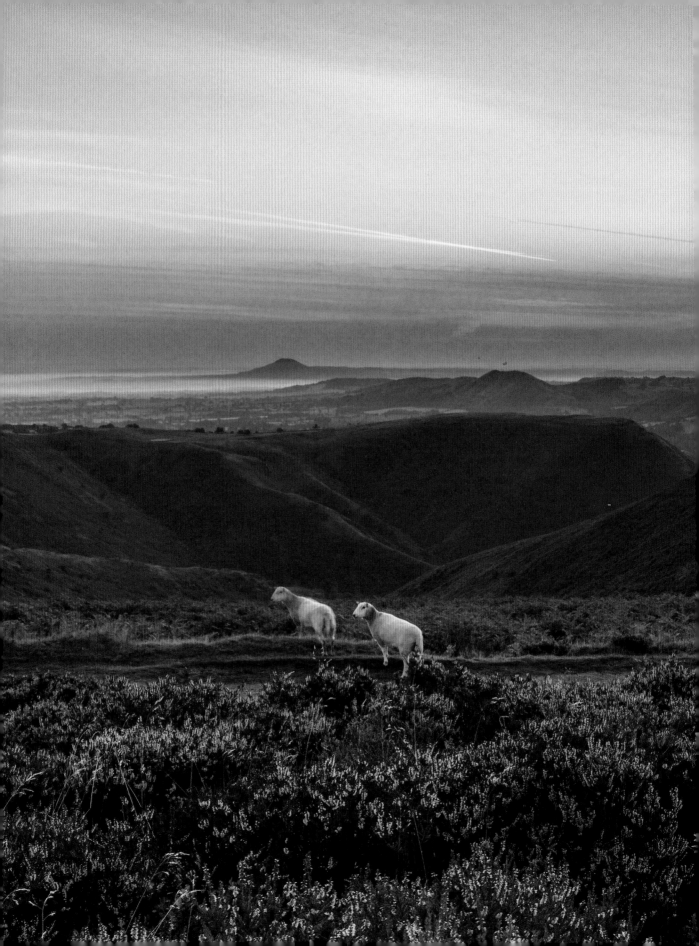

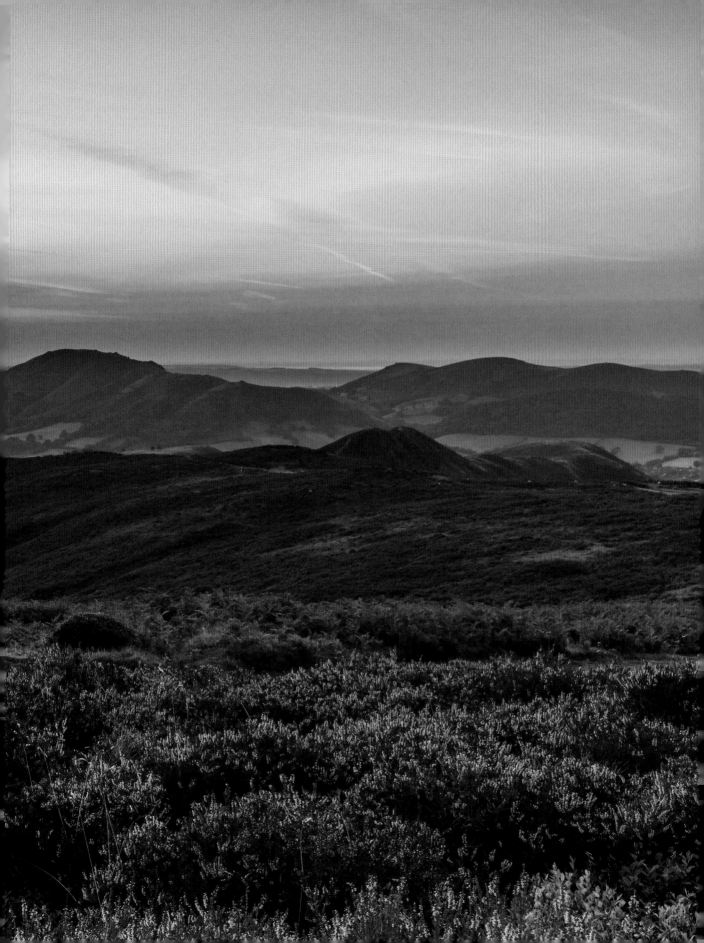

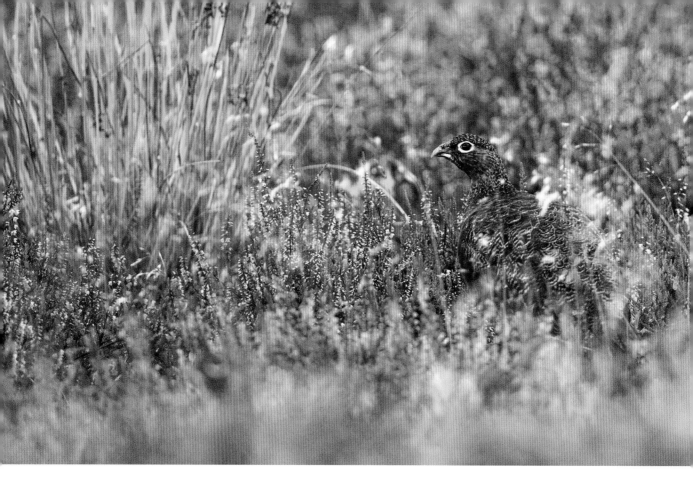

I then asked Peter why they had initially approached me for the commission:

'The great thing about your pictures Andy, is that you have photographed the most beautiful bits, the wildest bits, the places where wildlife is at its best. We can use these images to say to people, look! More of the landscape should be like this or, this is what it used to look like, we can recreate this. So you have helped us visualize our aspiration in the future for wildlife on the Long Mynd and Stiperstones. At the beginning of Stepping Stones, we had a good concept ecologically but we did not have images that we could communicate. Data does not excite most people but stunning photographs can really grab them, take their breath away, stop them in their tracks, make them ask questions: where do I go and see that? Only on nature reserves, because it's very rare, because our own species has not been looking after wildlife as well as we should be. Above all we have to avoid a point in the future where someone is standing on top of the Long Mynd or Stiperstones and slaps their forehead and says 'My god, we've lost it all, we've ruined it. There are no birds singing. I can see no flowers. We are coming up with Stepping Stones now so that there can be more birds, more flowers, more like it used to be.'

Pete's passion and concern for nature was a great motivator and the contract soon developed into an incredibly exciting discovery of the wonders on my own Shropshire doorstep. I had seen cheetahs on the kill in Kenya, tracked otters in Shetland and photographed white tailed eagles in Sweden. What about my own wild backyard? That night I drove up to the high heathland that covers the Mynd almost in a fever. The dusk was dim and the light terrible, but I had to take photos. As the sun dipped behind cloud, I had my first glimpse of

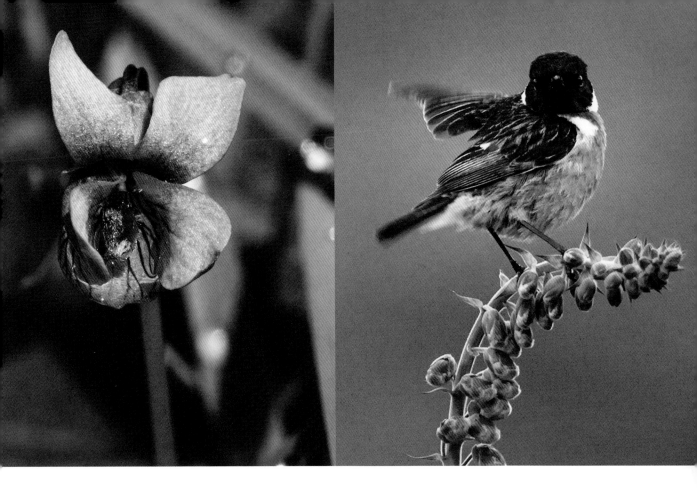

what Upland means to me. Far to the north west, the Wrekin showed as a mere dimple. A dead tree turned in the half-light into the bones of some long dead fossil as the view fell away, miles contained within a single frame.

As the months went by, I quickly understood that I could only do this work with help and so I took whatever advice I could, sat in buggies, and 4x4s as Simon and Pete drove me on tiny tracks along the hidden A-Z of these high hills. I found out that much wildlife is used to cars, and a slow vehicle becomes the perfect hide, enabling wonderful close-up pictures of meadow pipit, skylark and whinchat. Fellow birders and photographers gave me tips, took me out and helped me to find wonders which need a different map, where time is the main geography – dawn and dusk the two cruxes around which much animal activity revolves.

Page 18: When the heather is out, the Mynd is transformed. This female grouse feeding at dusk is easier to spot now.

Above left: The rare marsh violet is starting to make a good recovery at the Gatten on the Stiperstones.

Above right: In summer, a foxglove forest covers part of the western flank of the Mynd and is a favoured habitat for stonechats.

Pages 20-21: Dusk from above Lydham into Wales.

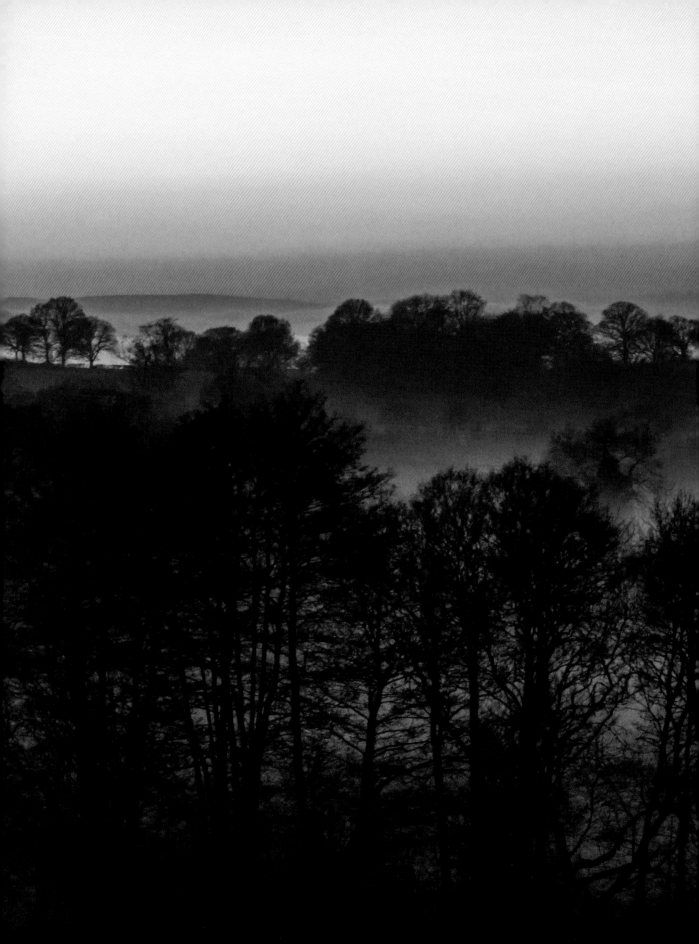

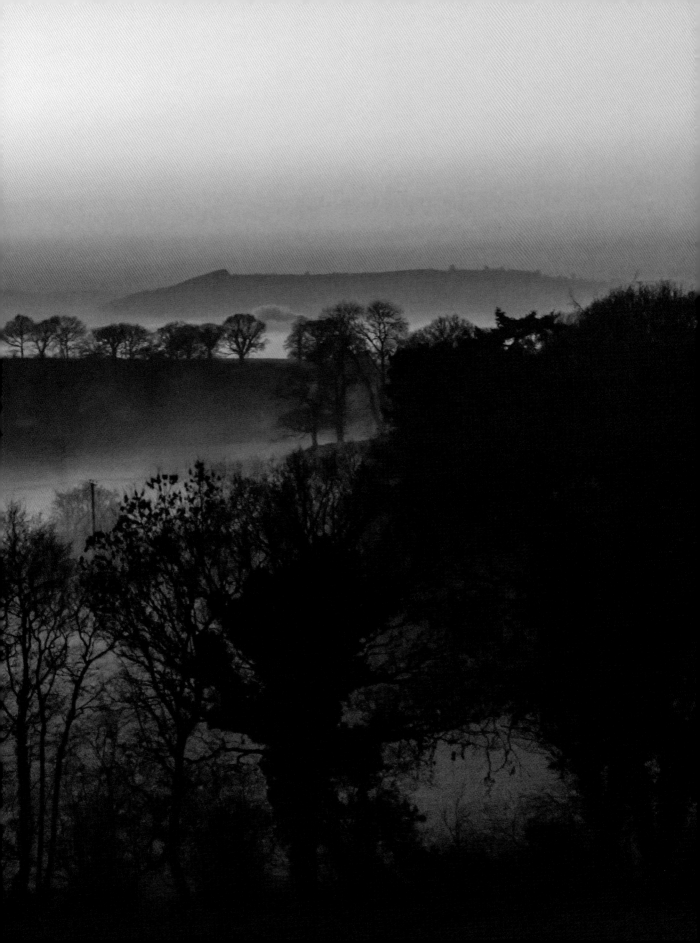

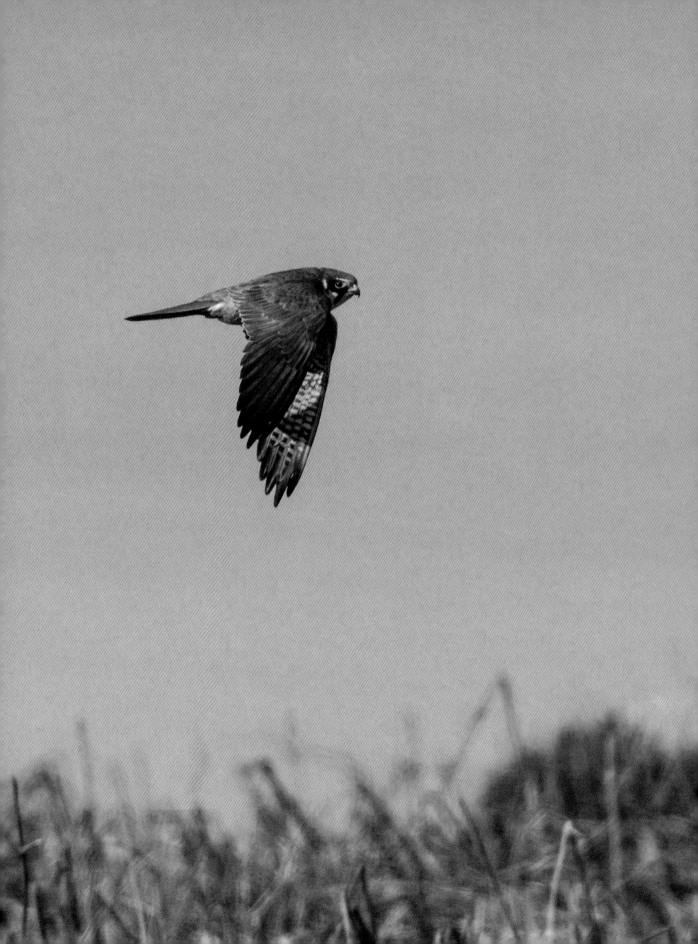

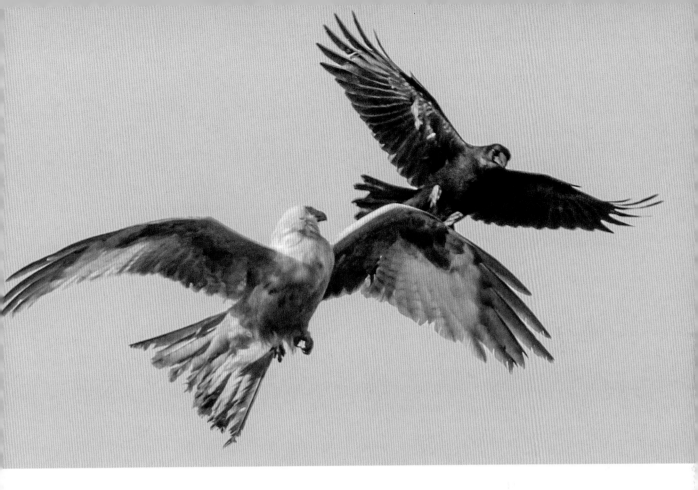

With work and patience, I came close enough to red grouse to touch, saw hobbies soaring over my head, whinchats posed in a blur of purple, ravens framed by heather and curlews fighting off buzzards. Rare marsh violets reclaimed old wooded stream banks, small pearl-bordered fritillaries hunted among thistles and the male stonechat sung his territory among a forest of foxgloves on the far western flanks of the Mynd. Here, there, everywhere, with effort, was colour for the finding, fixing and celebrating.

Here then, is Upland and its cradled valleys revealing extraordinary gifts throughout the year, from dawn to dusk and beyond into another landscape of rising moons and star constellations. My pictures and stories are the best evidence I can put forward to show that Shropshire is one of the great borderland jewels and strongholds of ever dwindling species. This book is a call out to put our county on the map, to celebrate a part of Britain that holds its own alongside the Scottish Highlands, the Peak District and the Lakes. What we hold dear in terms of landscape and wildlife has both national and international significance and Upland aims to showcase our fragile treasure.

Left: The hobby is a rare success story, possibly due to global warming and more availability of dragonflies. They are summer visitors and favour our uplands.

Above: A farming family have been telling me of their sightings of a very rare leucistic red kite over their land. After many visits, I finally catch this genetic anomaly in flight as a crow tries to attack it – a wonderful moment.

Pages 24-25: The bog pool next to Pole Cottage on the Long Mynd takes on an ethereal glow under a March full moon.

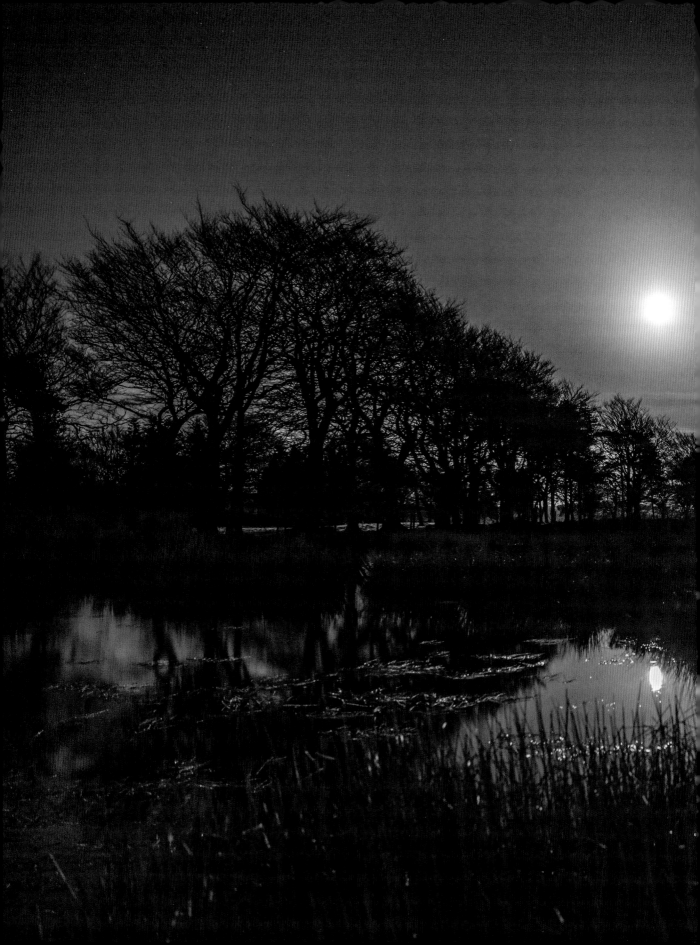

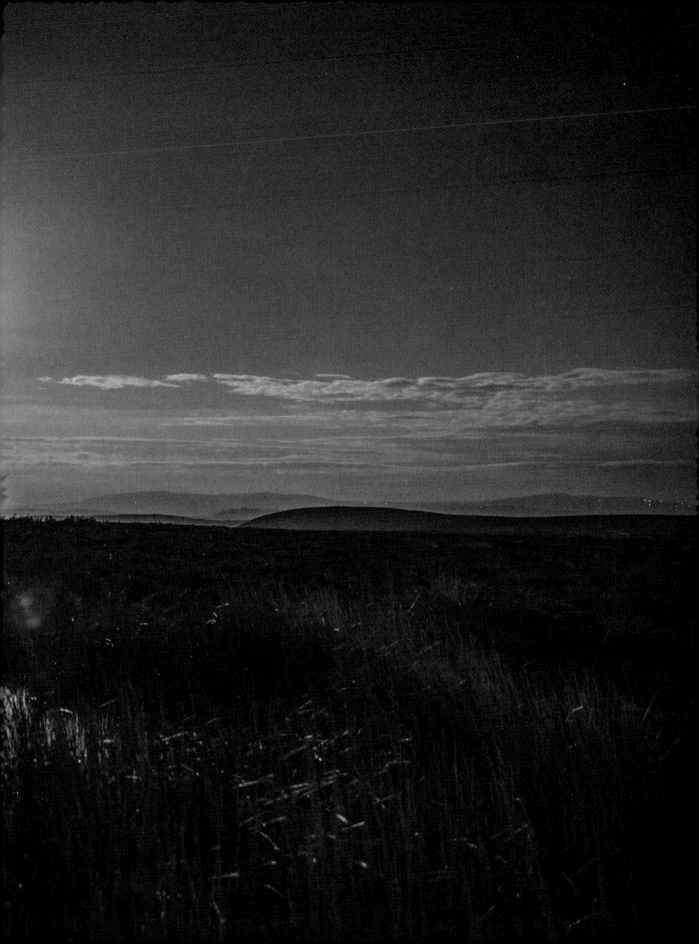

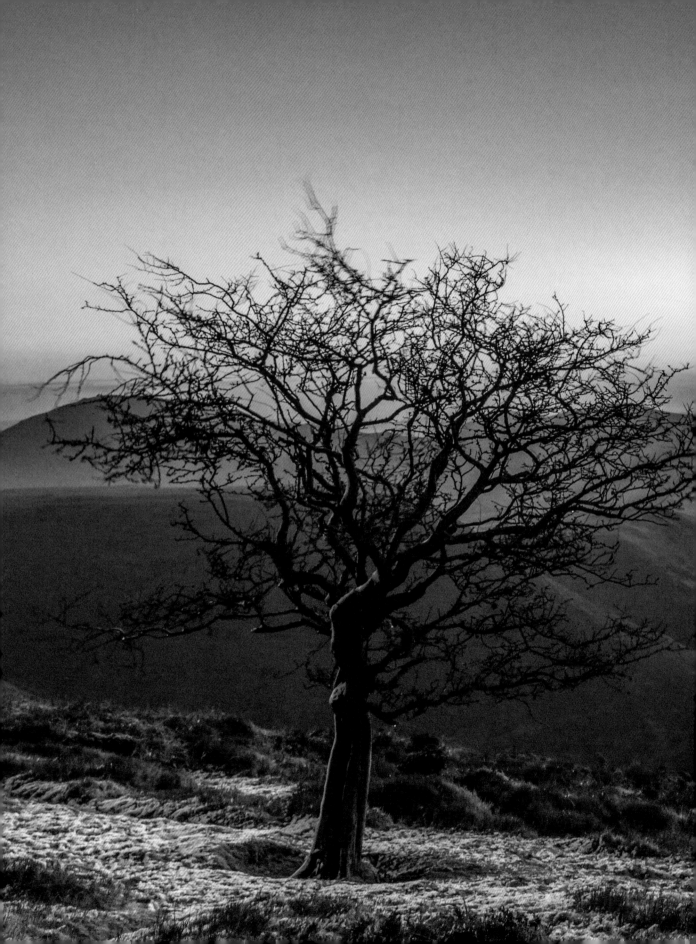

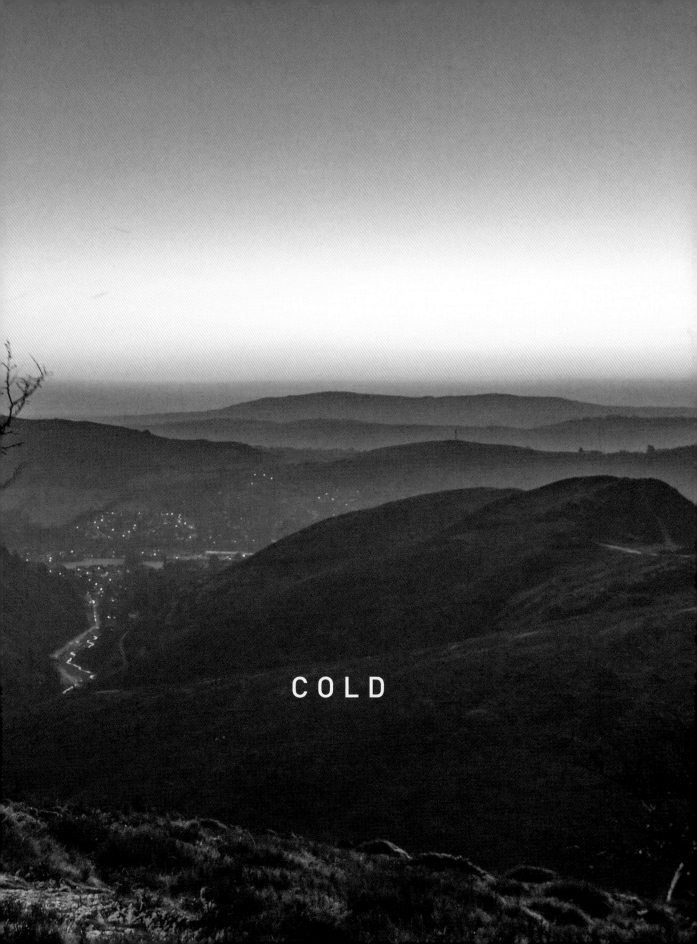

COLD

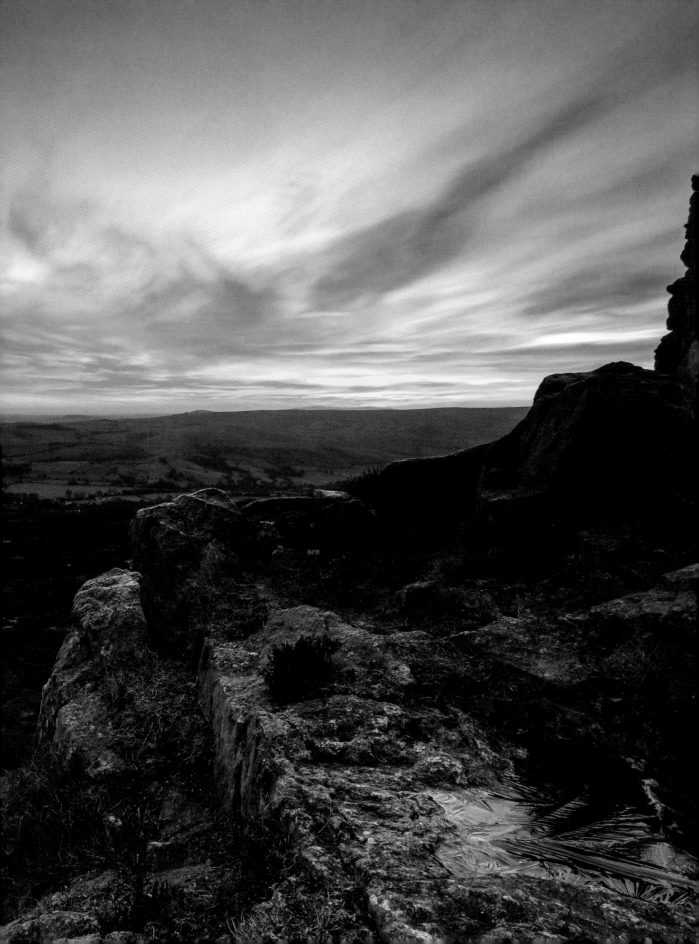

The absolute darkness of winter is the perfect disincentive to rising early. There is no hint of dawn at 5.30 am, just an instinct which tells me bed is the best place to explore, and that sleep is the only landscape worth travelling through.

But the itch is there, prodded into life by my weather app which promises the first lack of rain in ages. Winter has been one long downpour, drowning all wildlife sightings, good moods and distant horizons into a mush.

Frost has been forecast, and once I have grabbed my flask and kit, my breath is indeed visible and my lungs scorched by uncommon cold. I drive off through what is still night, only a hint of brightening to the west as I head through Bishops Castle and the Hope valley, then slowly climb up to Shelve and Pennerly. We are lucky in Shropshire to still have roads that are not roads, old rocky tracks leading to remote cottages high on the slopes of the Stiperstones. They were once inhabited by people who worked in the lead mines, and were called squatters' cottages. If you could build one on the common land overnight and have smoke coming out of the chimney then you could live in it.

Pages 26-27: At the beginning of January, we make our way up the Burway in darkness and walk along Cow Ridge on the first snow of the year to catch the pre-dawn with the lights of Church Stretton winking like fireflies.

Left: A freezing dawn on the Devil's Chair.

Pages 30-31: Taken from just below the Stiperstones. The snow makes for difficult conditions but it is worth battling through a Shropshire blizzard to show the land and valleys all the way to the far Long Mynd.

The desperateness of the mining community has faded. Now many of the cottages have returned to the earth as the pile of rocks they once were, while others are comfortably modernized and tucked into the side of the hill, filled with sleeping dreams as I rumble past.

Once I have left the tarmac, the adrenaline begins to kick in. My car grumbles about the bumpy line, tyres slipping on mud and finally patches of ice. How sad, with global warming, that a patch of frozen track excites me. Finally, after many twists and turns and beyond the last habitation, a gate indicates the beginning of heathland. The great mass of The Devil's Chair rises up in a silhouette. By seven, the sky behind has already changed colour, winter darkness leaching away and the stars struggling to strut their stuff. What I can't tell is if it is sky or clouds that have blinded the stars. A cloudy start, and the light, like elusive wildlife, will be hunkered down.

However, I have got this far. Time to head up the much narrower track that would throw my car into an exhaust-bashing crash and tumble. The frozen world beneath me threatens to make my legs do the splits. But I am happy, here, alone in the high lands of Shropshire, walking to meet the dawn. As I rise up the hill, I hear the first cackle of the red grouse and the male is suddenly in front of me, confused by my headlamp. Only a few feet separate us and he is doing what creatures often do at this time of day – not very much. I pull up my long lens but can't focus in this low light. So I merely enjoy the encounter, glad of grouse company before I head up onto The Devil's Chair itself.

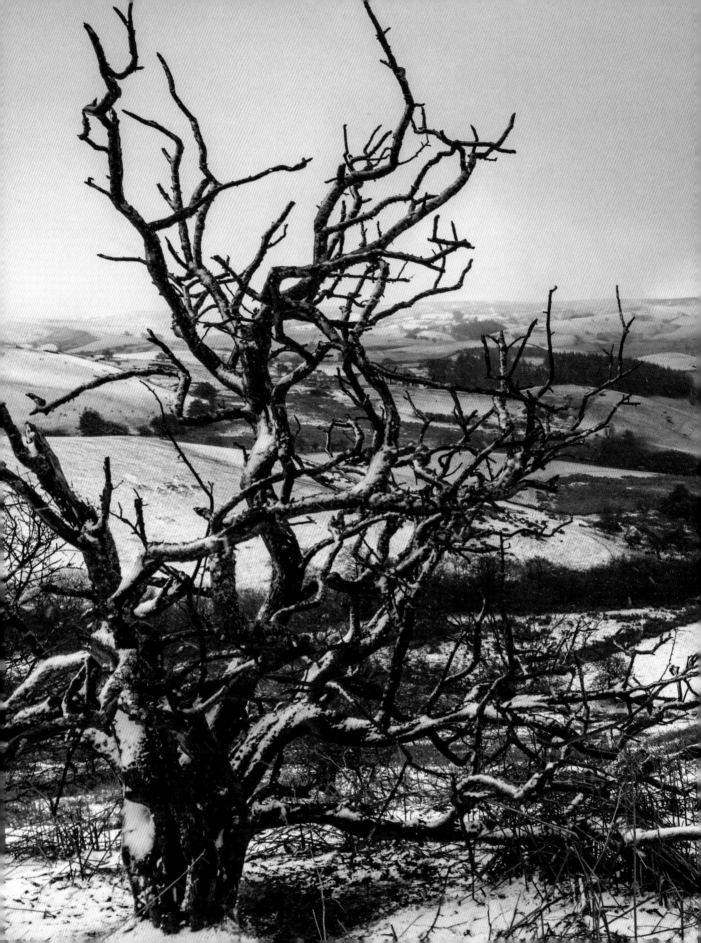

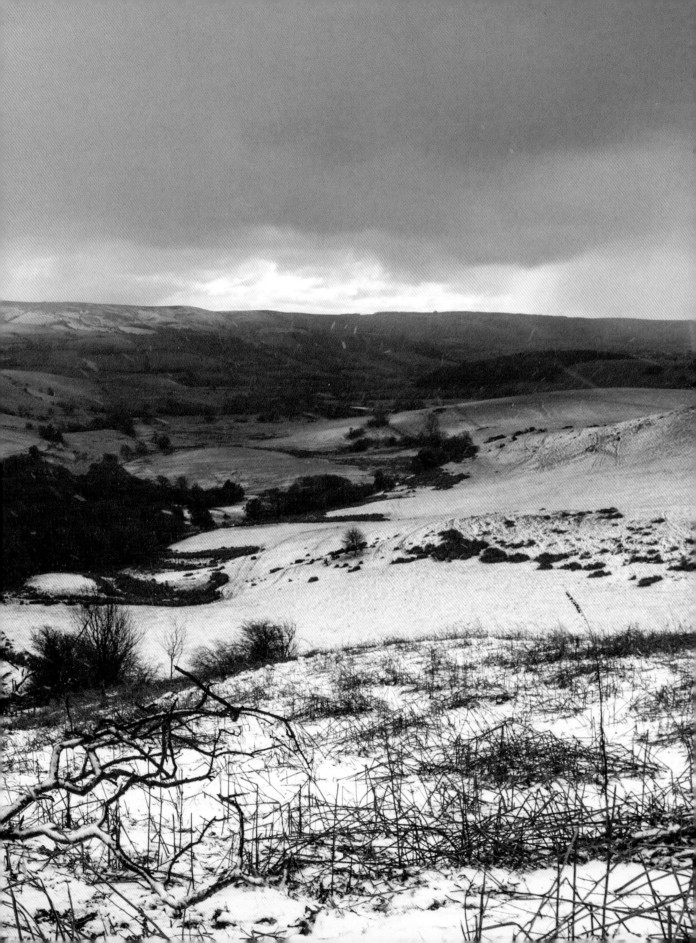

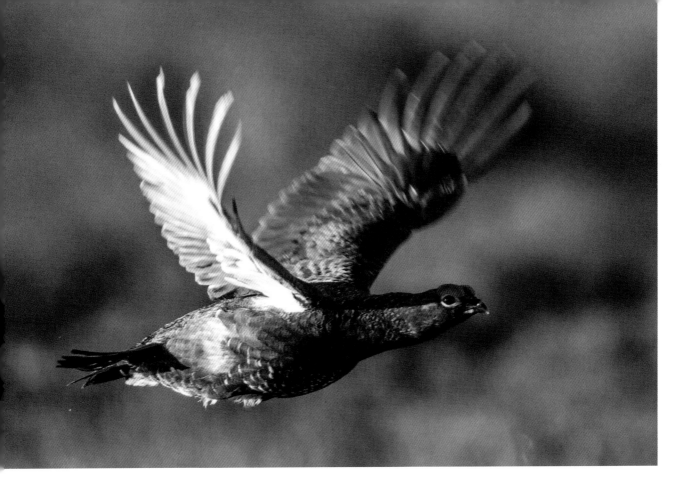

The Devil's Chair is one of several jagged rock outcrops known as tors that dominate a ridge running from northeast to southwest. The not well enough known novelist and poet Mary Webb, our own Salopian Thomas Hardy, describes my feelings this morning:

'The Devil's Chair loomed over them... like a fist flourished in the face. It was dark as purple nightshade.' – The Golden Arrow

But for me, the looming is architectural and inviting. I am in luck. There are enough clouds for the pre-dawn light to flare off, creating that classic few minutes of intense colour that looks photoshopped, though is, in fact nature showing every trick in the book. Here are frozen, tiny rock pools, intense patterns of ice and vast views that reveal Shropshire in its early glory. Now, only the camera needs to talk, showing both the far and tiny button that is the Wrekin and the striations of ice only inches from my lens. Land and light condensed into a frame. I am cold, but content.

There is a strange link to the past that goes from this tiny frozen puddle to the Iapetus ocean, 65 degrees south of the equator. Some 500 million years ago sandstone and pebbles bonded to form a quartzite sandstone. Along with most of Southern Britain, this beach migrated here at the rate of one inch a year. The tors themselves, those strange, fragmentary, scree-filled outcrops, were the result of glacial erosion, time frozen into a staccato ridgeline.

Not many know that time has layered on extra trick that I have not yet managed to witness. The upstanding shape of the tors, and the metallic content of the rock, make this ridge a perfect lightning conductor. No wonder it was said that the Devil sat here and brooded on winter's discontent.

A couple of weeks later, a forecast of snow

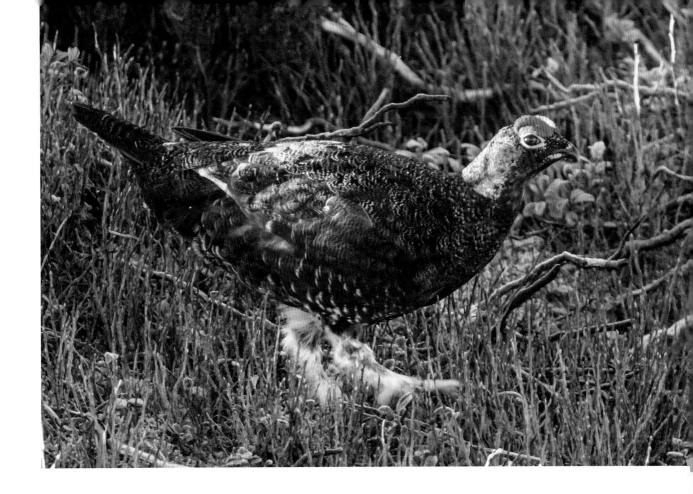

has me venturing out before the dawn again. It is sad that global warming has also eroded the deep winters of my youth, to the point where snowfall is a species to be tracked for its rarity. The roads are filled with slush and barely passable despite the gritters' best intent. I am ludicrously excited as an orange hue fills the sky, commingling with flakes thick as porridge. I make my first mistake when I turn off at Bridges for the tiny, one track lane up to the Stiperstones. This is farm-vehicle territory, where no salt has been laid and the road is white and unblessed with tyre tracks. I do not have a 4x4 but I do have optimism, having driven on permafrost lanes in Alaska. Needless to say, there is a difference between level, very wide American highways and a steep English road where the snow covers a layer of ice. I just manage to jump out of the car as it starts sliding back downhill, bouncing off a hedge with the door hanging out like a sorry

dog tongue. It's a massively expensive insurance job that has taught me one humbling lesson. Weather is bigger than me, and I need to listen to its teachings.

With my insurance replacement, and my wife's rather justified finger wagging turning me more careful, I do my best to prove that these cold months still have promises that can be fulfilled. Most wildlife keeps low, or rather wisely, winters abroad. But the grouse inhabit these exposed uplands come blizzard or shine. They are well equipped to do so, with feathers extending down their legs and even on their feet and toes. They look almost booted and suited as they stride through the

Left: Male grouse in flight, Stiperstones.

Above: Male grouse in heather, Stiperstones.

Pages 34-35: Bog pools above Wildmoor Pool at sunset, Long Mynd.

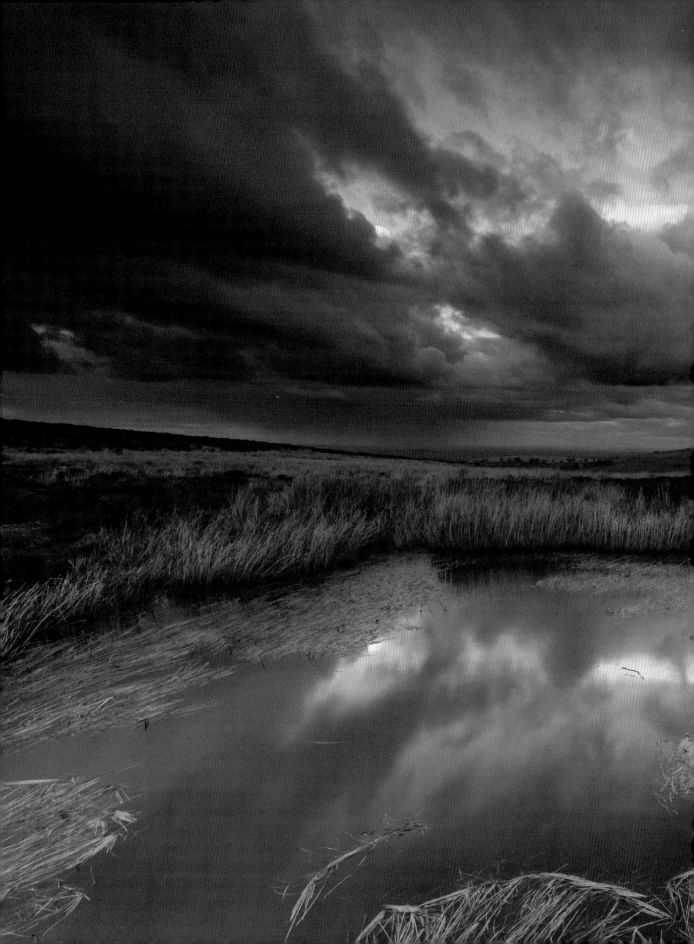

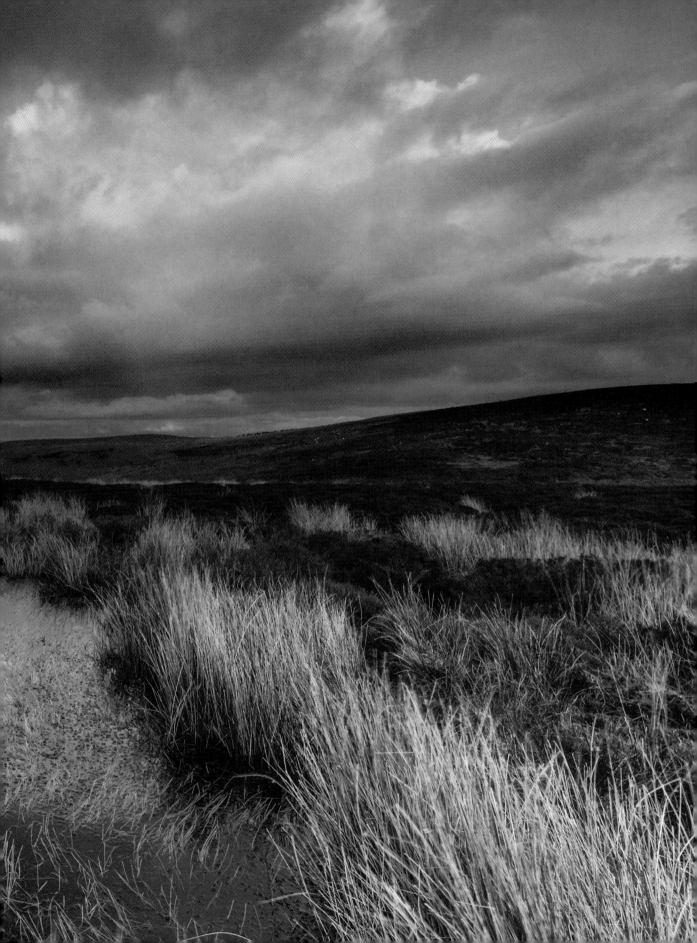

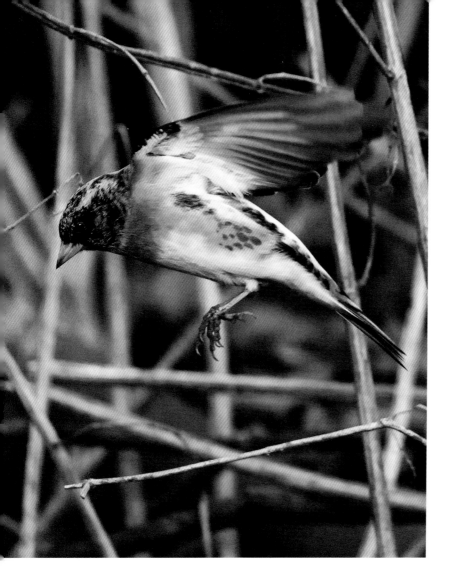

Brambling, a winter visitor, likes to shelter in one of
the few wooded spots at Pole Cottage on the Mynd.

Right: Bog pools above Wildmoor Pool at sunset,
Long Mynd.

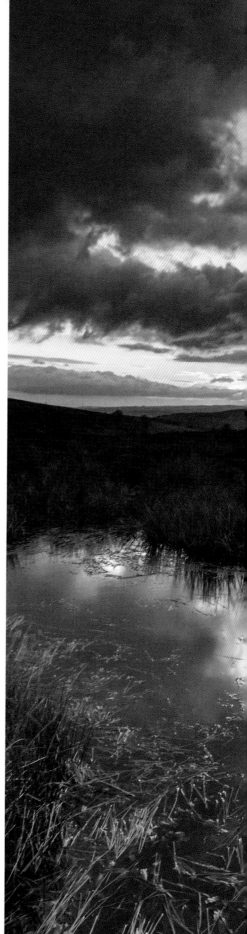

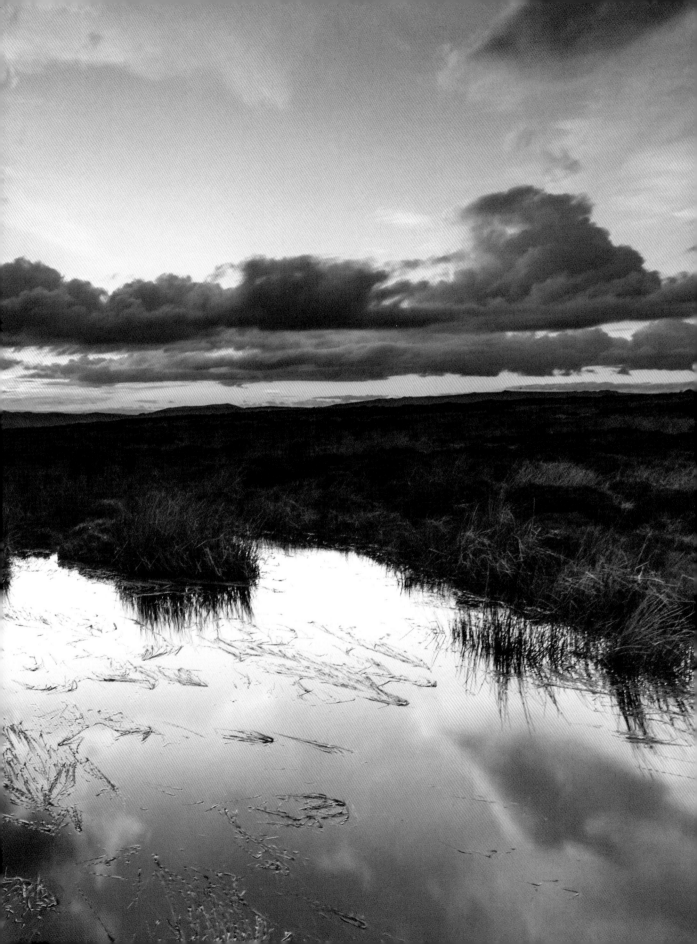

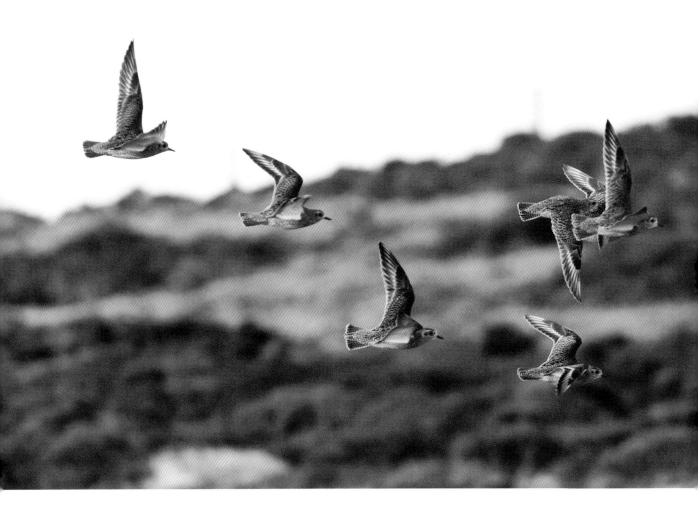

heather. When I manage to find them, and with their cackling call it's not hard, they look affronted at my presence and fly off in an awkwardness that reflects their plump bodies.

This is the time of sharp light, both at dawn and dusk. The bog pools hidden above Wildmoor on the Long Mynd are utterly transformed by the ending of day. I am constantly amazed that a pool of water only a few feet in diameter manages to swallow much of the sky and give it back again in a reflection that is both etched and immediate. At these moments, the landscape itself resembles a species. Blink your eye, and all is changed. Blue and pink transform to lush and burnt orange,

a warmth as my fingers freeze while changing camera lens filters. I feel absurdly brave though I am only a hundred yards off the footpath. Wading through heather is hardly a jungle expedition. But the loneliness of such moments exalts the spirits, lifts me to a point where I can feel overwhelmed. It is a far journey from my descent into depression. Nature is no longer a threat, but a wonder to embrace. The fact that I can do this, that I was in hospital five years ago, and that back then I knew this great despair was mine to shoulder for the rest of my life, even the fact that I did not know then that I would pick up a camera, change career, begin again, find new dreams; all of it is contained in this

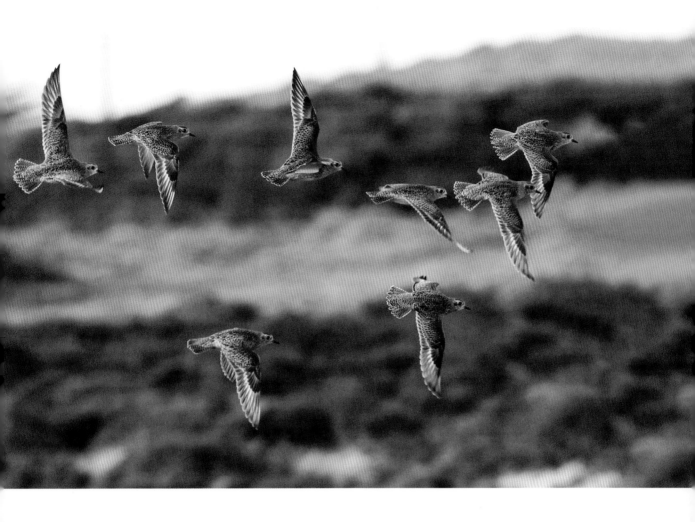

pool of water that changes before me.

I live here, but am like a tourist, astonished that the hills I have walked over for years have now taken on a new mantle. How was I to know that on the coldest of January days, a climb to the top of nearby Corndon Hill would reveal other visitors? What appear to be clumps in the grass, flare upwards and away to become a flock of wintering golden plover. And later, over at Pole Cottage on the Mynd, the far trees host a regular Scandinavian visitor – the brambling.

The season's promises are being fulfilled. Ice crystals turn clumps of heather into exquisite and brittle sculptures. But above all, this is the season of almost iridescent light that flowers in the predawn on the Burway above the Long Mynd, and has the last say on the twilight of winter as I drive home, watching colour filter through a bare tree.

In winter, golden plover like high remote spots such as High Park on the Mynd, or here on the bare, chilly top of Corndon Hill.

Left: Tree near Long Nursery at sunset.

Above: Ice crystals at Cranberry Rock, Stiperstones.

Pages 42-43: On hilly farmland where the curlews return in spring, a single kite soars against the snowy backdrop of the Stiperstones.

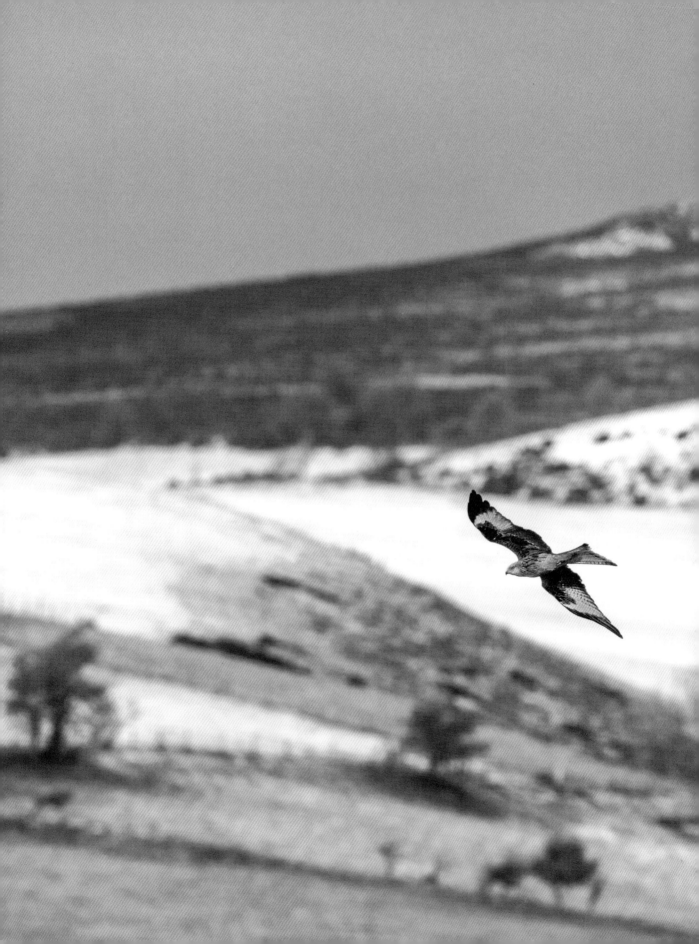

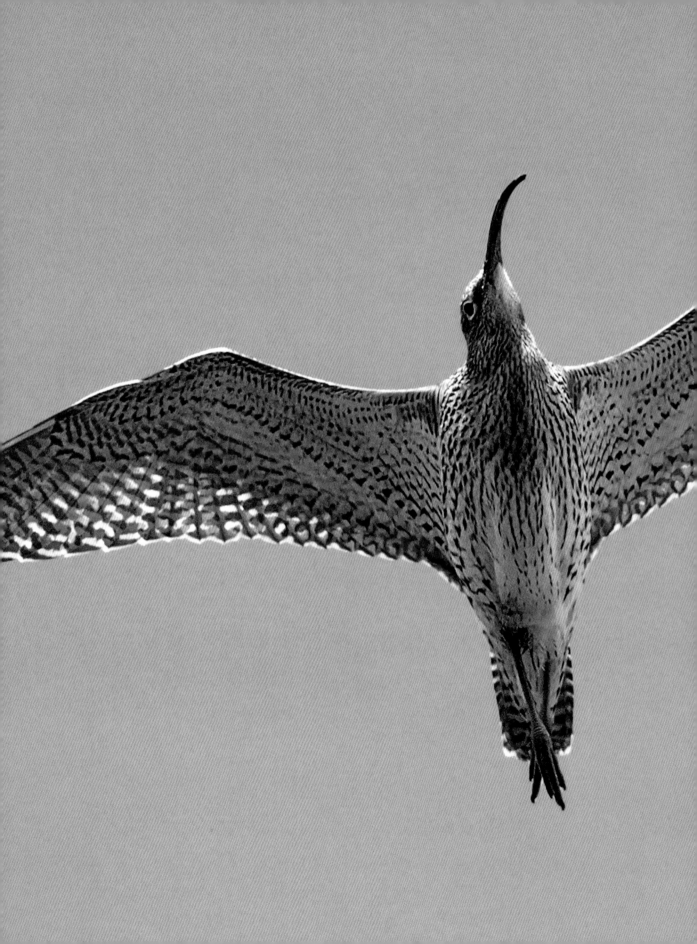

CURLEWS

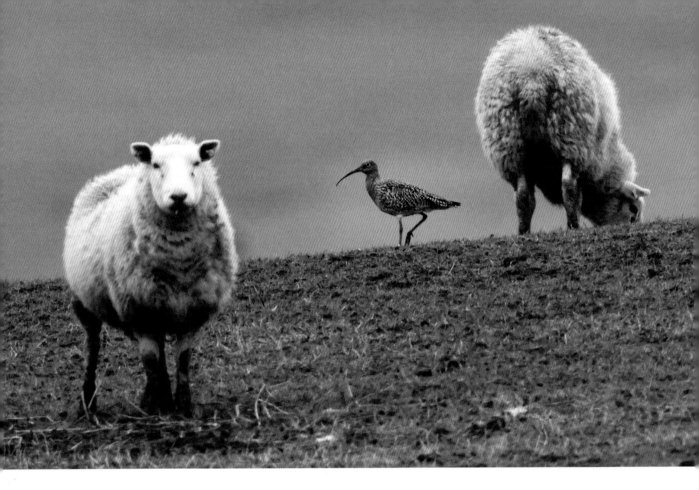

Though the grass is still bleached of colour, its greenery awaiting warmer days, there is one sign that spring is in with a chance. I get a call from my good friend Sue. Together with husband Phil and the boys, they farm 1300 acres under the Stiperstones.

Each year the curlews fly into a set of favourite fields, having spent time by the banks of the river Severn and before that, wintering on the Welsh coast.

I have struggled to photograph this flighty, delicate bird with its curved beak aptly described in its Latin name, Numenius Arquata, which roughly translated means new-moon bow-shaped. Two perfect metaphors for a beak that tips like an anchor weighing into grassy seas to pull grubs and wormy monsters from the deep. I too am pulled by this other-worldly gravity, keen to understand more. I am increasingly reliant on locals, landowners and farmers I have built relationships with, who are happy to share their knowledge and allow me to both walk and stalk their land. There is no way this type of photography can be done with a point and shoot camera – long and heavy lenses

are the door that opens to remarkable visions. Sue tells me the top fields on the left are a good place to start.

As I drive up the one-track lane with my window open I hear the unmistakable call of the curlew ringing through the grey day. It is almost daring, such sibilant chiming, an affront to a month that is looking backwards to winter while still tentative about new beginnings. I pull onto the verge, and try to exit the car quietly not clunkily, working out the source of the sound. Peering over a hedge, it is hard to spot these birds. They are brown in a brown landscape, mottled among mud, sticks and soggy flushes. But one bird does me a favour, feeding on a slight rise and obligingly walking between two sheep to frame up my first ever decent shot of this bird.

I am on to a good thing. I have worked out that by crouching low, using fences and hedges as cover, or my car as a hide parked next to a gate, I can shoot on silent shutter without disturbing them. There follows endless day visits where I track their movements, work out what times of day and where they are likely to be. Of course they like a wet flush, plenty of worms and when a crow flies too near, they take off straight towards me, water spraying from their feet.

On one of my visits, I am creeping along a hedge when a somewhat battered 4x4 pulls up at the field gate. I love to worry and my heart speeds up as a big bloke gets out with what looks like a gun bag. Am I in the right field, or have I strayed over farm boundaries and am about to get shouted out or worse?!

Pages 44-45: Curlew in flight above Bridges.

Left: After crawling along a hedge line, I got my first ever shot of a curlew in Shropshire.

Right: This pair is disturbed from a flush by a passing crow; A curlew's long curved beak is perfectly adapted to excavate for worms; With its diamond patterning, it is a most elegant bird.

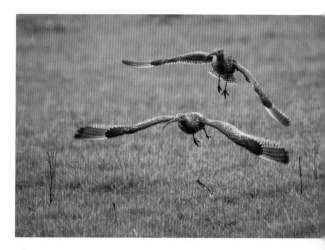

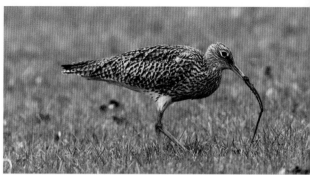

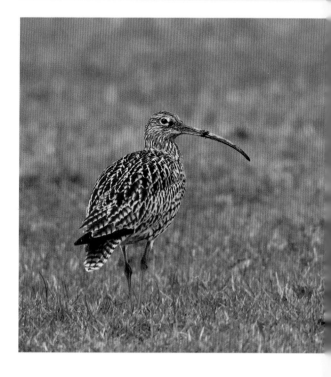

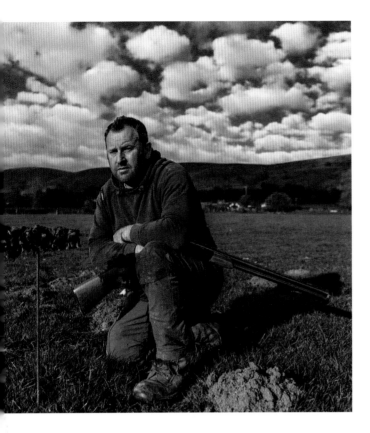

Taking courage in hand, I walk casually over to the newcomer and try to engage him in conversation. Turns out that Tony is the moleman, here on Sue's bidding to set his traps. I'm fascinated at someone who practises this ancient profession and he answers my questions with patience. Moles are never good news on a farm for two good reasons. Their tunnelling can lead to soil collapse and cattle breaking their legs. They also disturb the soil that often carries the listeriosis bacteria. Dispatching them quickly and humanely is a skilled job and Tony has been at it for some years now, at £7 a head. He has a nose for sunset stalking and can read newly turned soil like a book, spotting the latest volcanic earth eruption and quite often predicting when the mole will come out. Hence the gun. I understand more and more that my ideas of conservation need to be balanced. If one field gets infected, a whole herd can be lost. It happened to Sue and Phil a few years ago.

However, what Tony says next encapsulates all I feel about Upland. Having grown up round here, he moved to Shrewsbury for a while. If he said good morning to someone, they would stare at him as if he was mad. Being born and brought up in Norbury 'we talk to anyone'. Fairplay to him and it makes me smile, being a transplanted Londoner who married a Shropshire lass and never looked back.

When the sun finally comes a week later, even the colour brown takes on a richness as a curlew flies by me, all its wing patterning revealed as nature's intricate triumph. I grow more confident, find one spot on the road where they feed very close and where the hedge really is my invisibility cloak. It is heart-racing stuff to be so close to a truly wild creature that does not know you are there, and be able to frame and then share that beauty. I always offer to print up the best pictures and give them to the landowners who allow me access. They see them every year, but not this close and personal.

When I show Sue the first set of shots, it breaks some kind of barrier. I am invited in for a morning cuppa and croissant, when all the lads and other workers come in for a brew. I feel suddenly shy, but we all quickly work out that plenty of joshing and being rude to one another is the only way forward. I feel happy, cold fingers warmed up by sweet tea, and humbled by the knowledge gathered around me and the trust placed in me to go wherever I want. This tale has an uncertain ending. Curlew numbers have fallen by 30 percent in the last 11 years round here and monitored breeding has shown a very high nest-failure rate, despite support for farmers to mow later – meadows with high grass are the main breeding spots for this bird. Trailcams over the last few years have shown predation by badger, crow and fox.

Tony the moleman can read molehills to work out when a mole is next going to surface.

Right: Curlew in flight, showing their brown body designed to fit into its habitat.

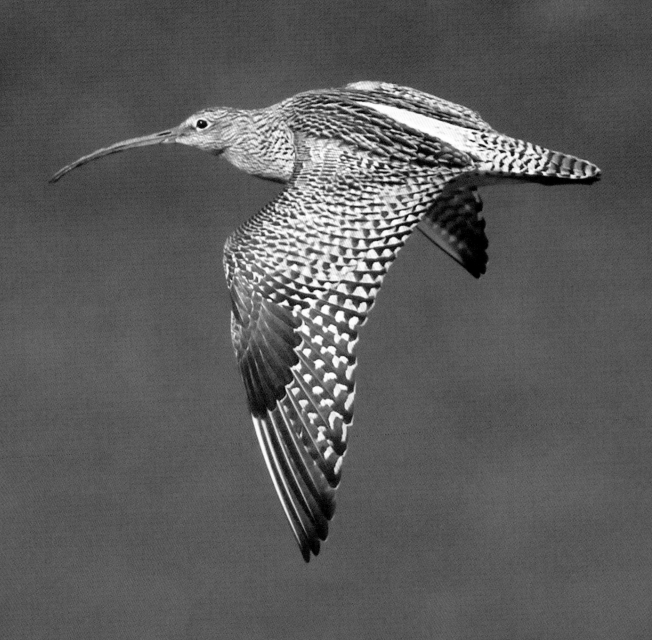

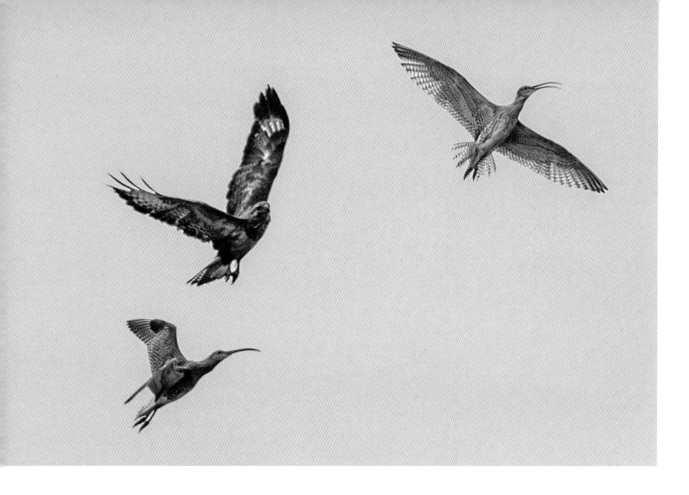

Above: A pair of curlews in a 'distraction display' as they ward off a buzzard. Curlews are in decline locally, but this distraction behaviour indicates that they might be trying to protect nearby young.

I feel incredibly welcomed in by the family who between them manage nearly 1300 acres under the Stiperstones.

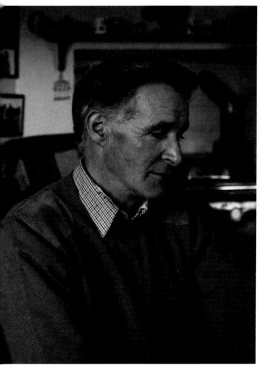

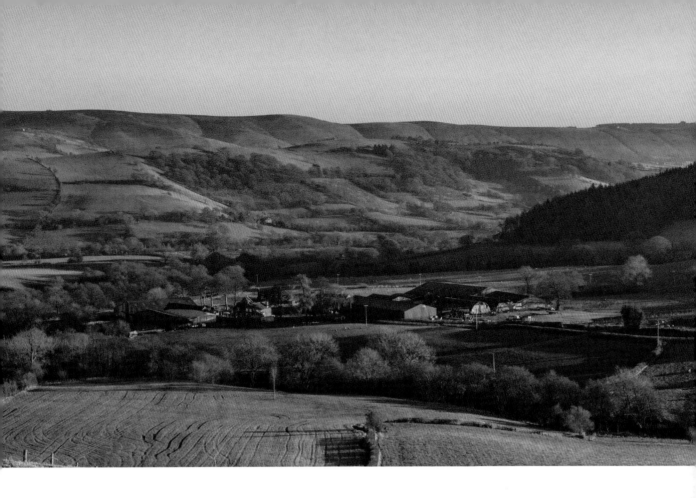

I spend time talking to John Sankey who has farmed by the Bridges for many years. He remembers there being hardly any crows or magpies about when he was younger. There is always an issue of one species doing well to the detriment of another. I am no expert on the ins and outs, but the cry of the curlew is heard less and less and that should not be the case. The Fauna of Shropshire (1899) says: 'The curlew is numerous on our Shropshire Moorlands.' I would that it were so again.

Once breeding season starts, I pull back and hear nothing until the end of June and an excited call from Sue. She has seen a pair of curlews fighting off bigger birds and wants me to check it out. As I drive to the edge of the fields I see the curlews take on a buzzard and a few seconds later, a crow is given short shrift. Such behaviour, called 'distraction display' is well documented. The name does what is says on the tin, indicating that parents will try to distract predators while their young are vulnerable. I witnessed this over and over and heard the curlew's whistle transform into an aggressive cry of warning not to get too close. There is no way of knowing if those young fledged successfully. This was one of the unrecorded nests on the farm. But two days later when I went back, all the curlews had gone. I wish them well and hope and pray some of the young managed to fledge.

The curlew belongs in Shropshire and I hope we can help numbers recover.

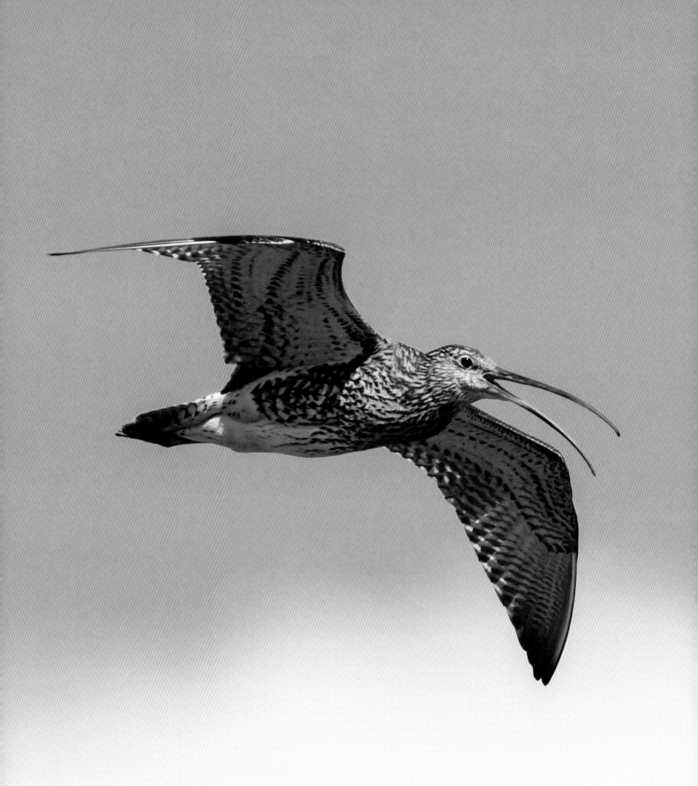

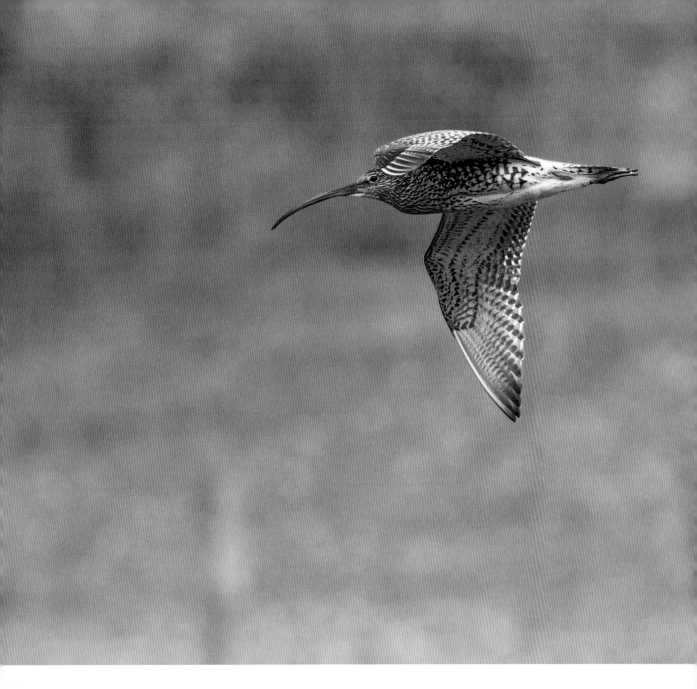

Left: The cry of the curlew was one of the best soundtracks I have ever had when working in the field.

Above: Once the meadows begin to fill with flowers, the curlews were framed by a vibrant landscape.

Pages 54-55: Driving through a spring storm on the way back from seeking curlew, I find the double-bowed beak of this rainbow on the west flank of the Mynd.

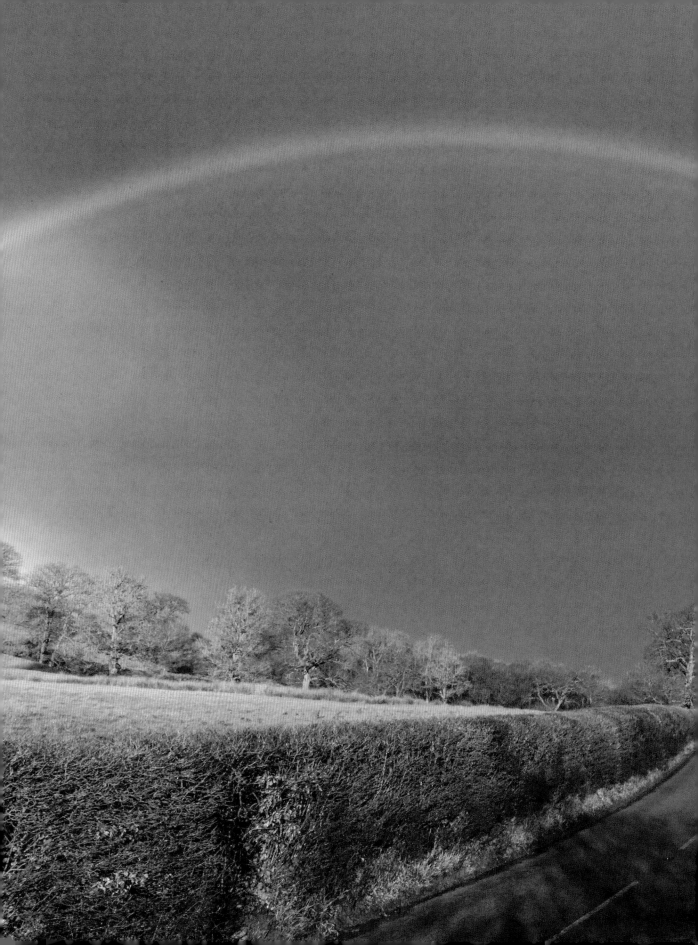

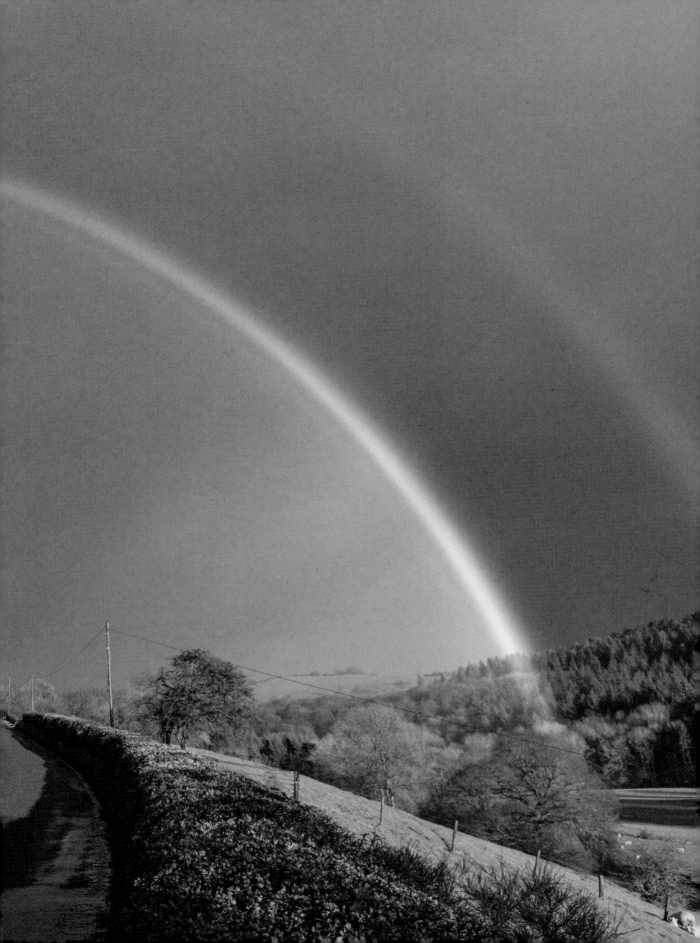

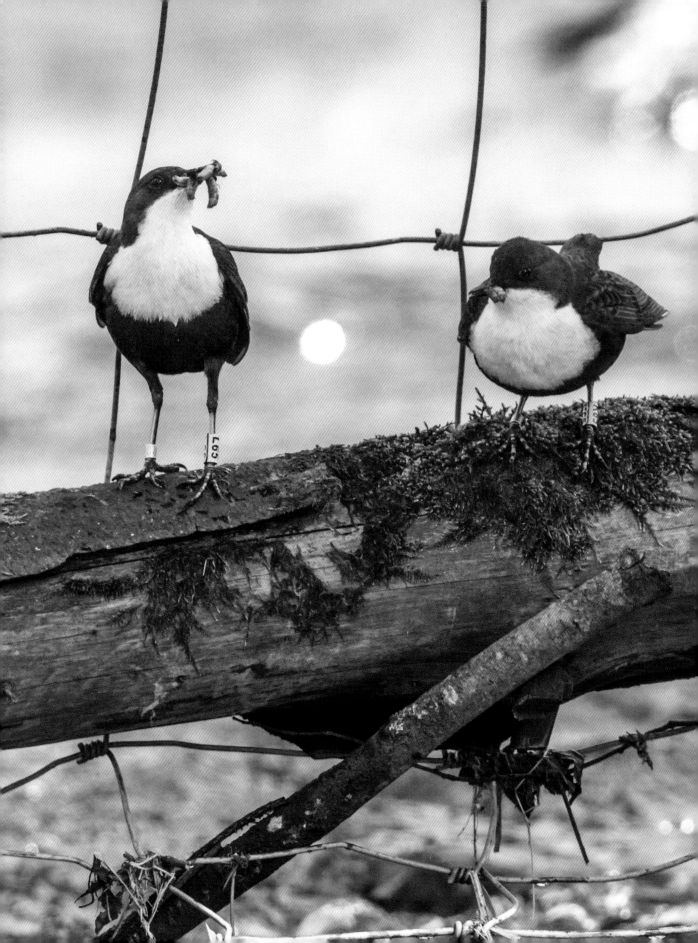

THE BRIDGES AND UPPER ONNY

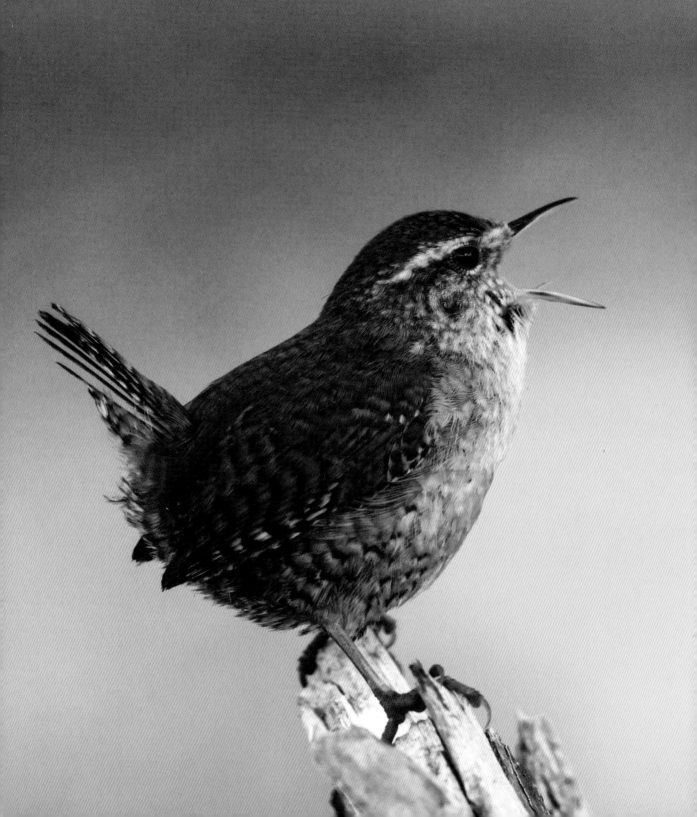

Occasionally humans can get it right and rectify species decline. The pied flycatcher is a good and rather hopeful case in question.

This spring, as I drive on my regular forays round the roads near Bridges, chasing both curlews and dreams, I keep seeing strange men lurking along the byways with even bigger lenses than mine. I can't help but wonder what they are doing on my territory.

Here is a new story I was not aware of, where trees, riverbanks, willing landowners and keen conservationists all come together to do some good. It appears that bird-boxes have been in a frenzied bout of breeding activity, and 400 of these tiny timbered and portable grand designs have been settling onto riverside trunks up and down the east and west Onny. The AONB reports that in 2014, volunteers who checked the boxes found 48 pied flycatcher, 4 redstart, 60 blue tits, 26 great tits and 2 nuthatch. Not a bad haul really and a good explanation for dodgy middle-aged blokes hanging round the verges.

I have never seen a pied flycatcher, though I have been fortunate enough to spy out a coconut shell being used by a spotted flycatcher family that featured in my last book Wilderland. Now I am hungry for something new. The song is distinct, which helps, and I am astounded in the dull, damp green of early spring to see such a stark

suddenness of black and white. Pied does not do the male justice. He is entirely elegant and the female with her soft beige colouring is also far from the 'small brown jobby' that birders call the more uninteresting songbirds.

They are not entirely shy, which is why the tripod brigade are grabbing some great shots. I always prefer to go in handheld, sit for a while, even use my knees, a branch, a fence for balance. It's not a bad way to spend the day, even when the weather squalls suddenly, bringing a flurry of snow. Here is optimism despite the last gasps and coughing fits of winter. As a red status bird, we must welcome and nurture these African migrants as best we can.

The imperative of spring and the fact that the Upper Onny is so damn beautiful means that any excuse will keep me on site. It helps that the Bridges pub was bought by my friend John Russell some years ago. His refurbishment and remaking has turned the pub into a Mecca for walkers, birders, holidaymakers and keen photographers such as myself. It is now run by John Sankey's son and I cannot recommend it highly enough for seriously good food, a drink, a stay, and a warm welcome all round. I like the fact that the Shropshire hills are perking up, as if they finally realised they are worth visiting and are now prepared to sing out about it.

So, after stopping off for a refreshing pot of tea and a great lunch at the pub, I am back by one of the old brick and stone bridges that cross the river. I had no idea, and I have walked this valley many times when the children were young, that underneath this bridge and under most others in this valley, there are nesting dippers.

Pages 56-57: Once there are young to feed, both dipper parents are on full time duty.

Left: A tiny wren sings a song that has 740 different notes per minute which can be heard more than half a kilometre away. It's the equivalent of our voice being heard from 5 miles away.

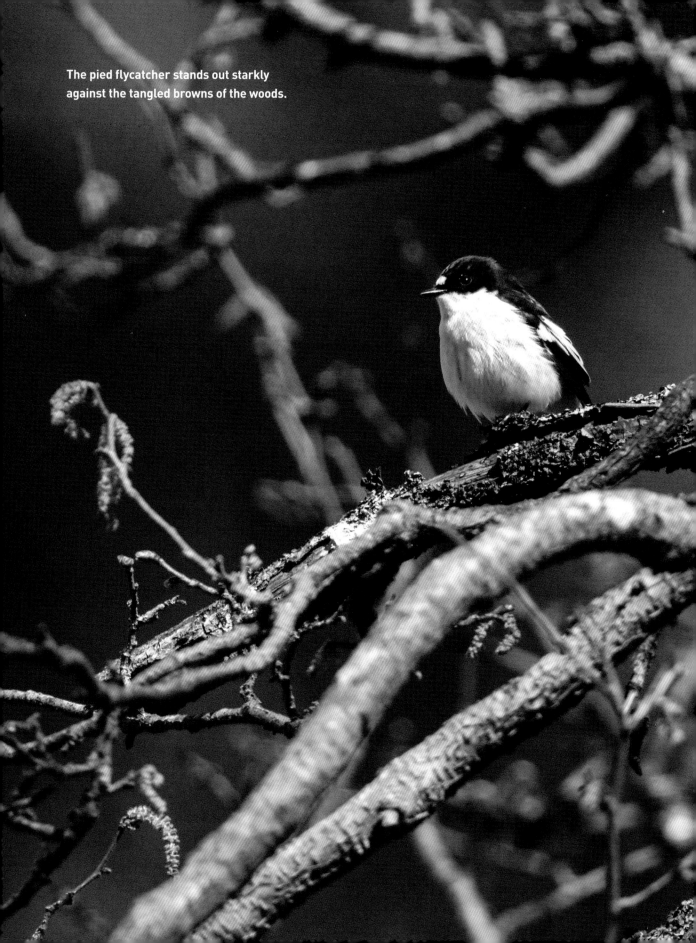

The pied flycatcher stands out starkly against the tangled browns of the woods.

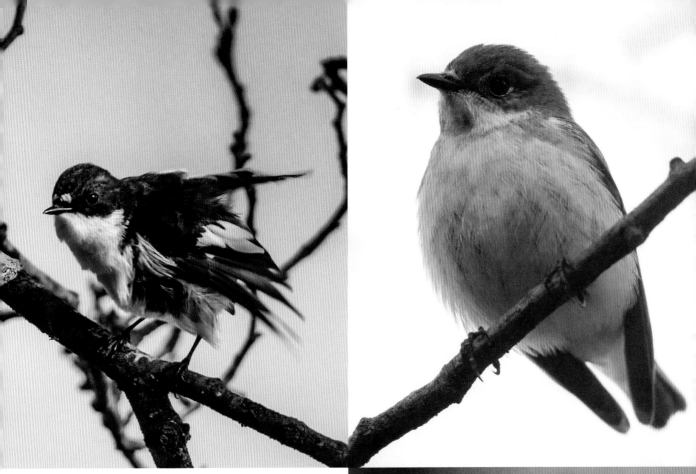

Top left: Pied flycatcher male preening.

Top right: Female pied flycatcher.

Right: Male pied flycatcher defending its territory.

Pages 62-63: In winter, this ancient bridge over the river is a quiet, contemplative spot, giving little hint of how it supports new life for dippers year after year.

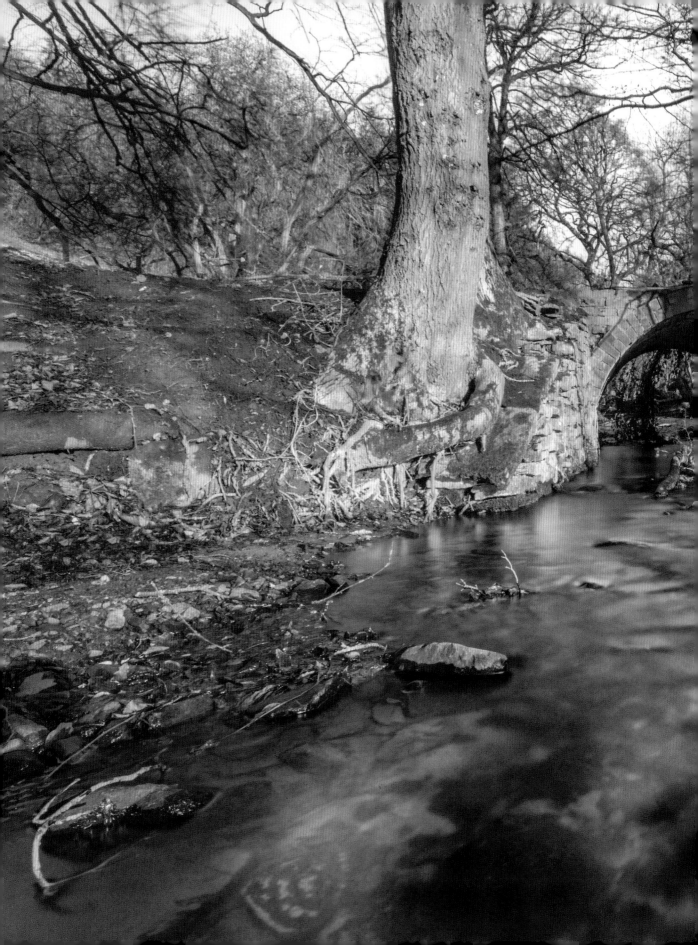

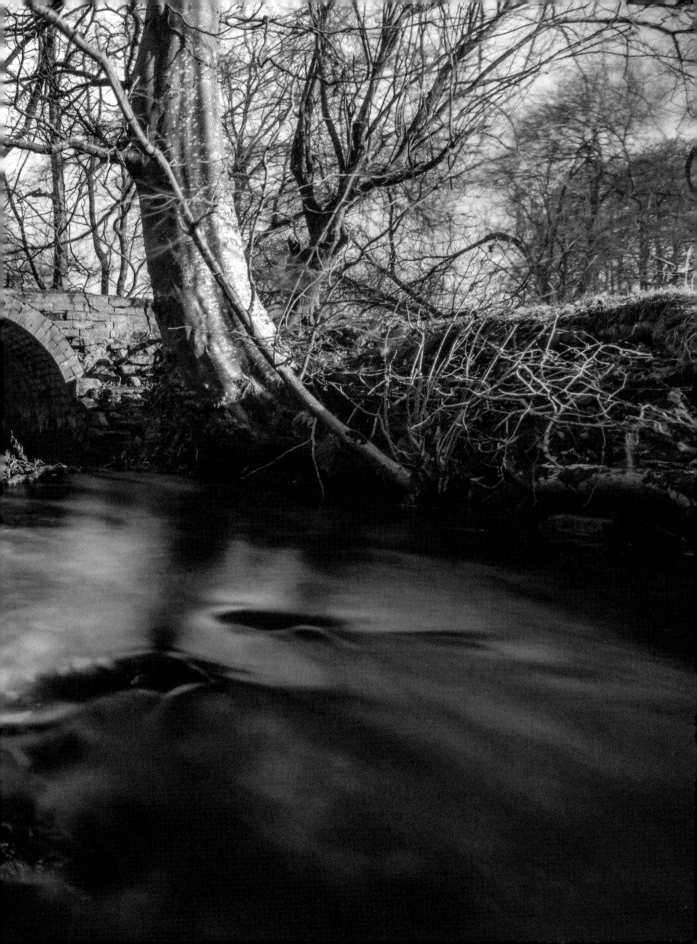

What an honour that flits alongside us. By the time I have finished with the flycatchers, I can see the dippers on feeding duty. This means there are young in the nest and a grand opportunity arises. With some of my more intimate outdoor work, I am intensely careful about disturbance. After consulting with Pete Carty, my mentor and employer from the National Trust, I start to work out a brief but effective outdoor studio. As the parents are off foraging for watery grubs and insects, I set up a couple of outdoor, low output flashguns on stands under the bridge. My camera, on a tripod, is pre-focused on the nest with a remote cable attached.

I retreat a good ten metres and wait for a parent to come back in before firing off a couple of shots. I do this twice and then pull the equipment out, with what appears to be no disturbance to the parents. The experience of working with blackbird and robin nests in sheds and outbuildings has been invaluable. It has shown me how the birds often live quite comfortably alongside humans. This spot is comparable, on a busy public footpath, used by tractors, sheep and walkers. I am able to capture

a magical moment of the parent emerging. A while later, new life emerges. The fledgling, a bulbous ball of a chick showing the fascinating white eyelid that marks all dippers, rests for a while on river rock before zooming off downstream to its own future and hopes for a good and productive life.

I am happy. Even more so as I return to the car and a wren lands on a stump in front of me, singing its little heart out, oblivious to my shutter. I even catch its thin tuning fork of a tongue. The wren is a surprisingly common bird that has mastered all sorts of landscapes, both harsh and benign. Here, in the woods of the Bridges, it bestows choral beneficence.

For almost six weeks, as I move on to other projects, I forget about the flycatchers. Until my friend Amber invites me to come out to another set of boxes near Snailbeach to see Andy Spencer, the ringer, at work. We go into another site on a steeply wooded slope where the footpaths are more suggestion than actuality. Within minutes of scrambling, slipping and swearing, I am covered in sweat and even wondering whether I should have given up my old career. Boxes are checked and when one shows evidence of habitation, Andy puts in some very simple whatchamacallits so that birds can go in, but can't come out. Half an hour later, we return from our birding round to recheck the boxes. Andy uses hoods to take out the birds and keep them calm while they are weighed, measured and ringed. I am able to take some intimate portrait shots at bird's eye level and observe the attachment of the rings to enable monitoring. This checking up is essential to understand what is happening with species and then to act on that knowledge.

April snow does little to deter nature about its work.

Right: No-one knows for sure why the dipper has a white eyelid. This is often mistaken for the semi see-through nictating eyelid that dippers use when diving for food.

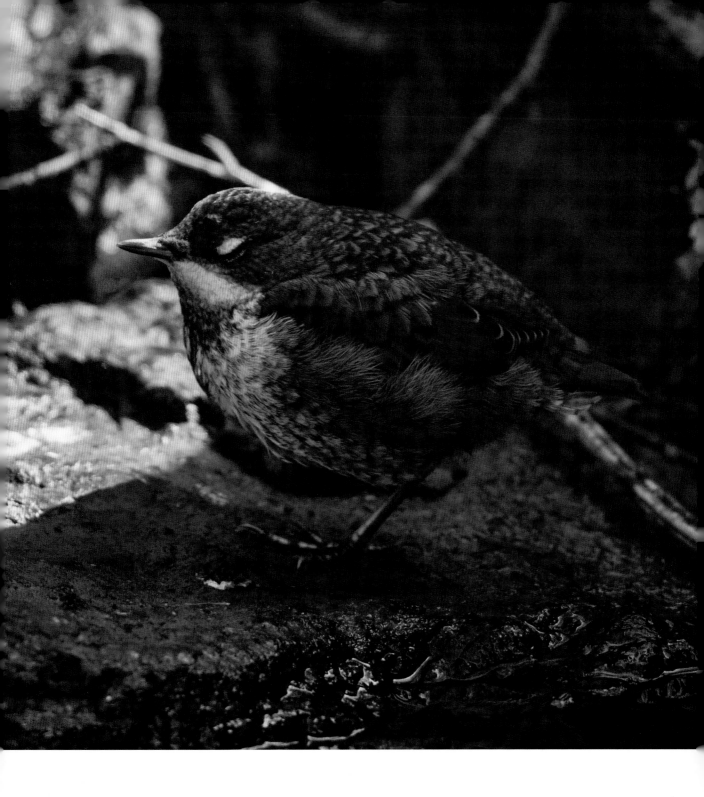

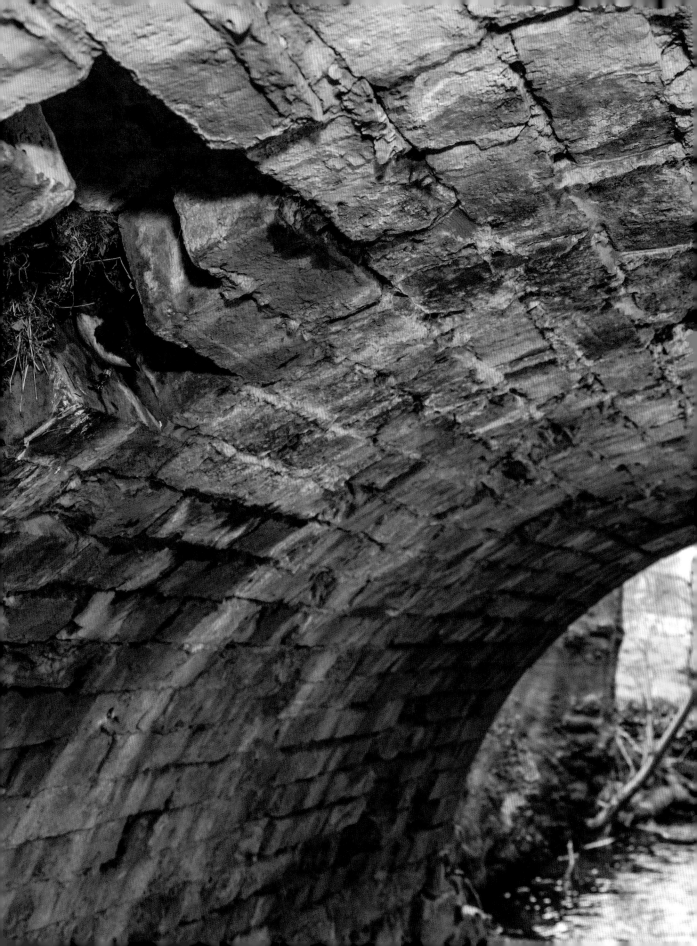

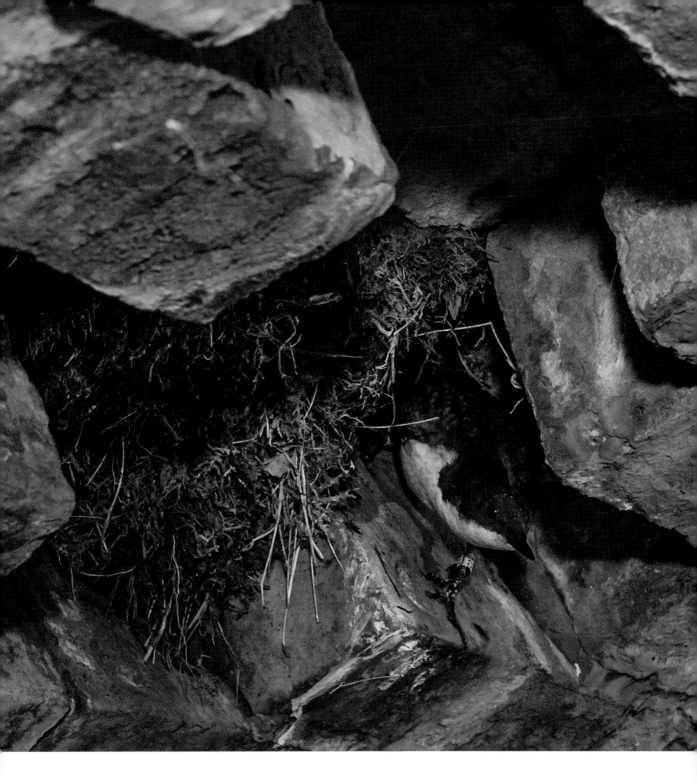

There truly are hidden treasures along the river if one looks hard enough. I only stay for a short while so as not to disturb the parent dippers as they feed their fledgeling.

Top: female pied flycatcher.

Middle left: male pied flycatcher.

Middle right: Andy checks the male's wing.

Bottom left: The most important thing is not to disturb the birds during this process. Andy has years of training and expertise. Only licensed ringers can do this type of work.

Bottom right: A ringing moment.

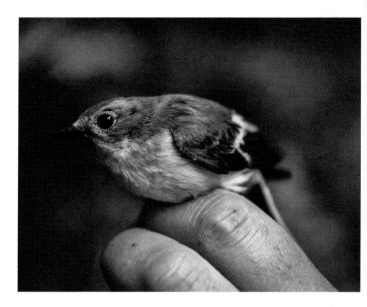

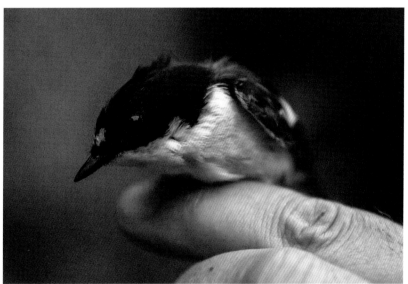

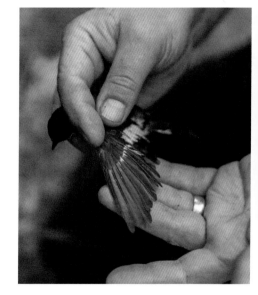

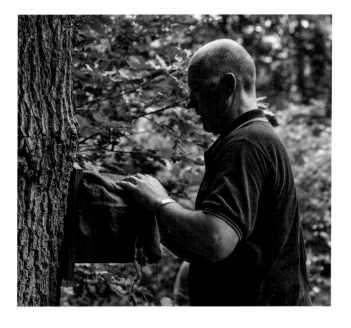

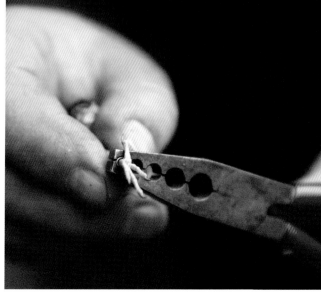

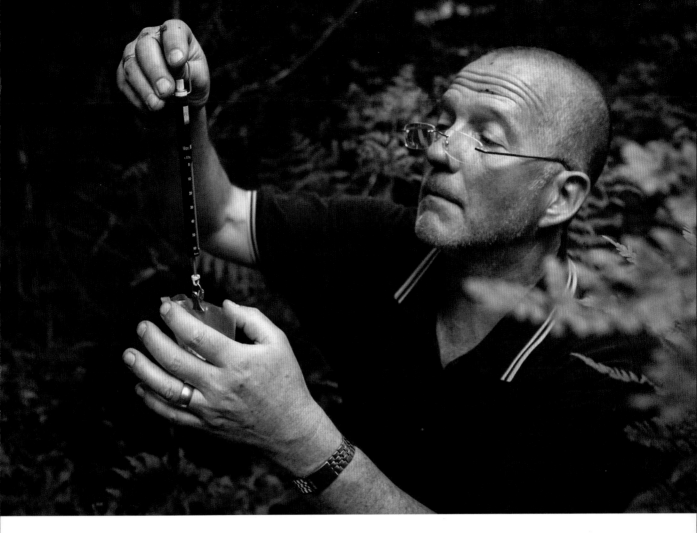

Without it, this recovery for the flycatcher would not be able to go ahead. The job is done, fingers gently uncurl, and the bird flies off into the wood.

The Bridges itself has one last glowing card up its sleeve. There is a reason that the council verge cutters only cut to a certain level round here. I have met up with my old friend Tracy at 10pm on a June evening to go on a hunt for green emeralds.I last saw them when I hitchhiked with my girlfriend through the Blue Ridge Mountains of Virginia thirty years ago. As we slept under the spreading boughs of a wilderness tree, they danced all around us. Being young and very new age, we thought them fairies. I am still inclined to believe they were, and on this night now, somewhat older, Tracy and I were out to see them dance right here in the Shropshire hills. But this shows my limited knowledge. Those were fireflies. And the female glowworm does not dance on these hot June nights. Neither do glowworms have wings but their gender politics are interesting. For it is their job to attract a male. Lampyris noctiluca only glows for a few weeks until she mates, which she does soon after laying her eggs. A molecule called luciferin is oxidized and the reaction causes light. Older readers will remember that matches used to be called lucifers, and the name Lucifer literally means lord of light.

Weighing the flycatcher for data which is then used to understand decline or recovery of species.

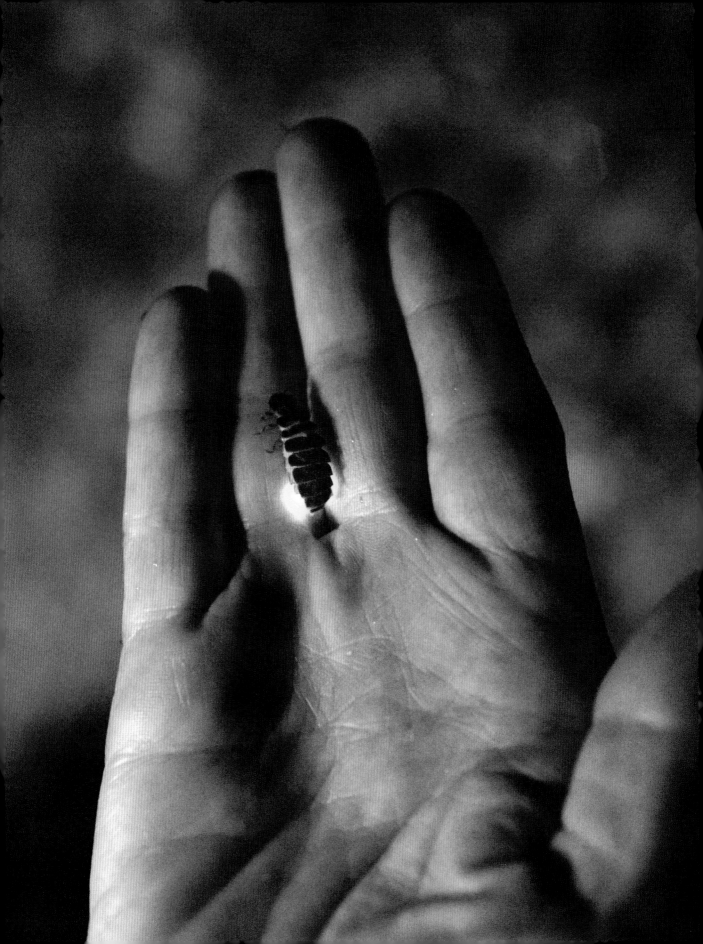

We have an amateur but knowledgeable entomologist aboard as we set off from the pub once it is dark enough. In the close still air, what we need is the last of the sunset to fade. When it does, the verge is transformed by dots of green light. This is exciting stuff, though hard to show on camera. I check with our resident scientist (and later run our actions by the main entomologist who works for Natural England on the Stiperstones) to see if it is OK to take a close-up portrait of the female. The all-clear is given as Tracy offers her hand as backdrop to show the hard work of the female, before it is gently placed back into the grass. If June is the greenest month, this is colour, light, and life on steroids, a remarkable miracle of evolution that shows life will out, even it requires the participant to act as nature's not-so standard lamp.

The female glowworm is a jewel in the hand, but quickly returned to the verge to continue her lightshow for attracting a male.

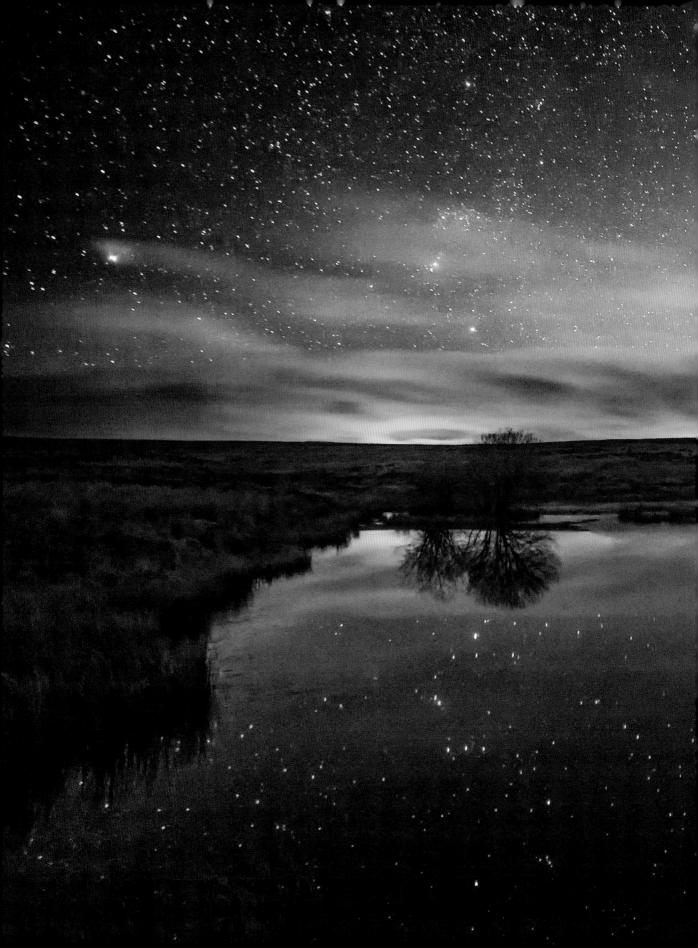

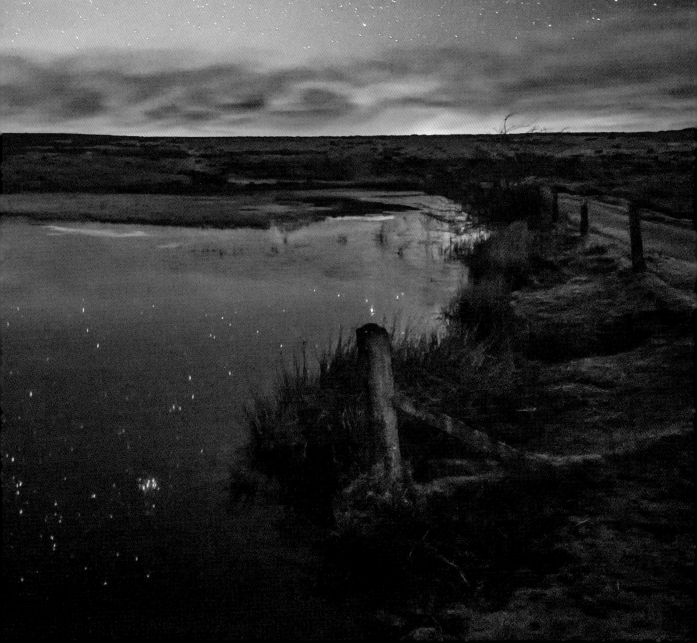

WILDMOOR POOL

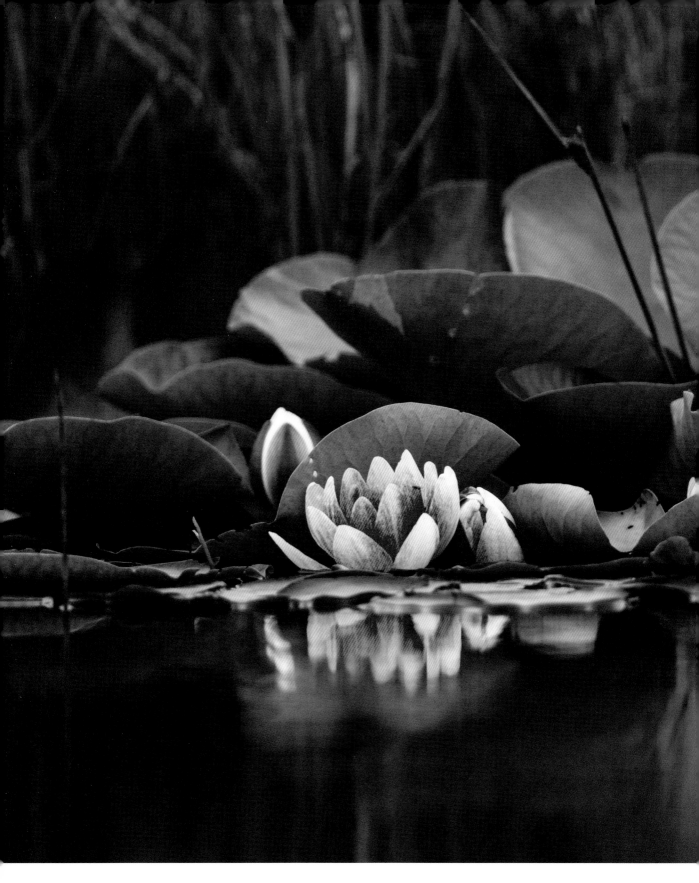

I have an affinity with water and have swum in the bog pools on the Long Mynd deep in November, when the mist was welcoming and the squidgy sediment surprisingly soft and unchilling.

But Wildmoor Pool, hidden in a cleft between heathery valleys has defeated me. There is no spot that has been hollow enough to take my body, so instead, I have come here often at sunset when clouds battle it out over the rippled waters while the Mynd ponies graze under skies softening into dusk.

Ponies have been bred here since the 12th century for use as packhorses along the Portway. The current 30 ponies and their foals are Cwmdale Prefects bred from Welsh mountain pony stock. They are not tame but are looked after by one of the commoners, who checks on them regularly.

I've thought long and hard about catching the stars as they rest in Wildmoor pool at night. But such an event would need many attributes.

Pages 72-73: Double constellation with Sirius, Orion's Belt, the Pleiades, Betelgeuse all reflected in the pool's surface before it froze.

Left: The waterlily at Wildmoor. These waterlilies have to be managed by the National Trust so they don't take over the whole pool.

Pages 76-77: Ancient rights allow commoners to graze horses on the Mynd. Although they are regularly checked, they lead completely wild lives through all the seasons.

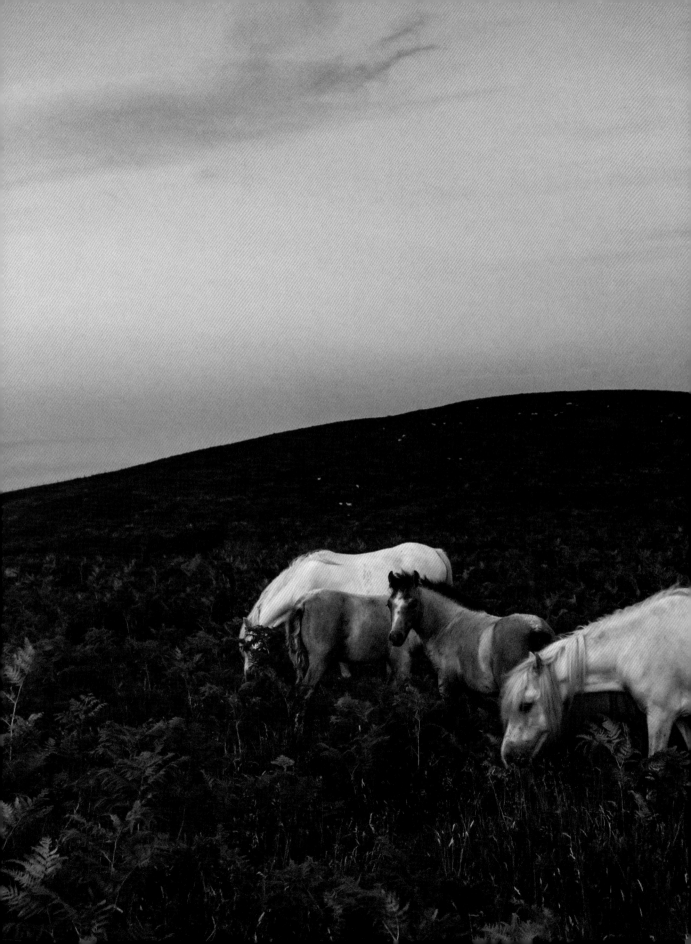

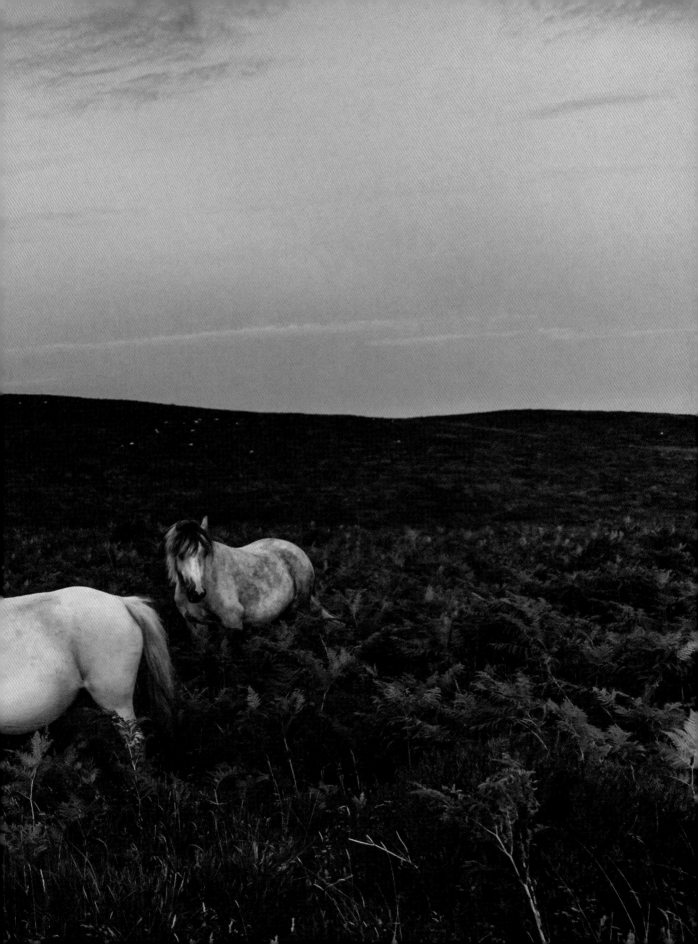

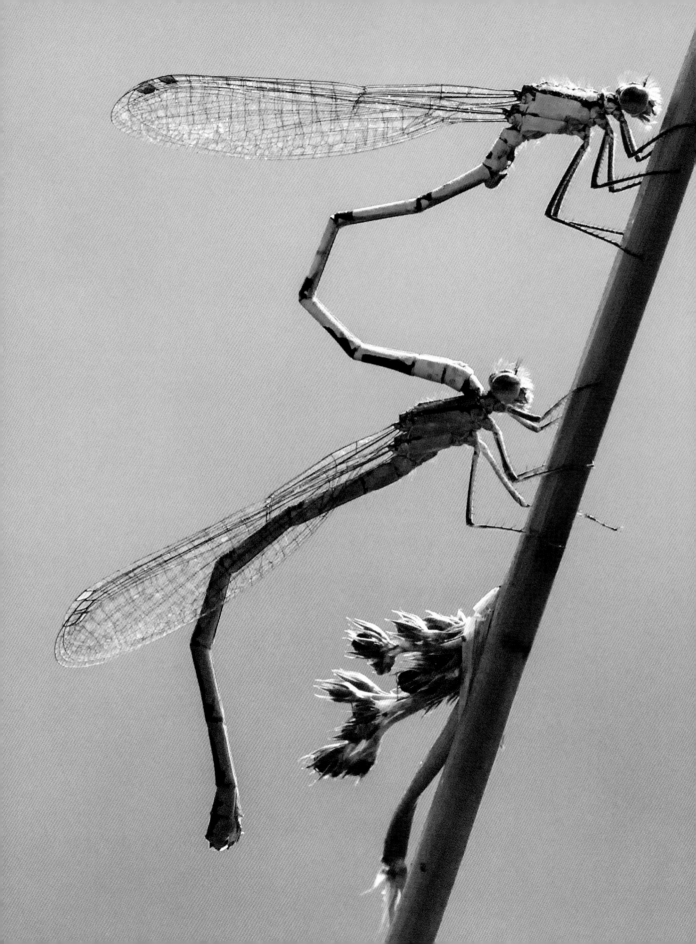

Namely: no moon, for the light of the moon is always a threat to constellatory activity, no wind for wind is the enemy of long exposures however heavy your tripod, and finally, a clarity that sometimes only comes during the spread of winter.

This early March, that old season still holds upland in its grip. The temperature is just below freezing as I slip out of Bishops Castle. By the time I pass through Bridges and beyond Ratlinghope church to hit the slopes that edge the Mynd, the cold has intensified. At -4.5 degrees, it's enough to turn 9.30pm puddles slushy as they transform into mini tarmac skating rinks my Zafira has no desire to slide over.

I drive slowly and somewhat fearfully into what is now an official dark-sky designated spot, and can see the verges and their grasses frosting up while I drift by. I feel both fear and anticipation when I leave the last farm behind, cross the cattle grid and wind up through heathland towards the fifth highest spot in Shropshire. With no mishaps, I finally pull up at Wildmoor. The Mynd, for now, is mine. My only reminders of civilization are the lights of Shrewsbury in the far valleys behind me. As I step out of the car and turn off the lights, I am enveloped in speckled glory.

Here is what I dreamt, for the sky has doubled up, unfolded a version of itself onto the flat meniscus of the reed-strewn pool that spreads before me. I am not alone. A pair of Canada geese appear under my LED headlamp, affronted at this two legged interloper. To have got them in shot would be a great wonder but they wisely squawk and flare off into the darkness. I am left with the clouding of my breath and the technical challenge of catching this view. Fortunately, there is enough glow in the sky to backlight the landscape. The ripples of goose-exit slowly die away. The pool finally falls still and the smudge of reflected stars sharpens. This is my moment when the sky and stars fall into a swoon and are swaddled in the coldest of smooth cots.

On the way back, I stop to climb the heathery

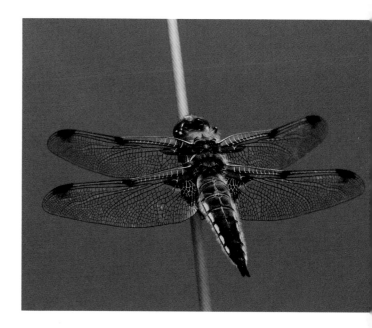

tussocks for one last look. As I take a step, a skylark leaps up, caught in my beam and turning a blanching white. It flickers from sight, a strange silence so opposite from its daytime song. The roads glitter and earlier slushy trickles and puddles are now solid and unyielding as I thread my way home, glad for the gifts of this Shropshire Upland.

The picture which emerges from its digital exuvia is of a glory that both impresses my agency and the national papers. Orion's Belt, known as 'the string of pearls' in Arabic, admires itself in this purpled mirror. I feel like a rock star with a hit on his hands, and this gives me the confidence to take Wildmoor Pool to heart and use it as my own natural station of the cross that requires repeated pilgrimages through the seasons. When I wade further up the series of flushes that make up Wildmoor at the end of spring, and fall in to a properly terrifying sludge up to my waist, the snipe are rightly disturbed and do not stay to pose for me.

Left: Mating common blue damselflies. I have to crouch in the water and stay very quiet to catch this wonderful sight.

Above: Four-spotted chaser dragonfly.

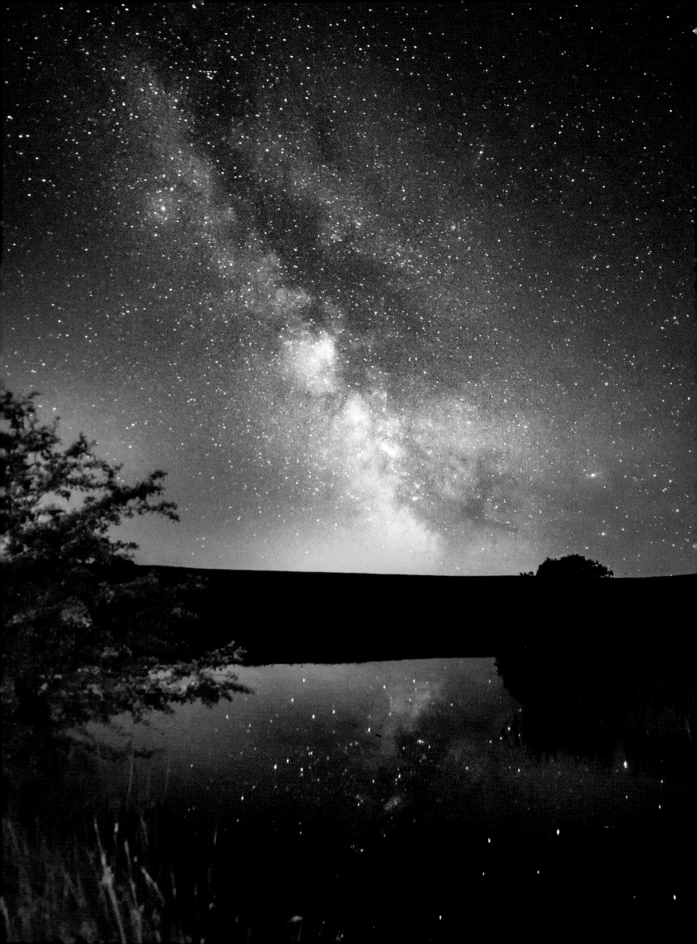

When the weather warms, there are four-spotted chasers and mating common blue damselflies. Stonechats use the concrete posts as perches and reed-buntings dart among the far reed beds.

The water lily is a daytime star, twinkling in outrageous blushes of pink. I wade into the water to reveal there is life not just reflected on the surface, but below as well.

Finally night returns. This time, I have no need to avoid the ice, but that same breadth of aloneness is with me as I aim my sights higher, to move my dreams on from stars to the huge span of the Milky Way. This summer migrant hides below the horizon in the winter months, so once again I am hunting the elusive, waiting for the endless day to truly end. Civil twilight is uncivil to stars, bright enough still to go about without torch or candle. During nautical twilight the stars are bright, enabling mariners to steer a course by them. Astronomical dusk is the instant that the sun is at 18 degrees below the horizon. At this point, approaching midnight on my final visit to Wildmoor, I begin to make out a strange and distant diagonal glittering smudge across the heavens that is entirely the point of me being here.

Here, I must rely on my camera, the long exposure far more sensitive that my eye, to help reveal the everyday mystery of the far heavens. For this, once brought to life on my screen, is what I dreamed of. The Milky Way caught not once but twice, sharply pointed across the sky with its attendant echo, laid on the waters like a slightly misty afterthought.

Left: The Milky Way reflected with light pollution from distant towns provides an eerie horizon glow.

Right: Bog bean has made a good recovery up here and is indicative of good upland habitat health.

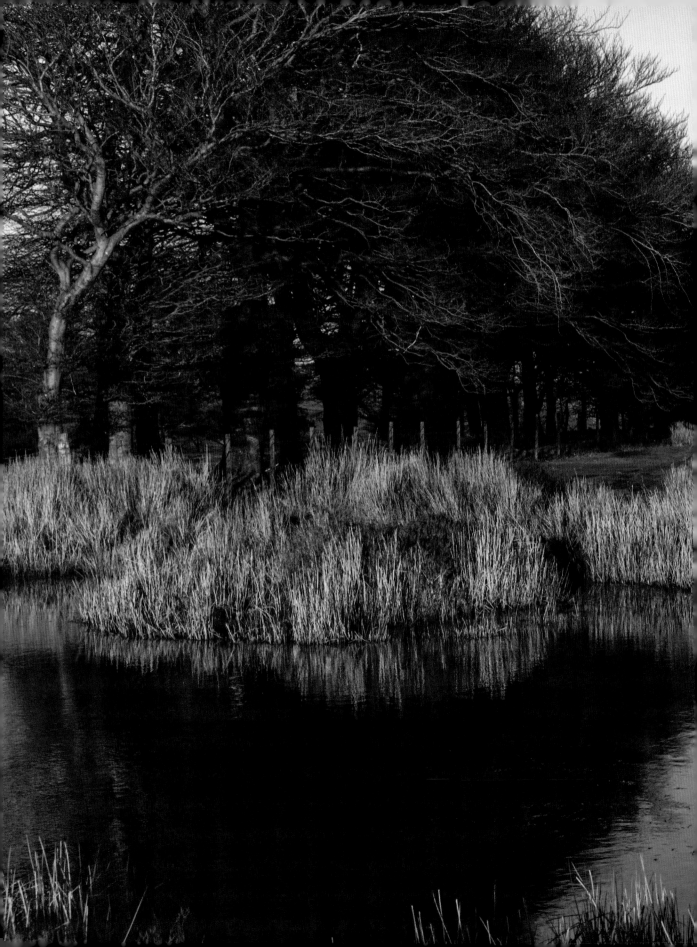

REED BUNTING IN THE
LANDSCAPE

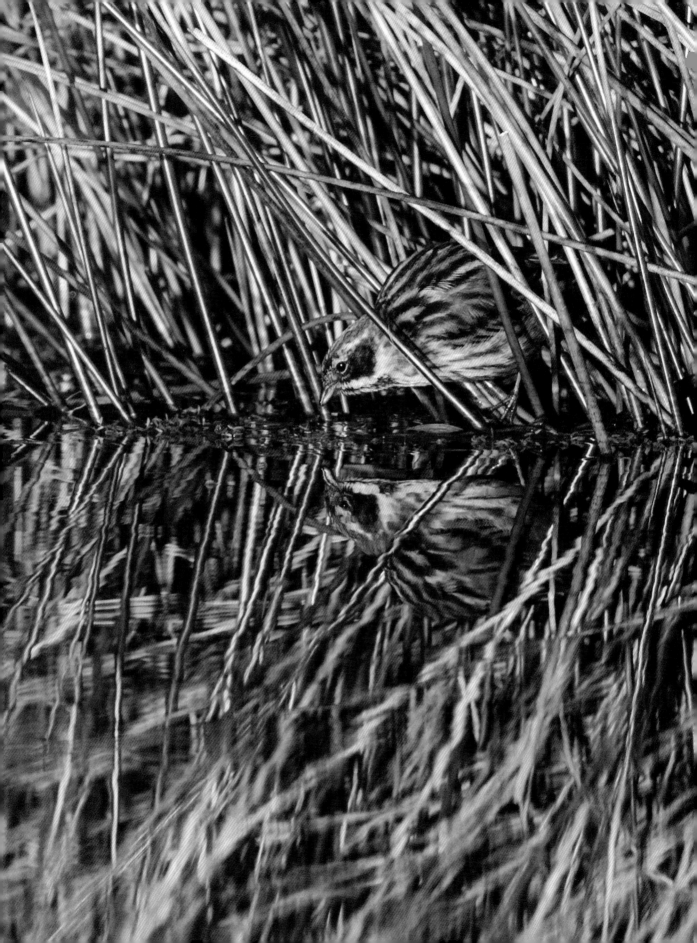

At the end of April, the evenings lengthen and suddenly I can spend time on the Mynd without shivering. The light is full of promise and the birds in the flushes in front of Pole Cottage have been full on with creating and holding territories.

All is song and promise. This time of day is perfect for red grouse coming in, another golden window along with dawn when anything might happen. I am in landscape mode, enjoying the play of sky on water at my favourite bog pool. The reeds are like straws, siphoning all the goodness of the day and rendering it molten and shimmering.

As I look close at the back of my camera, my eye catches a small blob among the reeds and instinct kicks in. I sometimes feel I am about to be found out as a photographer. What? You think you can do landscape AND wildlife? To me, it's all beauty, understanding and listening to the moment and responding to it. I'm glad I lugged my big lens out with me. Very quietly I swap my kit over to hone in on that blob. Happy is not the half of it. The reed bunting has eluded me elsewhere on the Mynd. Even close-up shots in stalking mode appear washed out, ghosted with flare as if the bunting knew what I was up to and declined to look good. Not tonight. This little bird is feeding on insects at the edge of the water. Even better, this female has no idea she is perfectly reflected in the pool. Double the pleasure as I sit on the bank and share a good twenty minutes as the light intensifies, then glows into dusk. All in all, not bad for an evening's work which has taken me from far views of Brown Clee right into the tiny feasting of a reed bunting as a doubled up treasure in front of my eyes.

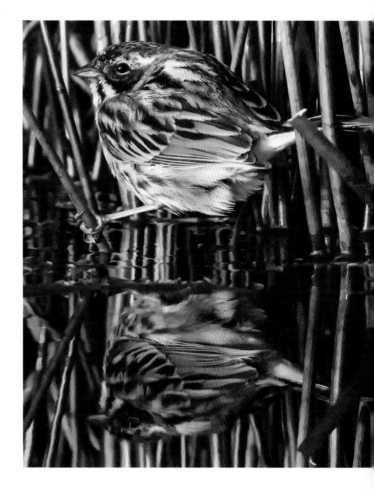

Pages 82-83: Incredible to think that this bog pool was originally dug out as a duck decoy pond when the Mynd was a grouse moor and before it was bought in 1965 by the National Trust, with money raised by locals.

Left: Female reed bunting feeding at sunset.

Above: After half an hour I risk crawling closer to catch this intimate portrait.

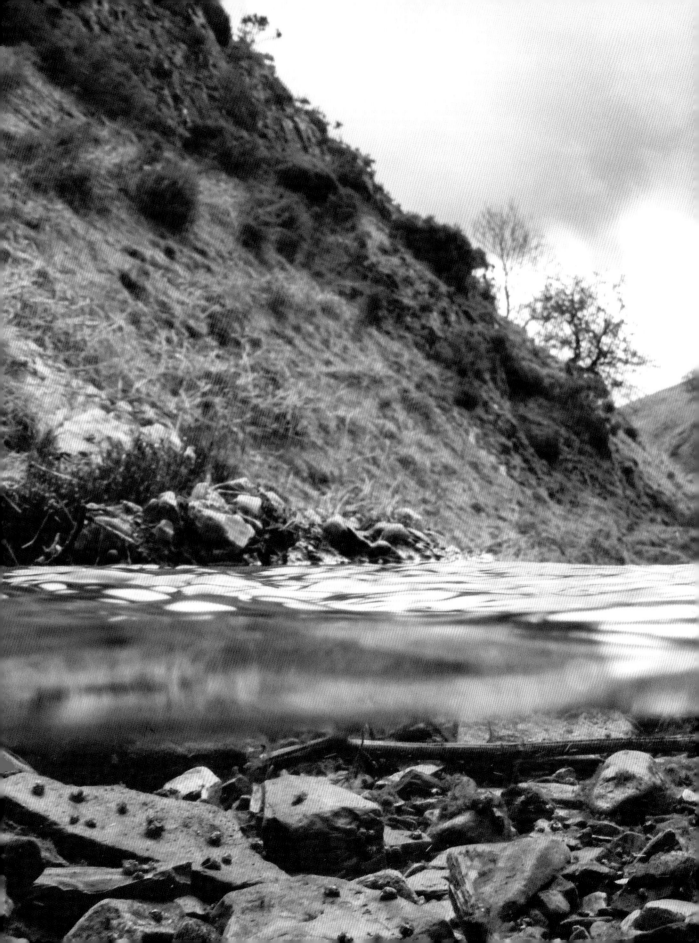

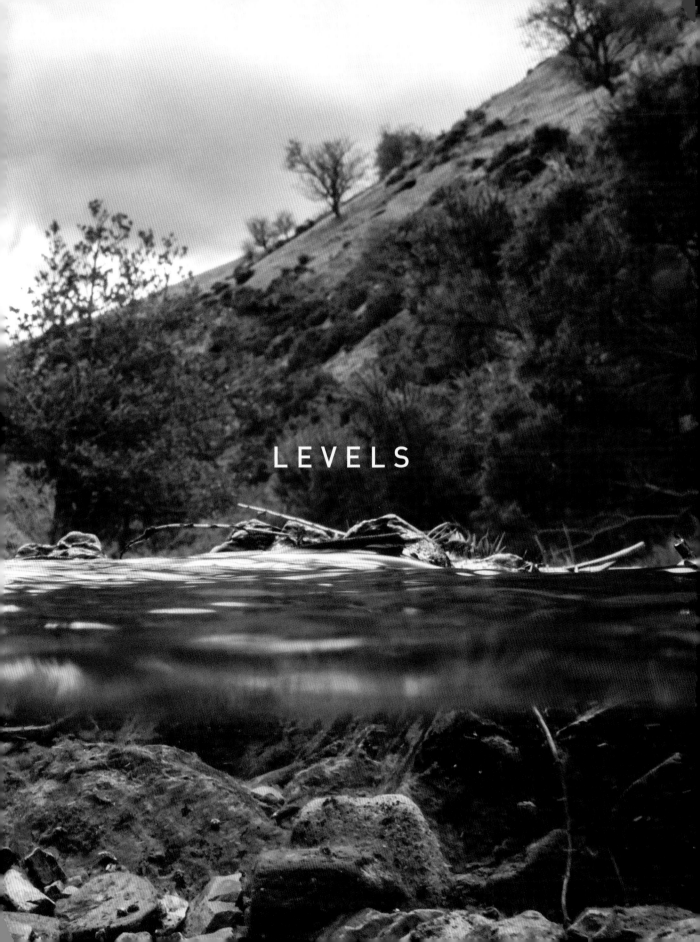

LEVELS

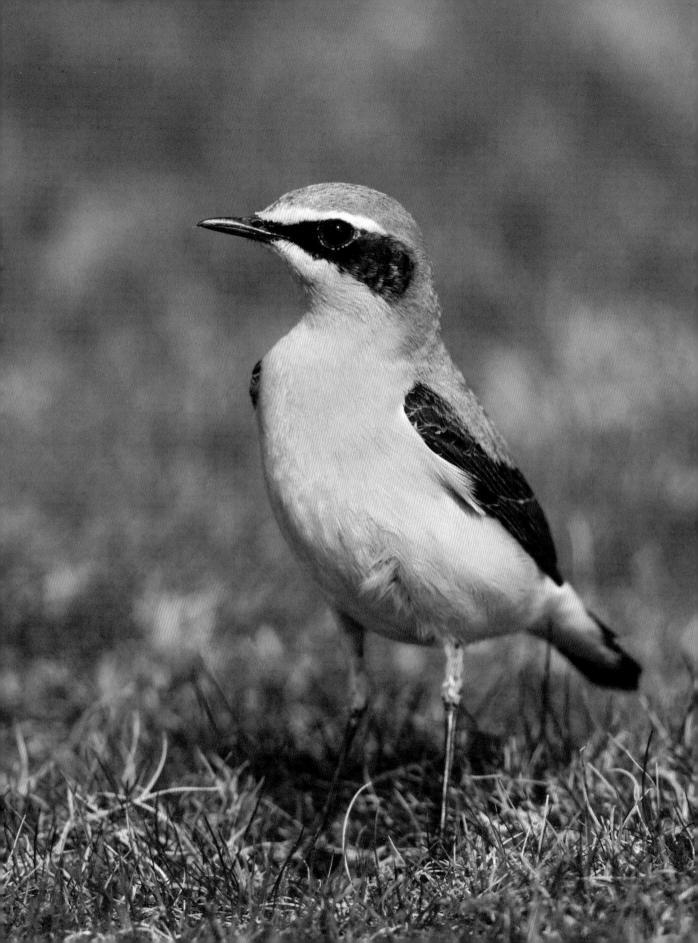

In late spring and early summer, the concept of tree and snow lines can be adapted to upland. However, the contours I am now talking about involve species. In my exploration of bird habitats on the Mynd, I am frequently amazed by the sudden and invisible crossing point that means I have moved from the territory of whinchat and stonechat, whitethroat and tree pipit, into a higher heathland more populated by skylark.

Sound is a good addition to map reading skills, the scratchiness of a whitethroat's song being replaced by that wonderful Phillip-Glassian repetitive motif of skylark. In the space of a few springy steps, my breath laboured, I have gone from valley to the high lands.

Down in the flushes that soak through the land below Pole Cottage, I have been in pursuit of a bird that now breeds here on the Mynd and nowhere else in Shropshire. My guide and employer, Pete Carty, is insistent that they should be around by now – right month, right place, right time of day – morning. As we clamber down we are following the tiny hill stream that grows and changes from Marshbrook to Quinny to Onny to the Teme I have dived into at Ludlow and spent time framing the leaping salmon of autumn. For now, it is a mere tinkle of a dream. The peregrines are in, sitting on a far rock promontory that even my ridiculously big lens would quail at. Sometimes it is good to simply look, admire the stillness of far hawk silhouetted on a rock. But on the blue days, with a fair wind at my back, I have been able to catch their leisurely, airy stroll.

Pete has been birding all his life. It's an honour to spend time in Upland with him. He has a whole alphabet of song in his head so that we track with ears rather than eyes. As ever, the target, which

Pages 86-87: My underwater camera set up helps to show this tiny stream bed below Pole Cottage and the steep glacial sides of the valley rearing up to the top ridges.

Left: Patience brings this male wheatear almost up to my car window.

Above: Pete Carty, Countryside Manager National Trust South Shropshire.

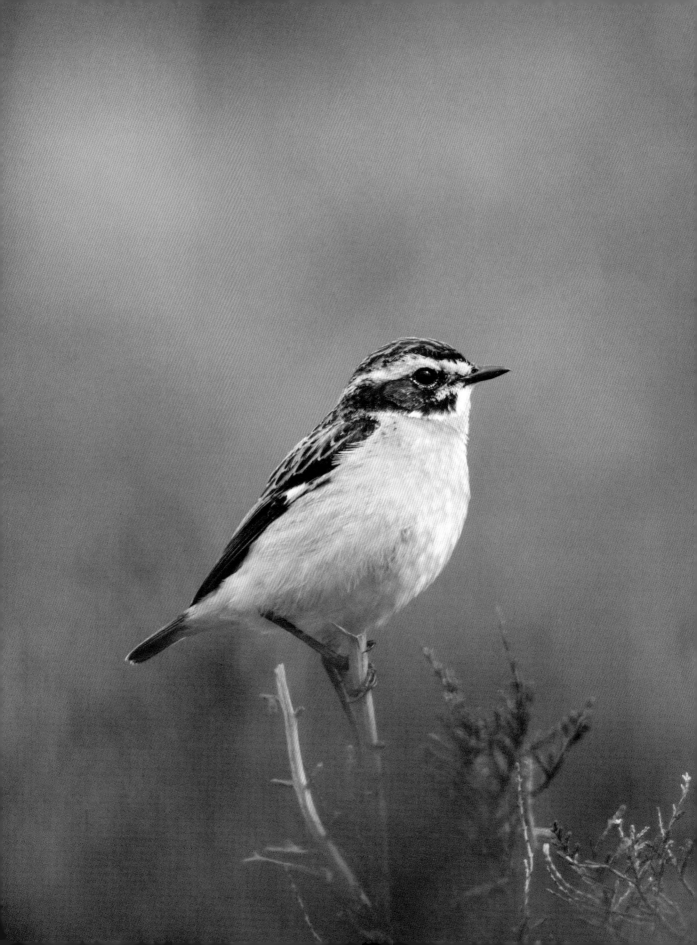

he leads me towards, but then lets me do the hard work, is up a steep, pathless incline. I too have now learned to hone in, to listen out – for small song birds often hide too well in a big landscape. It's a miracle we ever get to picture them at all. What I am beginning to understand is the concept at this time of year of territory – the male setting out his wares from a favoured tree or two. It is a pair of hawthorns that seems to hold endless activity. As I approach, their cleverness both inspires and deflates me. For any songbird worth its due has a million places to belt out its latest Darwinian hits – each and every one of them hidden from sight, folded in among branch and leaf, yet still lifted out with an ease to echo across the valleys.

I walk slowly, trying to imitate the serious birder I might never be, watch my footsteps for crackly things, pray for quiet to be my cloak. But the circle of comfort today is broken with one vibrating step too many.

The whinchat loops off to land on a far off bit of brown bracken. I only get an excruciatingly distant glimpse of a bird that has been a mystery to me for two years. As I half slide, half climb, back down the steep gully to Pete, he shakes his head, insisting that whinchats are normally quite approachable. But Pete is ever the positive one. What the day has brought me, he insists, is knowledge that I will use in my next foray. Also, as if reading the wind, he accepts our journey might be a bit early, and that any time after next Wednesday, the chats will be in and ready to accept pictorial praise.

I go away glum, but also do as I am told. For this game is about learning, listening and taking advice. After all, Pete's been birding for forty years now. Perhaps he knows a thing or two. So, come next Wednesday, I am heading back in the morning, in fairly good light down into the very same flush. Five minutes in, by a fallen hawthorn that despite being more bush than tree, is still clinging onto life, a bird sits and surveys the stream, delivering a song that I do believe is spot on. My silent shutter is set and I

try not to shake as I lift my lens and shoot.

What I see is, for me, as good as a snow leopard in the wild. With that strong white stripe above the eyes and buff orange breast, this male is a showpiece and the fulcrum around which my day has turned from hopeful to happy. I continue my descent following the stream. My eyes, now attuned, see whinchats popping up everywhere. It feels like paradise regained as I zoom in on colour and claw, the female whinchat to my mind easily as interesting as her mate.

A twenty-minute walk, then a quiet climb, places me right above the hawthorn that held so much promise a few days before. Again, I can hear scratchiness coming from inside that green curtain. I must be patient, and wait, hoping, that like the skylarks song, this bird will eventually rise to the tip of the tree. He does, only for a few seconds, and I have whitethroat, with his Elizabethan ruff and beady eye, singing out to all of Shropshire.

I climb back up the levels, my walk peppered with a multiplicity of whinchat moments, as they hop between stalks, until finally, I am beyond their territory, reaching the high lands again, the different land where the grouse are wonderfully disguised in the budding heather. Finally, as I drive towards the back of the Mynd and the steep drop behind the gliding station, I slow to check a piece of open grass favoured by pipits and larks. A single wheatear flutters off in annoyance. I stop the engine and play nature's waiting game, where a circle often figures in feeding patterns and patience is sometimes worth it. To my great joy, the wheatear returns, ignoring the shape of my car and feeding so close I can hardly fit this delightful bird in frame.

My first ever whinchat – a male in fine breeding plumage.

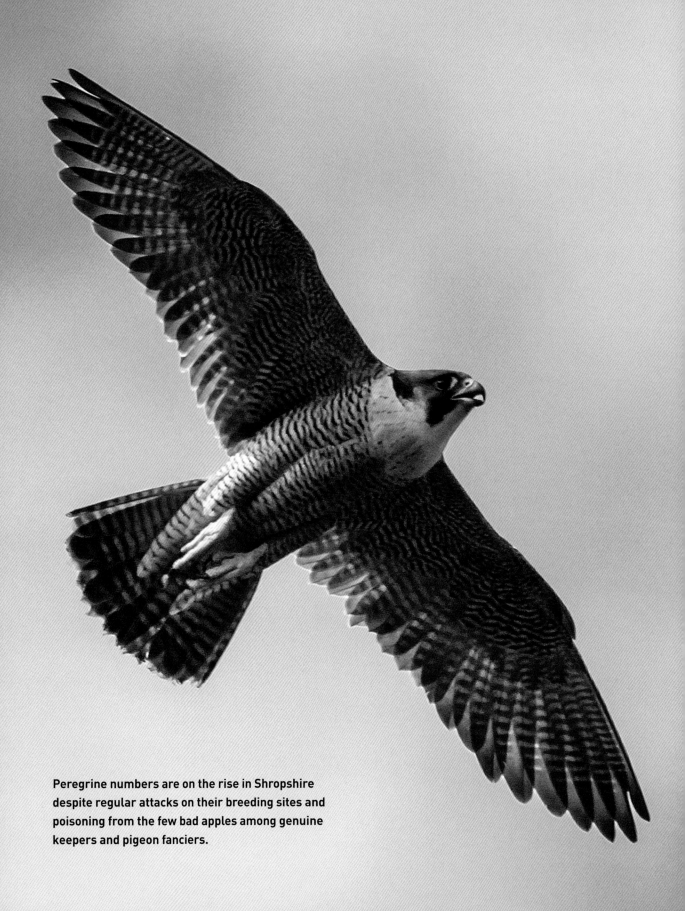

Peregrine numbers are on the rise in Shropshire despite regular attacks on their breeding sites and poisoning from the few bad apples among genuine keepers and pigeon fanciers.

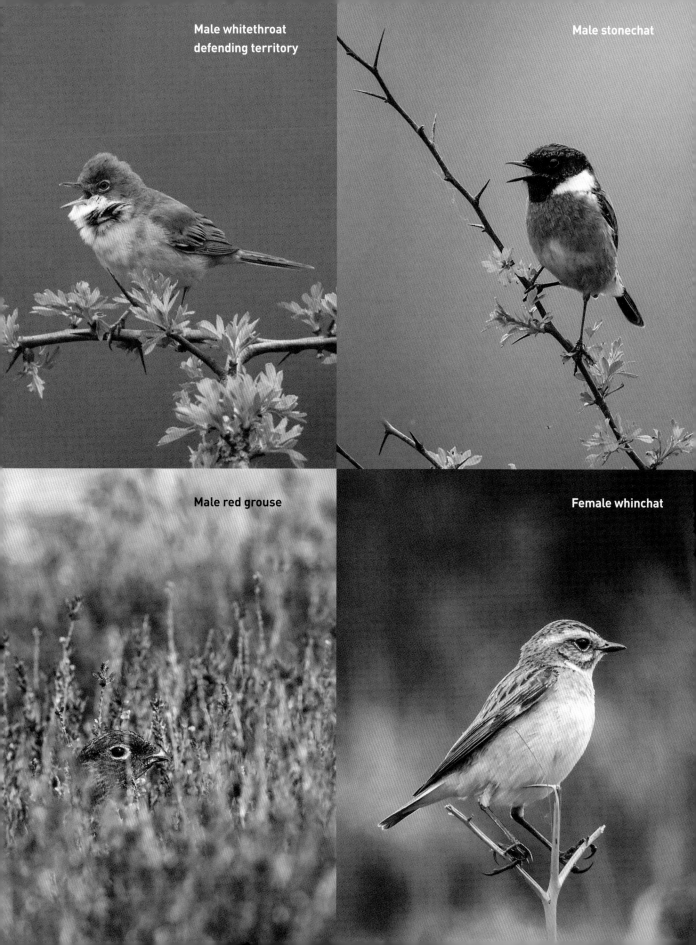

Male whitethroat defending territory

Male stonechat

Male red grouse

Female whinchat

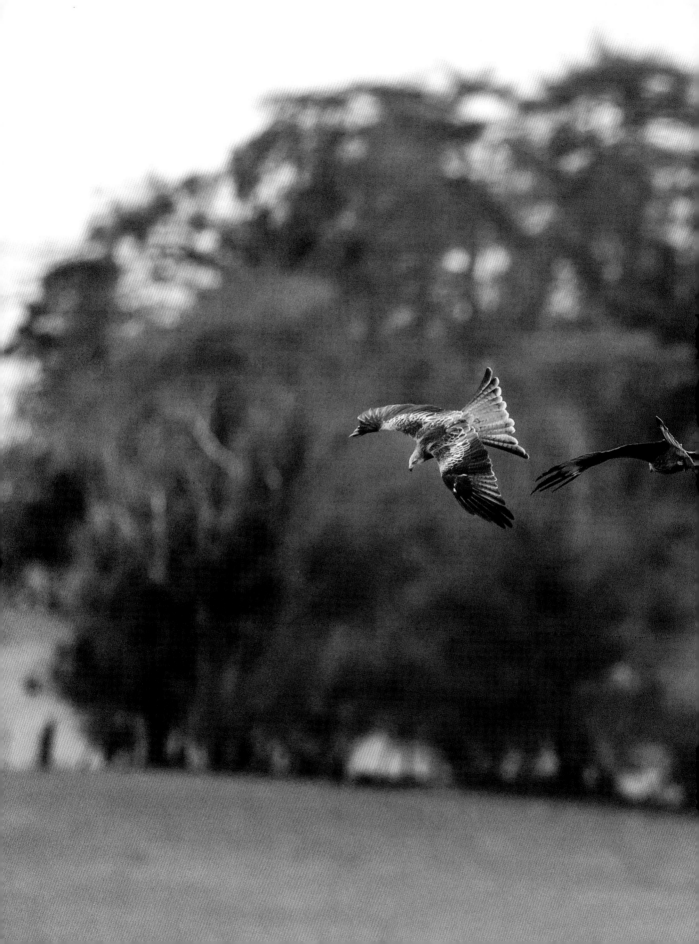

A SMALLHOLDING IN
THE HILLS

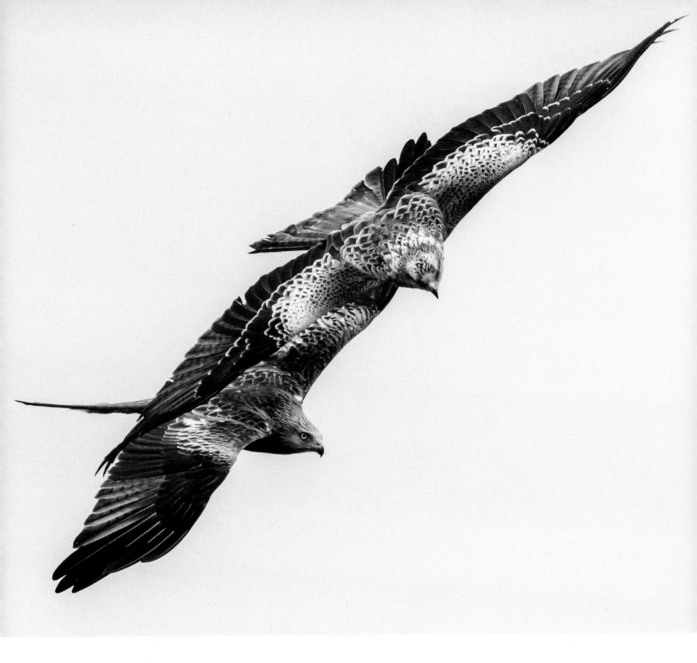

Pages 94-95: Two red kites in display on a grey day. The smallholding is tucked in among the valley farms.

Above: I love watching kites' aerial abilities.

Right: Kites and crows are ancient enemies, though neither ever seem to win the battle, in this case, to have the butcher's remnants strewn on the small hillock below.

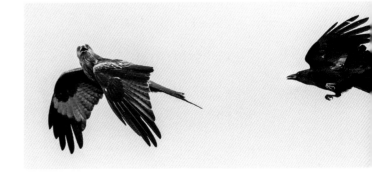

I have recently become friends with J who has kindly invited me onto the smallholding she has been developing for some ten years. This is a transformation of six acres between the Mynd and the Stiperstones from basic grazing land to something else entirely. A stream fills the dug out pool that is large enough to support water voles, frogs, toads and a few aggressive ducks and geese along with a nesting moorhen.

Finding evidence of them is a pleasure, particularly in the nibbled reeds and vegetation that give the voles away, along with the holes that emerge from the bank.

But J has another secret. She has consistently fed the red kites for the whole time she has been here, using donated butcher chuck-away. There is even a platform of sorts, a small hillocky rise below the pool that gives out to views on all sides with nearby trees and hedges to give good cover to the hawks.

On the day I arrive, dull light turns the whole scene gloomy and bleached of colour. Horses are in the stable, the geese are asserting waterside rights and J leaps out of the pickup to sprinkle bones and meat like a modern day Hansel helping the hawks to find their way. As with all birds, a potential feast is never approached directly. There are fly-bys, high hovering manoeuvres as heads crane down to take a peek. The hawks use the nearby, still-bare trees as branchy stepping stones. They flit from one to another, closer and closer until finally the bravest circles into the put out meat, pushing off a couple of crafty crows. But for me, the action is ever skyward. The kite might have proclaimed itself leader of the food pile, but that doesn't stop a crow from having a mid-air go. All the crow succeeds in doing is annoying the kite, as small chunks of meat are delicately picked apart while still on the wing.

It's the look on the kite's face that makes my day. My agency says they want 'quirky'. This ought to do it. It's in the next day's Metro, distributed throughout London and, like the meat, another waste product by nightfall. I am not complaining about a published celebration of all J's hard conservation work, considering that sightings back in the 1980s were limited to a few spots in the Chilterns and above the M40. J has told me to treat her land as my own. I feel humbled and grateful as further visits reveal not the vole I was desperate for but the spectacle of mating toads. The edge of the pool becomes my study area as I kneel on hands and knees or even lie in the wet, damp and clodded grass to catch a close-up. It helps to have a camera that is not put off by a dunking under English water. This is April and new life is being enacted here in this shallow spot. After three days, the toads are growing used to my presence and the shot I have been working towards comes into focus. As above, so below. These half-and-half photos, taken with the lens half out of the water lead to later accusations of photoshop yet this is a single shot that took much work to achieve. My lens is only a few centimetres from the mating pair – the female much, much bigger than the male. But forced perspective is a gift of the light. They appear monstrous in their submerged world, intent on procreation while the world and its geese above go about their springy business. Here we have two existences folded into one, a rather beautiful

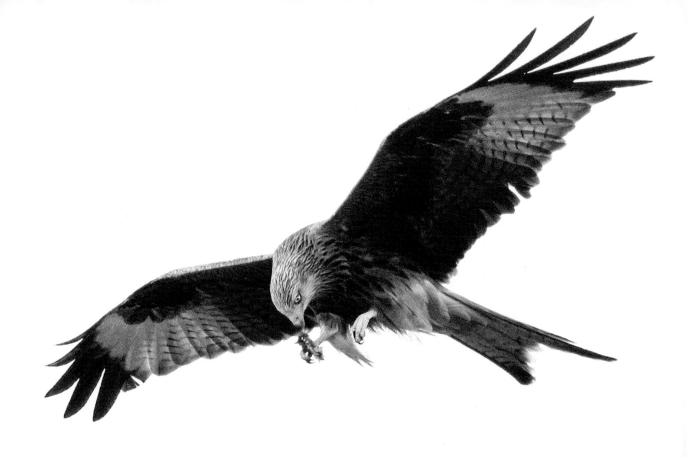
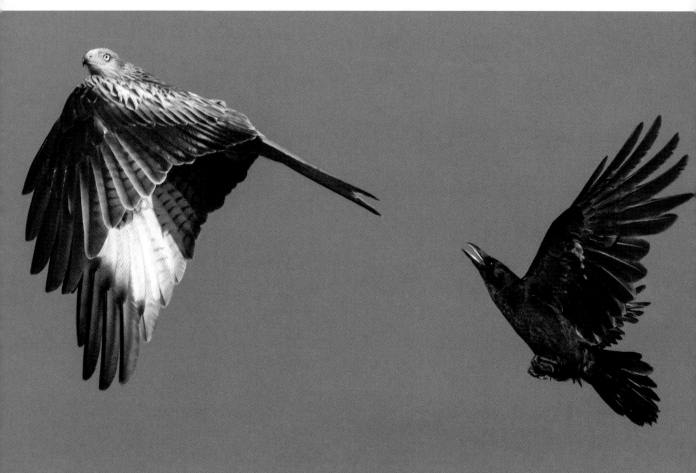

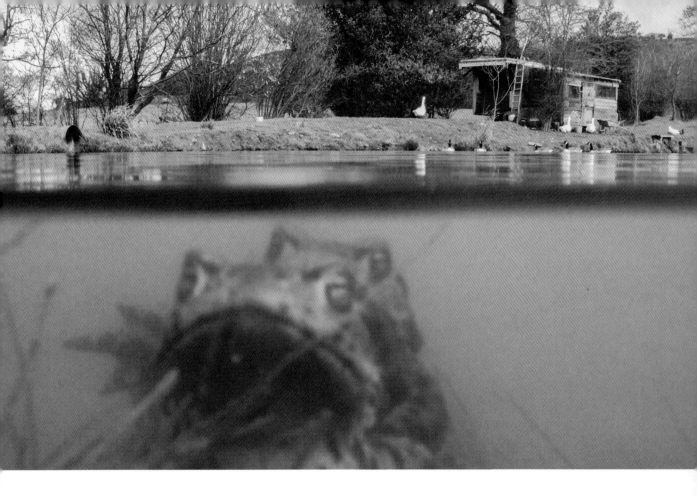

singularity. Thank you J. I owe you one!

On my last visit in May, I have the blessing of early morning storm light, that rare and incredible glaze which covers sky, hawk and persistent crow with a painterly, almost renaissance quality. All is sharp, eyes perfect, sky hammered and shining like pewter and I later learn the result of fickle fortune. The papers have already published one photo of a kite being taken on by trickster corvid. This is the same theme, so no thanks. Only here, in the pages of Upland, can I publish twice, for this picture is chalk and cheese to the first. Hey ho. At least I get to tell the story. I turn from my kite moment and see a little pied wagtail making a nest in one of the many sheds that dot the smallholding. He is the last sweet gift, snatching barbed-wire strands of wool, dead grass and moss, ready to cradle eggs through storm and sun. Good luck, I say.

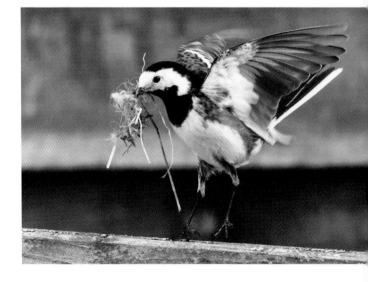

Left: Kites, like hobbies, will often feed in flight.

Top: Mating toads.

Above: Pied wagtail with nesting material.

SHEEPISH AND SHIPSHAPE

It feels like the Mynd has been here forever. But the steep-sided valleys on the eastern flanks were formed as glaciers melted after the last Ice Age. Humans moved in, preferring the high places for visibility and safety.

They cleared the trees with stone axes, one of which turned up on the Mynd in the 19th Century. Here, rather windy and cold, was the perfect spot to graze their livestock and build settlements. After axes, came fire and controlled burning until by the late Bronze Age, the Mynd was deforested.

Sheep played their part, with huge herds owned by the abbeys after the Norman Conquest. Alongside them, the feudal system allowed commoners to graze their animals and gather wood.

These rights are still held today and are one of the main reasons the Mynd was never enclosed. One would never think of Church Stretton as a rebellious town, but there were riots to protest these very rights, which often made the difference between eating and starvation, warmth and freezing. I am grateful for this strange, historic gift of wide open places. Wool and sheep are no longer drivers of the country's economy. But back in the Middle Ages, Laurence De Ludlow of Stokesay Castle was the equivalent of an internet billionaire. This building which is not really a castle, is a classic

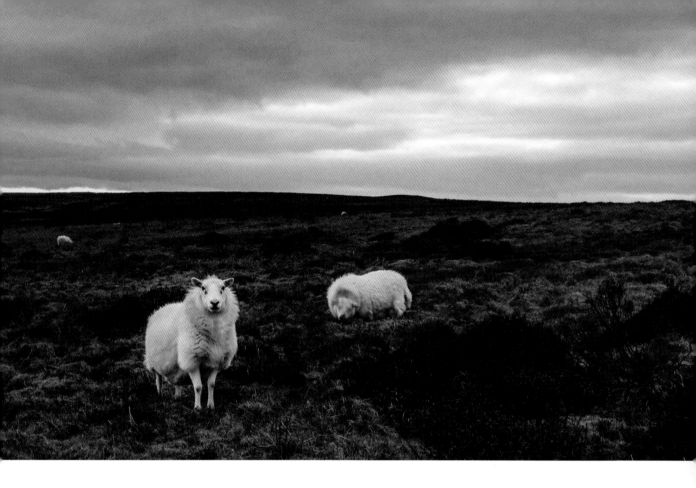

example of where wool money financed the addition of crenellation on top of its walls. Such battlements were no longer necessary for defence but they made a very expensive fashion and status statement.

Wool was the oil of the Middle Ages, traded with European cloth manufacturers from long established markets such as Church Stretton. Money was there to be made for both the church, and after Dissolution, entrepreneurial wool merchants.

The indigenous sheep, called Longmynd, had the most prized fleeces in the country. Sadly, they are now extinct though the current hardy inhabitants are descendants. I admire their complete disinterest in seasonal extremes. There have been days up on the Mynd where I feel as though the wind is about to lift me like a glider, and where the wind chill turns my fingers to popsicles. As I fumble with framing, my teeth chattering to themselves, the sheep look on contentedly and I thank them for their role in keeping Upland open to all.

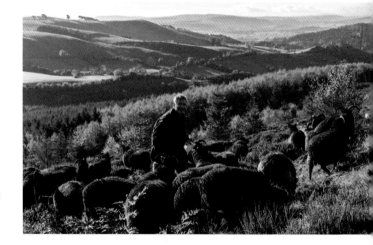

Top: Sheep at dusk above Light Spout Hollow.

Above: Simon Cooter feeds a small flock of black Hebridean sheep under Nipstone rock. Until recently there was an ugly conifer plantation here and the sheep have been brought in to maintain the restored heaths through grazing.

Sheepish and Shipshape 101

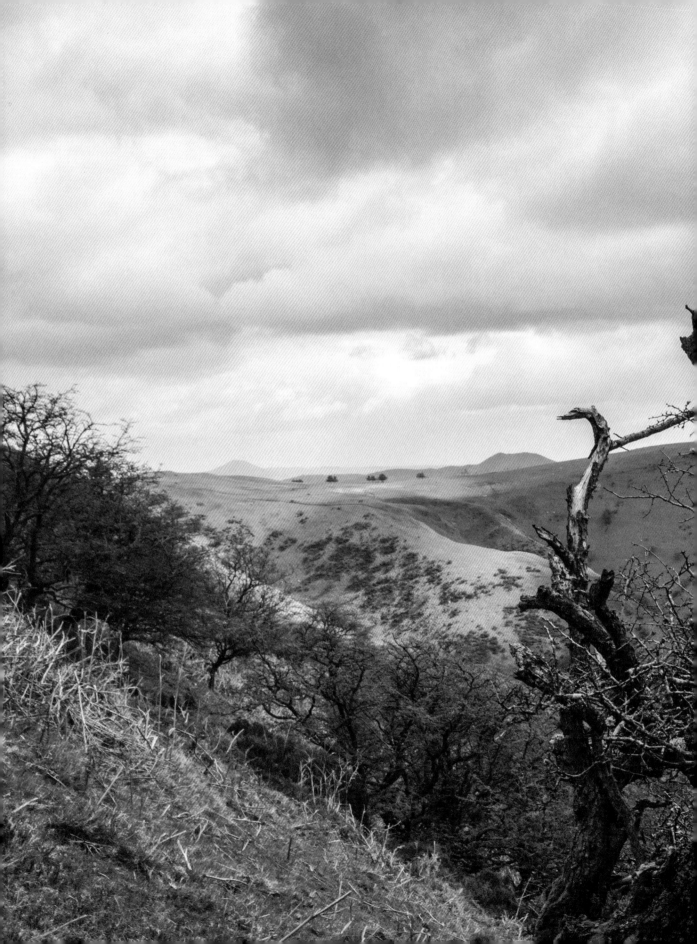

COW RIDGE

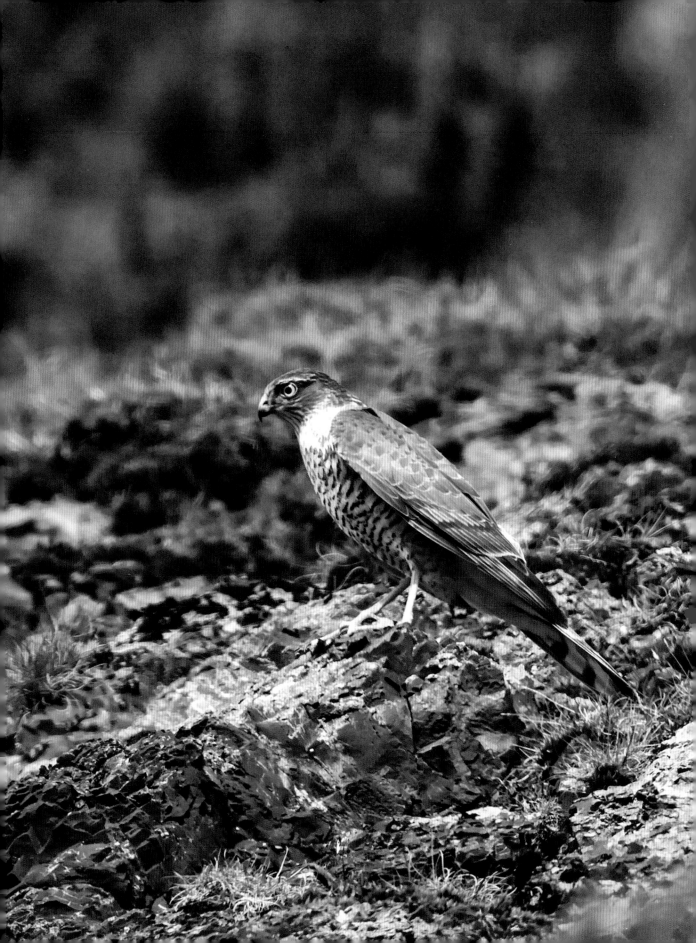

Cow Ridge is a steep-sided valley that veers off to the right above Carding Mill reservoir. The name echoes with the ghosts of ancient cattle that grazed the Mynd.

However, the cattle were also a pesky nuisance to the gentry who found the Mynd made the perfect grouse moor. But cattle damaged the butts – hides screened by turf walls for grouse hunting. The side effect of banning cattle in 1908 was the encroachment of bracken which continues to be a problem.

Glacial grinding out of this difficult shape has done wildlife, and me, a favour. The path is not easy once you hit the proper slopes and wildlife always likes a lack of people. I have seen and heard the cuckoos calling along this ridgeline, hopping from tree to tree, eluding my lens. Maybe I need to be happy simply because I have spotted a bird that, sadly, is in decline.

As I listen more to the landscape and the locals who know its ways, the aim of my visits becomes more specific. They are tied to time of day, place and season. Sunlight used to be my guiding hand here as the reservoir is a chilly and delightful wild swim spot. The National Trust had all sorts of warning notices of the 'do not!' variety that spell out the terrible dangers of deep water. And having seen teenagers tombstoning off the top waterworks tower, I understand its concern, as larking round, mixed with drink, bravado and a misjudged leap can lead to tragic results.

Pages 102-103: Cow Ridge in May is steep and slippery but worth the effort as it is a mini haven for birdlife.

Left: The sparrowhawk stayed for a couple of seconds then flew off.

But I have swum here for nearly twenty years, come winter, come summer. From short, screeching dips to more languid forays out to the middle where I shiver at my fantasies of hidden depths and monsters. It's clean water, fed by the streams that gully down from Cow Ridge. I have sat afterwards, scrubbed clean of daily anxiety, drinking good coffee from my thermos and tucking into a picnic, unaware of the birdsong rising from the surrounding scrub and hawthorn.

There is a reason for this hidden glade of trees, as this area has not been grazed by sheep. Where there are trees, there is also refuge and cover to an incredible variety of bird life. Shrike have been spotted here, though not by me. Yet with patience and endless visits, I have found other, equally joyful and unbidden gifts. It takes courage to literally step off the beaten path, which is no easy measure with such vertiginous slopes. Carrying heavy kit means every step is a potential slide. I promise myself a swim at the end of this walk as the sweat makes a runnel down my back. The hawthorns are my staging posts, my observation that a line of them strung out across the level are the perfect stopping off spots for birdlife.

My stalking pays off, and I'm glad I have my eyes peeled. Landing on a rock to my right is a magnificent hawk. My lens is up and I am shooting, aware of its shining yellow eye with a button-black pupil able to hone in on prey. I have never been this close to a sparrowhawk and it's an honour to see one on these less tamed slopes and not just pigeon-plucking in my back garden. Here is a sign that my instincts about Cow Ridge are good. I am here for cuckoos, have heard them echoing out of the trees at sunset all the way to the Burway. They are

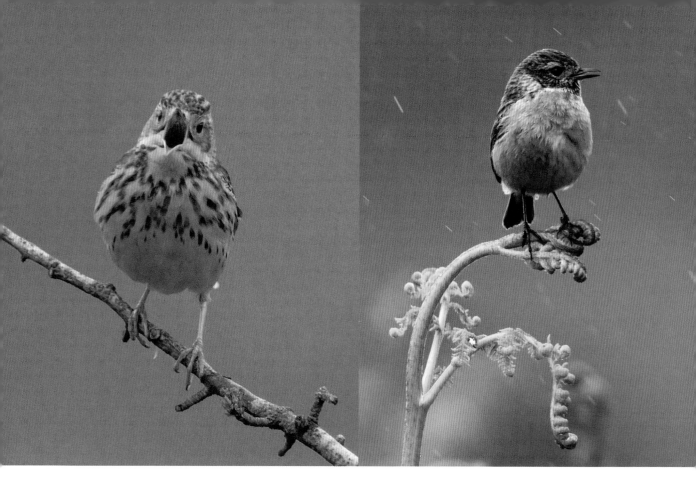

around today, always hopping insouciantly just out of reach of my camera, following their own flighty and looping route. But you get what you get and my aching body requires a sit down.

I place myself above the tree line tucking myself in quietly like a hare, hoping that the birds below me ignore my presence. It's stalking with laziness and after some time as wildlife settles down and accepts this new stillness, it works. The commonest bird on the Mynd is the meadow pipit and I am more than happy to photograph it, though not excited. It's cousin, the tree pipit, is much rarer and harder to spot. I have never spied one until today. It lands on a twig right below me and sings out its territory, proclaiming that it's the breeding season. This male, with those lovely pink legs – the meadow pipit has more orangey legs – desires the females to understand that he's the one for them.

Even better, as I finally reach the source of

the stream, there is a hissing sound rising from a few metres away. I can't find out what it is, then kick myself as a hobby takes off, grabbing at blue sky before heading off along the ridge. This is a good year for them with a breeding pair on the Stiperstones and plenty of sightings on the Mynd. My work has paid off and a dive into the deep waters of the reservoir is a perfect finale to my day.

Cow Ridge holds other treasures on a smaller scale. On a later visit with my daughter, we come in from the top road. By the end of June, bracken has started to choke out the valley. It is a problem for the National Trust and the commoners who graze their sheep. Too much bracken and gorse means the sheep can't travel to graze and when there is over dominance, the heather and wildlife are affected. However, butterflies are not so choosy about habitat and I catch a small miracle in the making as a pair of green-veined whites mate in the

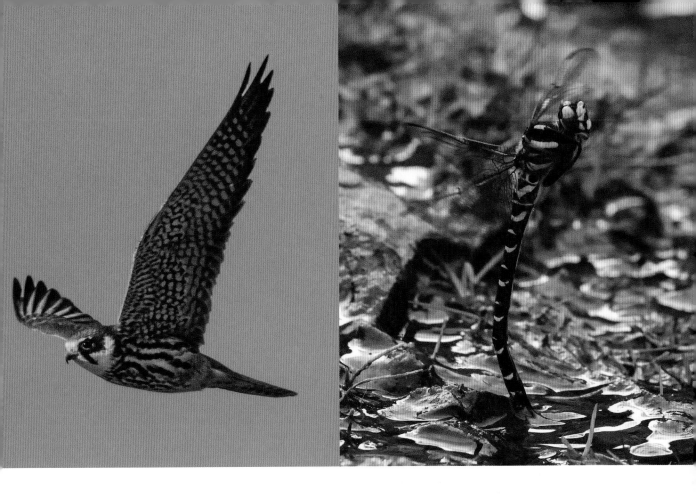

verdant-lit shadows.

I have also been after one of the iconic Upland species that represents all that is best about the Long Mynd. The streams that feed the reservoir are one of its main strongholds and passing walkers will not deter its determined thrusting towards new life.

I caution my daughter to stop, for this species is about its business, bouncing up and down on the waters edge, a banded black and yellow quill dipping in and out of running ink. The term is somewhat scientific as the golden ringed dragonfly oviposits its eggs into the trickling water. The movements are too fast and jerky for the autofocus on my lens, so I go with the old photographers shooting film who had no choice but to use manual focus. Somehow I pull it off, full in the frame, the elegance of evolution dictating their dainty dance.

Left to right:

Singing tree-pipit. It might sound obvious but tree pipits are to be found more in trees than on the ground. But another difference from the much commoner meadow pipit is the waxy orange colour of their legs.

Male stonechat in the rain.

Hobby in flight.

Female golden-ringed dragonfly ovipositing.

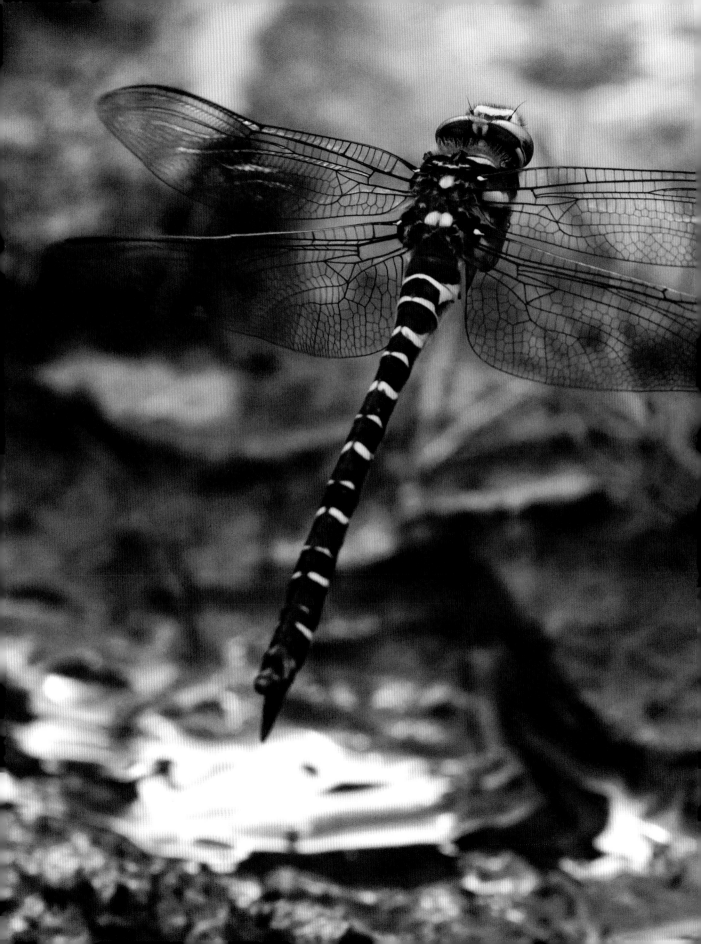

It's mind-boggling that the larvae of the golden-ringed dragonfly can take five years to develop before they emerge and start to breathe air. When they burst out of their larval skin and rest to let new legs harden, the wings inflate, the abdomen extends and they are ready to take off.

The dragonfly is part of an ancient group which includes Meganeuropsis permiana, the largest insect that ever lived, dating back 325 million years with a wingspan of over two feet.

Cow Ridge reveals one more soaking wet secret. On a rainy day I slip through bracken at the head of the valley, bemoaning the depths I sink into to get my shots. But I hear a recognised tsk-tsk of the stonechat, defending territory whatever the weather. My camera has weather seals, but my body doesn't, as I spy a bracken frond curled over by the weight of the male. We are both surprised to see each other in such unpleasant circumstances. It's worth it though to show how life persists come rain or shine.

Left: Golden ringed dragonfly.

Pages 110-111: Mating green-veined whites.

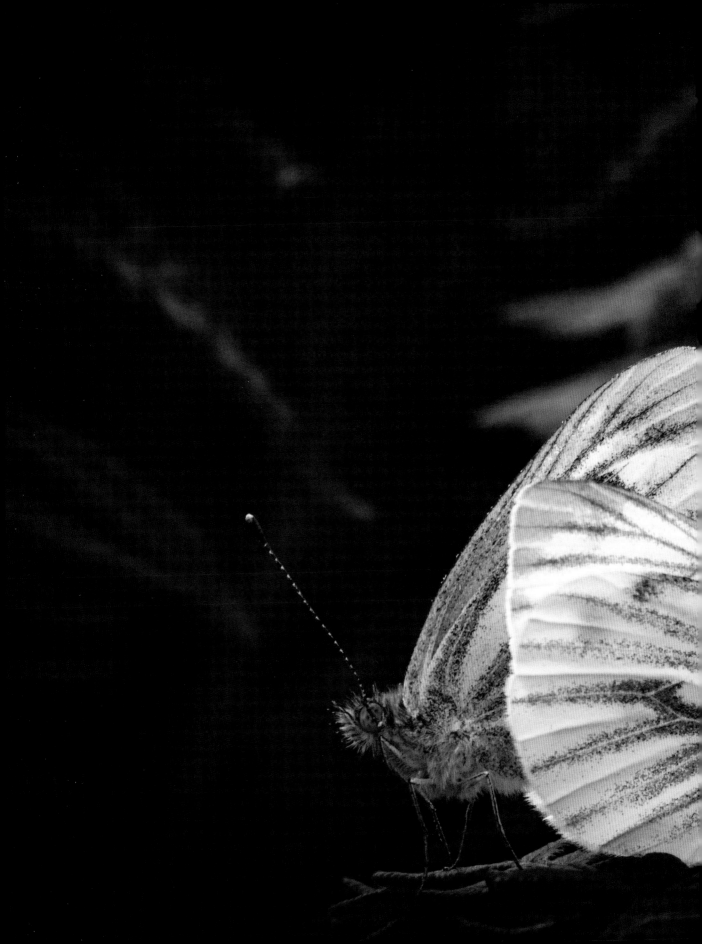

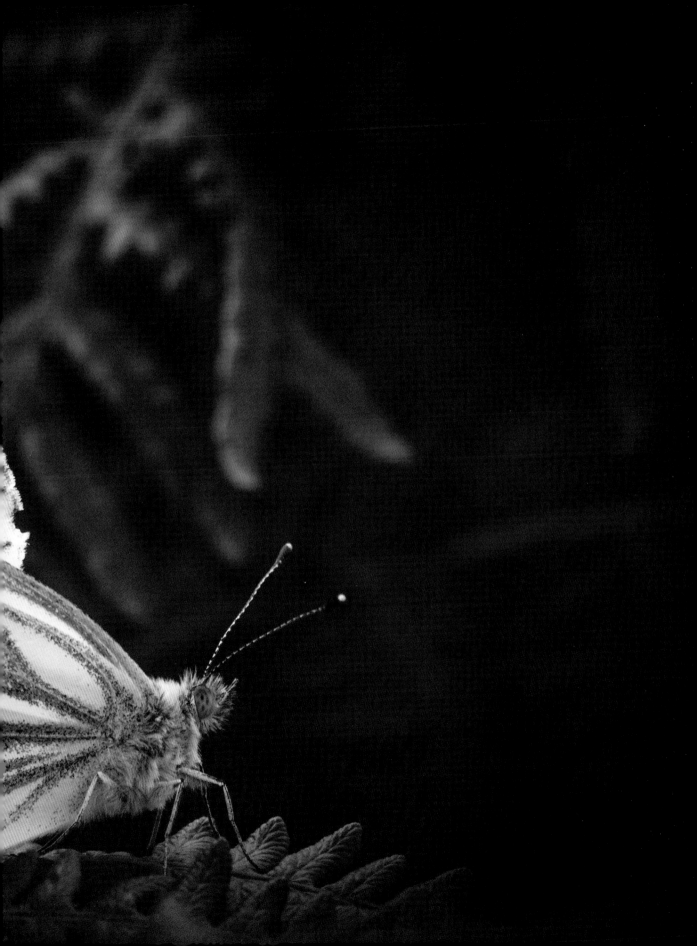

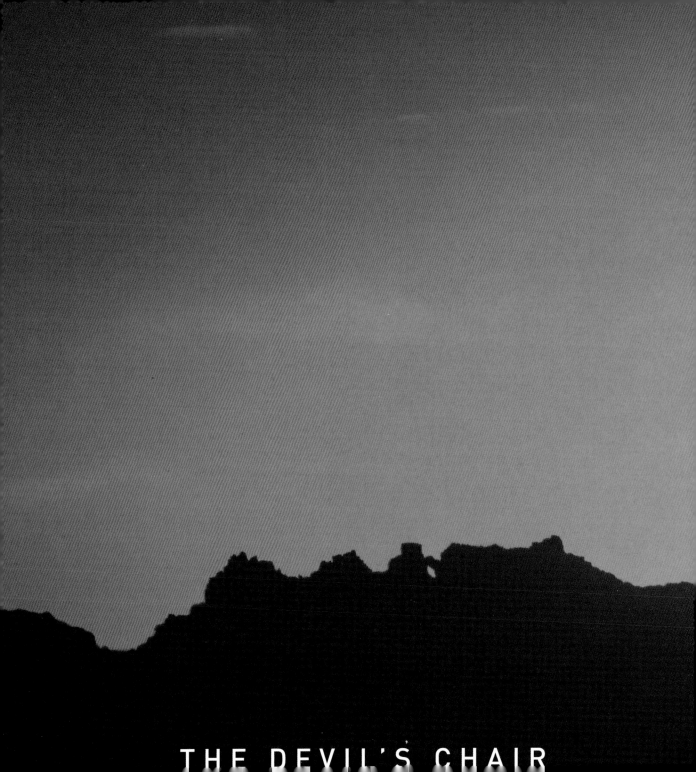

THE DEVIL'S CHAIR

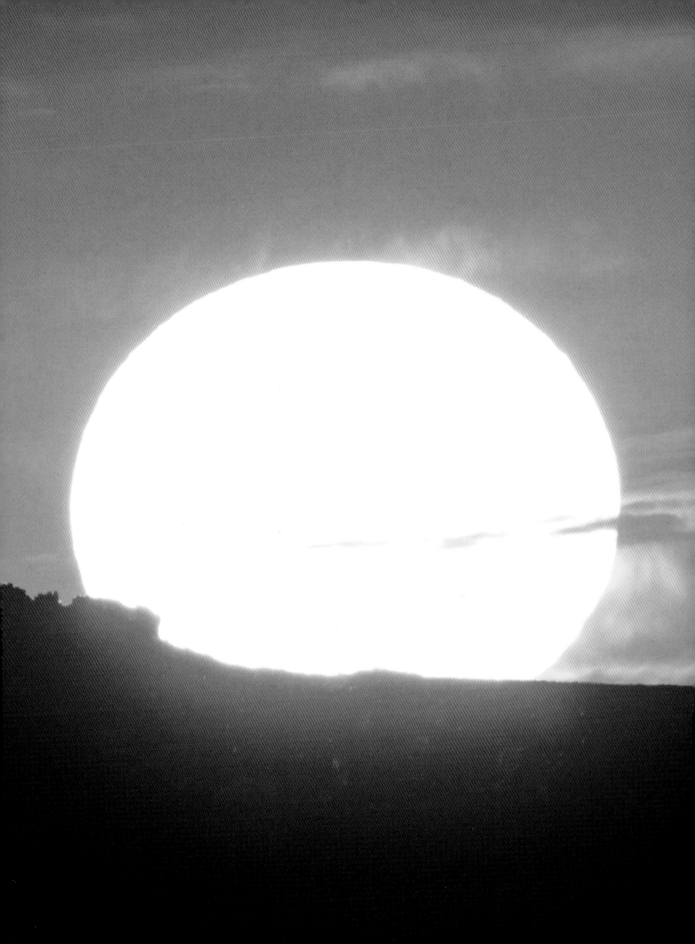

My youthful foray into television presenting began on the Devil's Chair. Or rather, it began with me trying to impress Fran, the director of Central TV's *Heart Of The Country* with my didgeridoo. During a storytelling evening at the long gone Wenlock Edge Inn, my contribution resulted in an appearance for the sum total of twenty seconds.

However, it was a popular regional programme with over a million regular viewers, some of whom liked my wackiness. Fran and I got talking about Shropshire legends and between us we worked out that a feature on the Devil's Chair could work. Not a dry, retelling of the myth, but something dramatic and with soul.

This required my storyteller's costume with obligatory 90s blue velvet beret, the didgeridoo and a smoke machine. Pre-digital, we had a whole team on board – director, sound man, cameraman and continuity person. The rocks themselves provided backdrop. The great jagged teeth of the Devil's Chair rearing into the sky always shock as I drive on the single track road from Bridges or walk up from Pennerly. This is landscape as starkness, glaciation rubbing and cracking the ancient quartzite into an

Pages 112-113: From Shooting Box on the Long Mynd, lying down in the grass with my 500mm lens, I am able to catch the sun setting over the valley right next to the distant Devil's Chair.

Right: In February, the Devil's Chair is both freezing and foreboding.

Pages 116-117: Looking west to Wales at sunset, the layers spread like a Chinese painting.

architectural suddenness. As D.H. Lawrence put it in his novella *St Mawr*:

'The knot of pale granite suddenly cropped out. It was one of those places where the spirit of aboriginal England still lingers, the old savage England, whose last blood still flows in a few Englishmen, Welshmen, Cornishmen.'

He was right to describe it thus. In summer, it can soften. I have seen it surrounded by acres of impossibly white cotton grass, as if the clouds had deigned to drift down in feathered flakes. But when the weather is unkind, it is easy to imagine the Devil striding over the ridgeline.

Where is he going? To Shrewsbury, or Salop as it was known then, the rocks in his apron ready to chuck in the Severn river and drown the lot of them. Nothing like having a massive resentment against the Mayor of Salop and all his inhabitants. But mass murder is a rather extreme reaction. For the TV piece I was speaking to camera, perched precariously high on the Chair. My tale needed to explain that the Devil grew tired and sat down for a rest. Thank God, literally, his apron string broke and all the stones spilled out, making the pile of rock that is so familiar on the Shropshire skyline today. No one drowned and it is said that on foggy days, the Devil broods on his failures as he sits on the Chair-in-his-name and smokes his pipe.

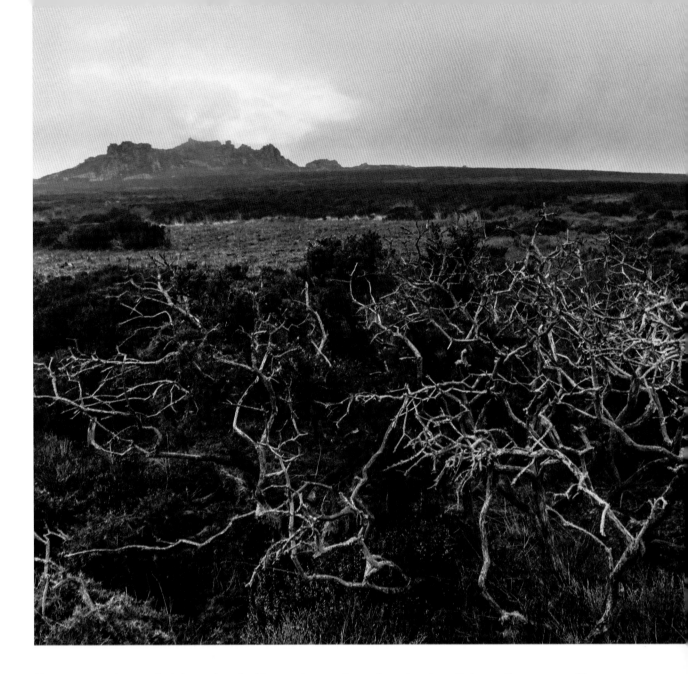

Now you see the need of the rather feeble smoke machine.

The programme was well received. I was even recognized at the cheese counter of Sainsbury's in Shrewsbury. But what I also gained was a love of the high places. I have no need of devils, having been well enough haunted by the spectre of severe clinical depression a few years back. I carried enough rocks around to weigh me down throughout two hospitals, endless counselling and changes of medication. It would be trite to say that the camera and these open spaces cured me. But I would happily observe that being out among the wonders of nature makes it harder to focus on that inward spiral. Whatever we have done to the world, there is majesty in the shires and the effort to get up early or late, to climb this craggy quartzite is always worth it.

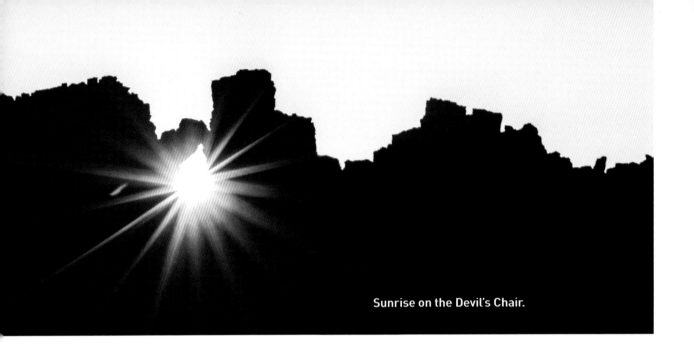

Sunrise on the Devil's Chair.

My storytelling days are now long gone, though the aim is no different. To conjure a picture, create an atmosphere, sometimes enchant. So I have come back to the Devil's Chair with a different set of tools and a new understanding of light. On one of my trips out with Simon, the ranger, we look up to see the rising sun pouring through a gap called the Devil's Needle. I can feel the presence, for a moment, of promise, of what lies ahead. It's not all doom and gloom and there is a harmony, an order to this forward round of night and day, summer and winter.

Over a few winter trips I have seen the Chair as a gaunt etching sliced out of the sky and again, swaddled like some slumbering craquelured monster by a soothing, colourless fog.

It's not rays I am after, though their effect is what turns the moon silver, that enables its brightness and its character to be seen by earthbound humans. The moon requires study, particularly through the Photographer's Ephemeris, a serious tool and app that gives me the when and where of moon rise. I have had an idea to catch the moon as it climbs up

behind the Devil's Chair. Google tells me it has not been done before – the kind of challenge I love. There's a lot of ingredients to make the mix not just palatable but delicious to the eye. There are many good photos of the moon itself but I am a foreground fanatic. I need to tell a story, as ever. Through trial and error, I have begun to comprehend that you need a big lens to bring the moon closer – a sleight of hand that never ceases to amaze. Your landscape setup renders the moon as a tiny button ever in danger of popping off. With a big wildlife lens, there is a chance to catch the elusive creature. I also need to fit Shropshire into that same frame, and the bit of it I require is this stark angularity of rock. The time of year is crucial. Heather only blossoms for a few weeks in August and early September. That means I have the chance of one moon, on one night that has to be free of all persnickety clouds.

Not only that, but at the time given for it to rise, I am a quarter of a mile down the track, big lens at the ready, frustrated as the minutes tick by with no appearance. What's going on? Have I read Greenwich Meantime wrong? An hour later I have managed to frame the layers

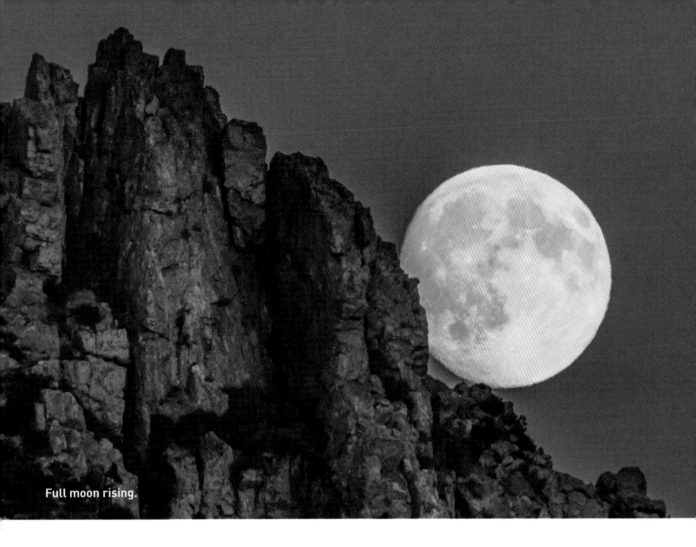

Full moon rising.

of hills behind me like a Chinese painting. I am frustrated, and wonder whether this is the beginning of some great planetary cataclysm. It is easy to catastrophise when you are on your own in a fairly remote spot. When the edge of the moon finally tips itself over the rock escarpment, I understand. It is the fulcrum principle. I am downhill of the rocks, therefore the moon has to rise over the horizon and then much further to be visible from where I am standing. A bizarre chase begins. The moon is somewhat to the left of the rocks, so I run up the track and the moon appears to move with me. It feels strangely pleasing, as if I might have some control over where to place the moon.

Finally, well-behaved, the moon puts on a magnificent show. I feel filled with humble glory as I rush home with treasure on my memory card. I send it to my agency, not expecting much as I have had a poor run on pictures recently. But the next morning, my full moon over the Devil's Chair is published in three of the national papers. It's a long way from that young man who balanced on a rock playing his didgeridoo.

Pages 120-121: I lie on the ground at dusk to shoot the full moon through the cotton grass.

Pages 122-123: This is a shot I have envisioned in my head for months and it finally all comes together: moon, rock and purple heather.

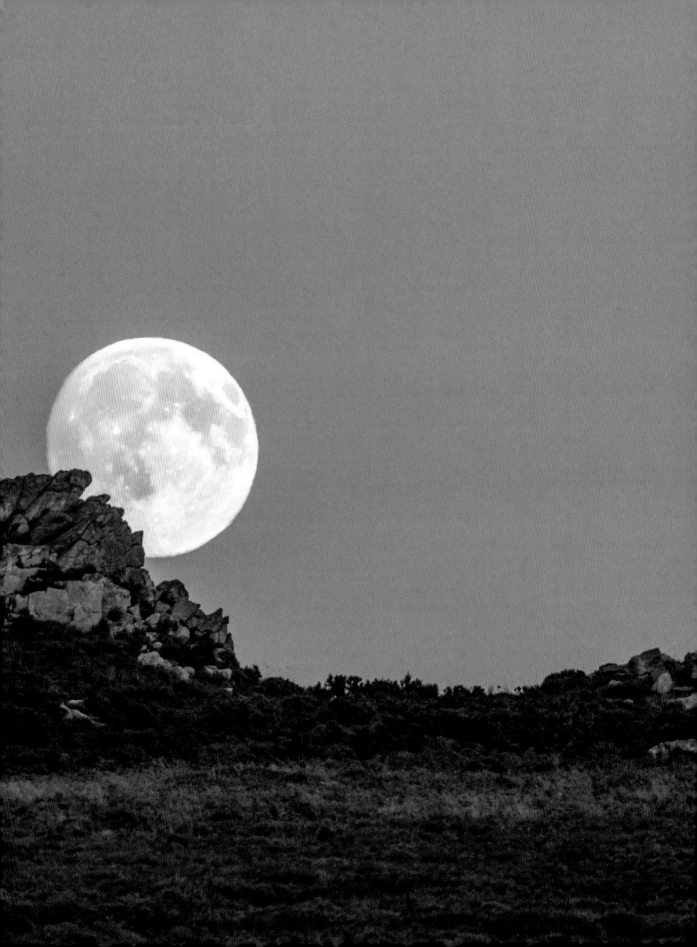

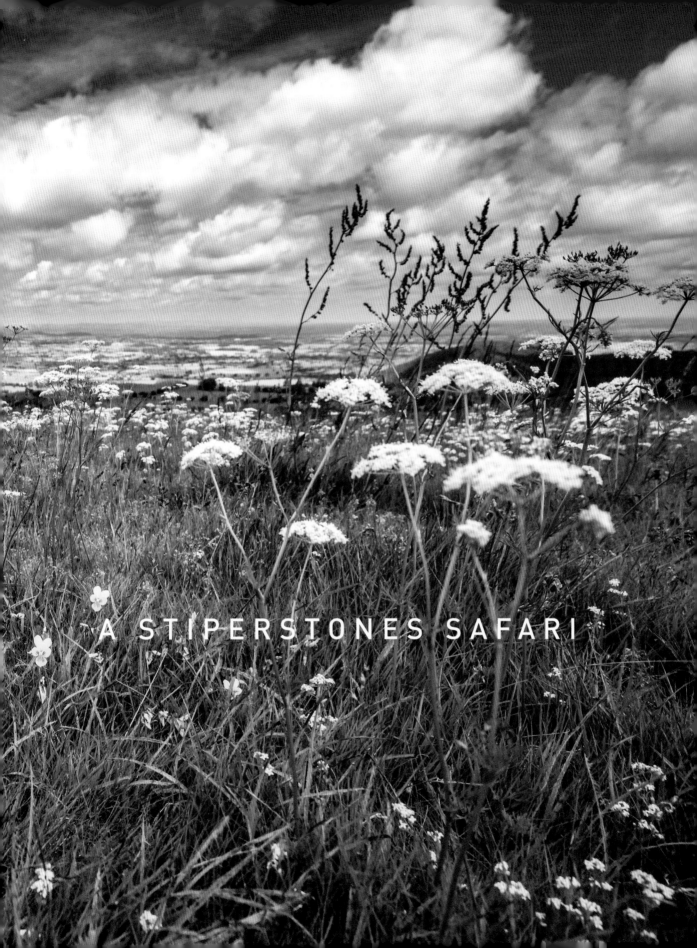

A STIPERSTONES SAFARI

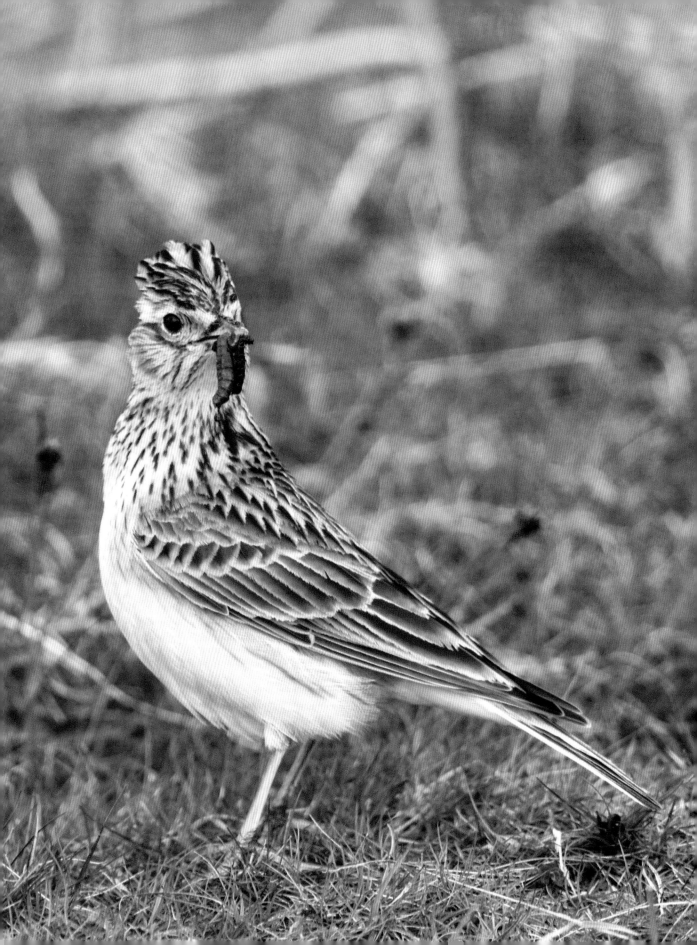

When I was commissioned for the Stepping Stones project, Simon Cooter offered to take me out in the company car – or rather, the essential Land Rover he and the Natural England team use to traverse the Stiperstones. There are tracks here that bear as much resemblance to a road as a piece of string, but the Landy, as it is affectionately known, shrugs its shoulders and sets to.

There is an advantage to trekking out in a vehicle with a ranger. The wildlife appears to be used to all that diesel noise and is not generally disturbed. I found the same on safari in Kenya. Our guides drove through the bush, bringing us close to lion and leopard. Walking in would have had a very different reaction. British birds are rather flighty to say the least, but a car does not have the shape of a human, does not present a two-legged silhouette. Even better, I get to access parts of the Stiperstones that are not such an easy slog with heavy camera kit. It helps that Simon is good company and we settle to an easy rhythm of ribbing each other punctuated by sudden stops, where he draws his binoculars like a gun and zooms in on a distant brown jobbie – the rather derogatory term birders apply to something small, brown and unworthy of interest. However, it can sometimes be worth the effort, as magnification and experience often reveal the unexpected. In over two years of trips out I am grateful to have soaked up a bit of that expertise.

Simon is a birder through and through. When he takes me past the car park on a bright May morning, we spot a bird with a red breast and forehead. Even better, it poses among the yellow dandelions, its colour almost an impossibility. It's my first ever linnet at a spot where there used to be flocks. I like this Harry Potter cloak. I can sit and fire off in silent-

shutter mode, check my settings and even grab a sip of tea from my thermos. The bird sees me, I am sure of it. But it gives no alarm calls and will often carry on with its business. The skylark digs for worms and grubs. Its crest is up, telling us all what a

Pages 124-125: Upland plants such as mountain pansies have been in significant decline. Blakemoorgate on the Stiperstones is one of the few Shropshire strongholds.

Left: Male skylark with worm.

Below: Simon Cooter, Senior Warden, Stiperstones.

Pages 128-129: In high summer, the slopes beneath the Stiperstones ridge fill with blooming heather.

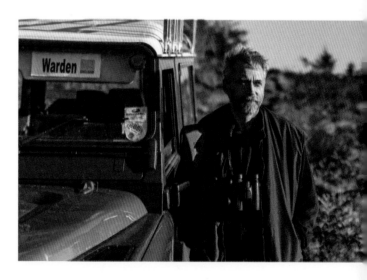

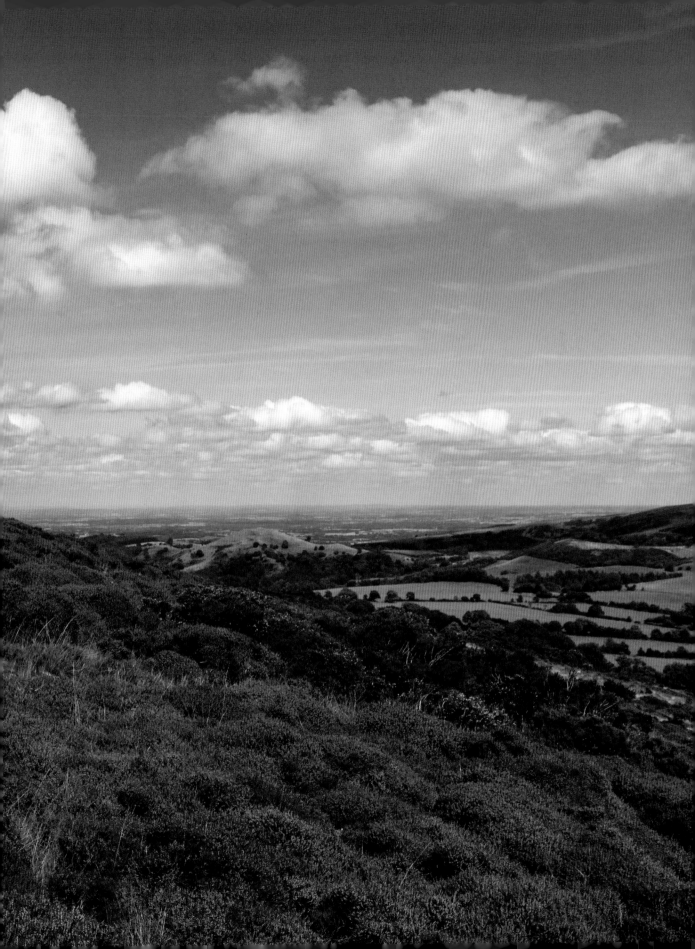

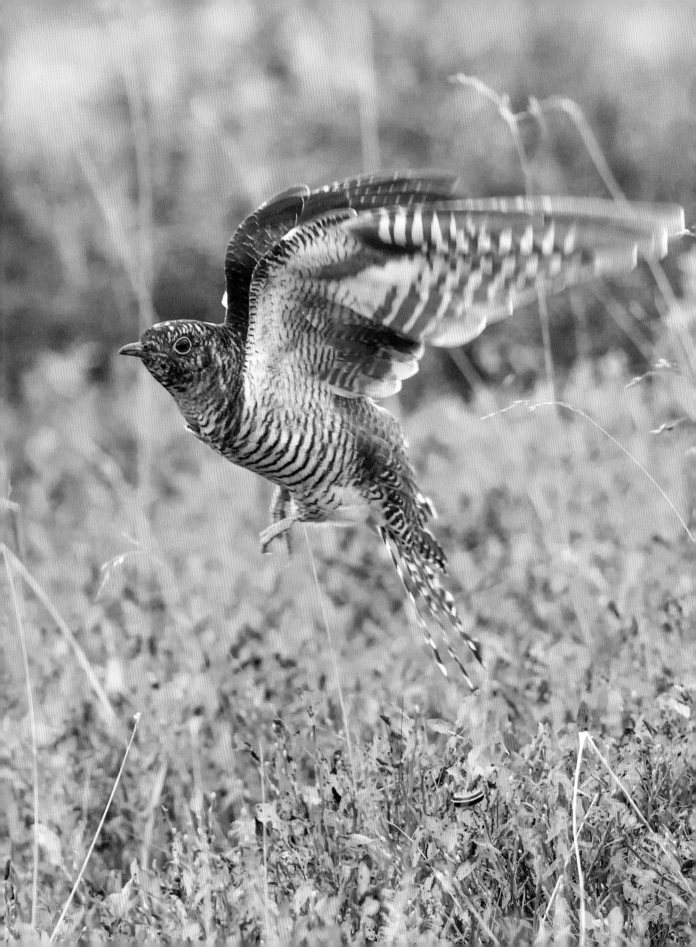

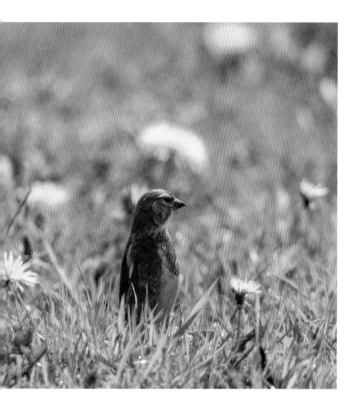

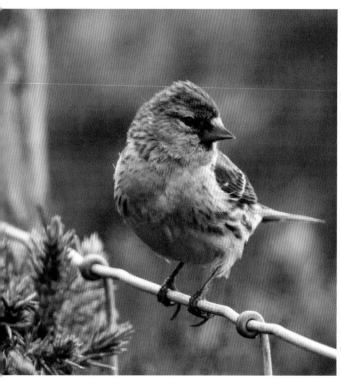

Pages 130-131: Juvenile cuckoo.

Left: Male linnet.

Left below: Redpoll near the Gatten.

Right top: Green hairstreak butterfly.

Right below: Hares are less common in the uplands and more likely to be spotted in the valleys.

magnificent specimen it is. And we are the watchers, marvelling at nature in close-up. It doesn't get better than this.

A few weeks later, knowing this is a good spot, I creep back in to spend more time with the linnets. What I see, flitting from ground to tree and round again, is a small flock of birds with plenty of red colouring. Expert that I am, I pronounce them linnets, only to be later told off on Facebook. Fair enough. I have enthusiasm but the encyclopedia is sometimes left at home. This is a redpoll and I find it utterly beguiling. I am a sucker for postbox-red and whatever evolutionary trait this is part of, count me in, especially to counter the grey days that make up the majority of most summers.

As the season continues, Simon and I stop not just for wildlife but for the small life that flowers on high grass. Viola lutea, or mountain pansy, is fairly rare in Shropshire and has struggled to survive in a few isolated spots. It is a real treat to lie down in dry grass to get the shot, as the pansy is tiny and requires a close approach. Simon also points out a green hairstreak butterfly near the Devil's Chair.

As a far cuckoo is mobbed by three meadow pipits, a hare bursts from the ground behind Brook Vessons. I have seen surprisingly few up here. I am more familiar with them on my near-home upland. When Simon drops me off, I decide to climb up the ridge towards Manstone rock, a spot where the thermals inspire flight on warm blue days. The hobbies are about, and a juvenile peregrine decides it's had enough hassle from a crow. So much that I see appears to be about invasion of territory or

space. We are not so unlike these species, trying to protect our own piece of earth. But these birds appear somewhat wiser, making a show of strength rather than going out for the kill.

I feel hot and sweaty as I hide in the shade of a hawthorn. All this ridgeline activity is exciting and my goal is to stay unnoticed. I have no car as cover, so the tree will have to do. Patience is rewarded when a pair of circling ravens fly straight overhead, so close that I can hardly fit one of them fully in the frame. A head tilts towards me and the underwings are revealed, their overlapping intricacy a marvel of evolution. I particularly like the tucking in of landing gear, or rather claws, in a move to streamline through air. Remnants of nest-building material are the only adornment. The sky is now beyond blue, a triumphant tint that proclaims summer's height. I could not ask for a better frame for buzzard as it poses on a post revealing the great subtlety of its feathering. As I make my way back down to the car park, a dunnock begins to sing from a nearby gorse bush. The camera reveals how bird claws are adapted to both land and balance on the most prickly of perches.

Simon's knowledge and enthusiasm are also of great help when he tells me that the redstarts are nesting in the box right by his office window. The first time I head out in the summer evening light with a friend, the male is darting around in fits and starts, gathering insects for the young fledgelings hidden away in the box. This bird fits into the softness of the light with ease. After a couple of visits, I work out the repetitive behaviour that enables me to take very intimate portraits. The male will often work his way down the fence right in front of the office, stopping off at various posts. I am even able to put my tripod and wide-angle lens to work, showing redstart in his environment. My Vauxhall Zafira is a good ally, scratched and dented through too many mad wildlife missions, but it is a surprisingly comfortable observation post. A redstart finally poses right in

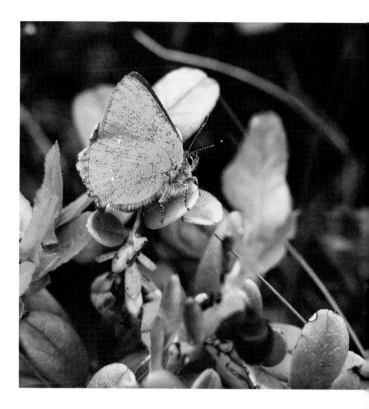

front of me, showing off a great gathering of food. I wish the young well as the nest is empty the next time I visit and the parents long gone.

On my last trip out with Simon, we spend a fruitless couple of hours heading past the Devil's Chair and out to Blakemoorgate. The sun has not come out today. Early autumn has confiscated the green leaves of whinberry bushes and replaced them with a spread of multi-coloured acres. The breakdown of green chloryphyll in leaves on tree and plant is a seasonal miracle that never ceases to astonish me. Simon stops, convinced that the bird on the path is a juvenile sparrowhawk. The discovery is even better. I have chased them over by Brook Vessons, crawled along Cow Ridge following their echoing call, and I am determined that this is the year I catch them in frame. Nothing, until now. A juvenile cuckoo, so late this early October, makes it a Shropshire record. Nothing appears to be wrong

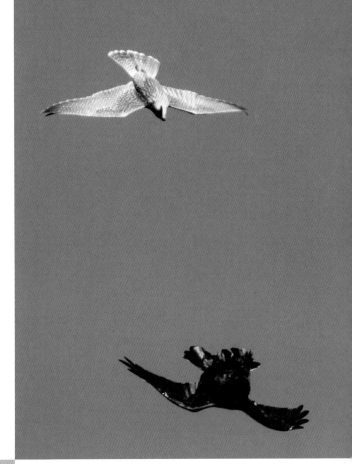

as it feeds away on caterpillars, ready for its long migration. Here again, a bird, once common, is now talked about in terms of rarity and surprise. It should not be so, but at least here, in these uplands, the cuckoo persists.

Left: Raven under Manstone Rock.

Above: The thermals on the Stiperstones ridge make for a great deal of raptor and corvid activity on a hot summer morning.

Right: Buzzards are normally very shy but this magnificent specimen poses in perfect light.

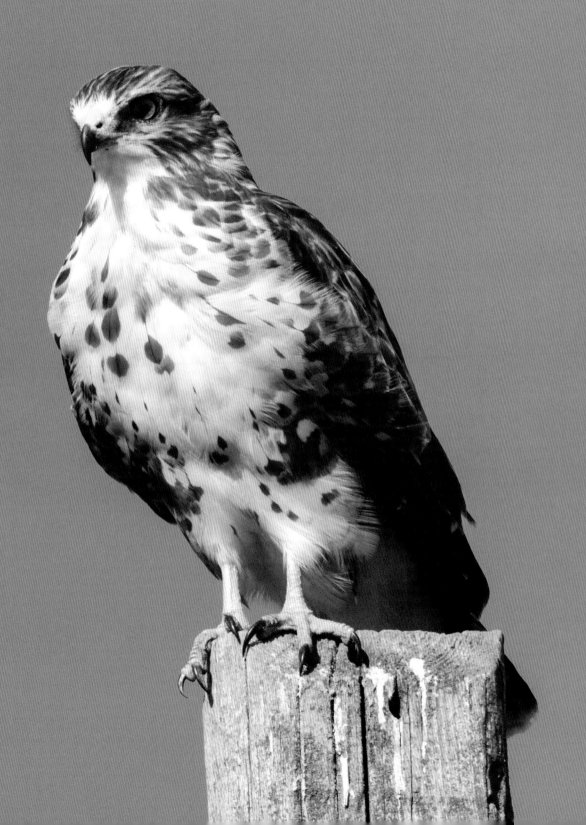

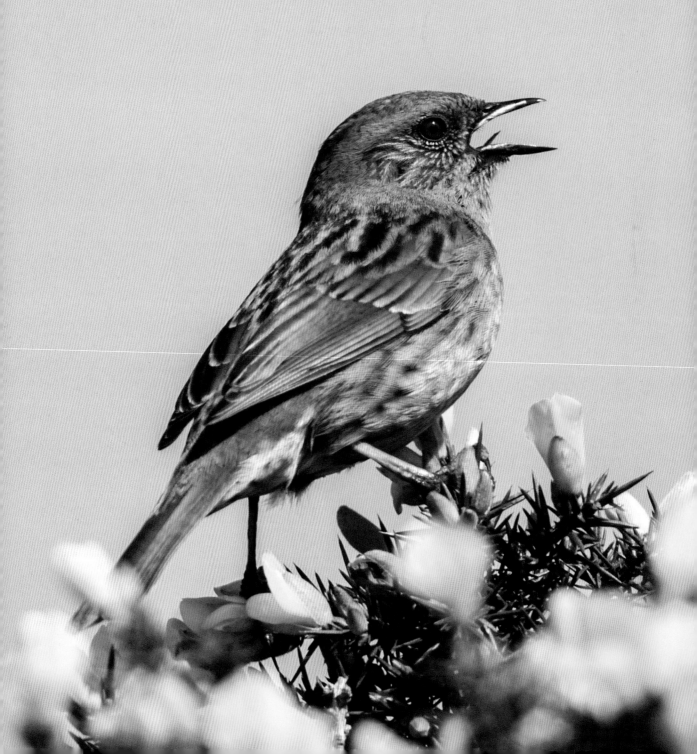

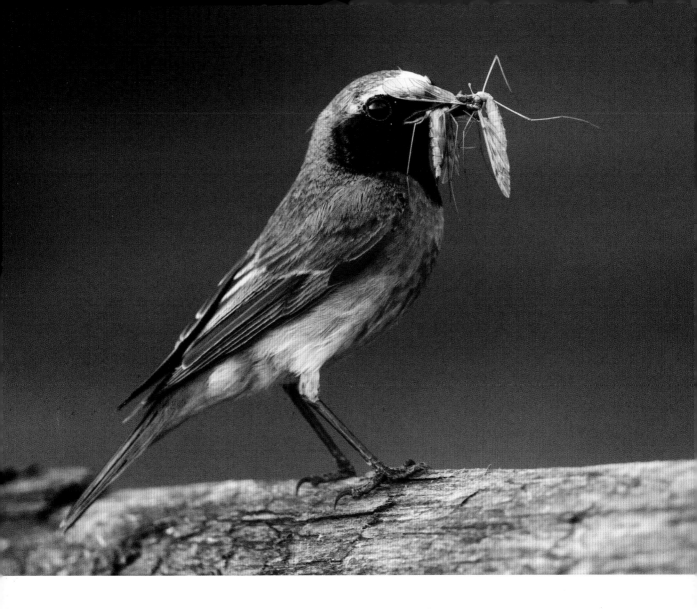

Far left: Though dunnocks are quite common, it is lovely to get such a close up among the gorse.

Above and left: With my car as cover, I am able to shoot ridiculously close to the redstart parents as they feed their young.

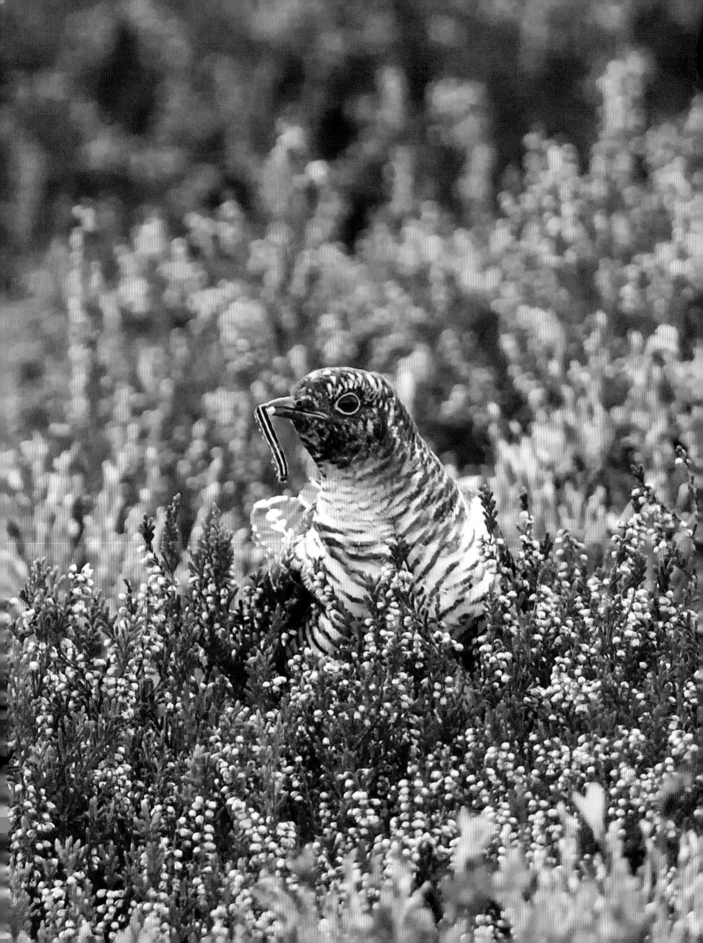

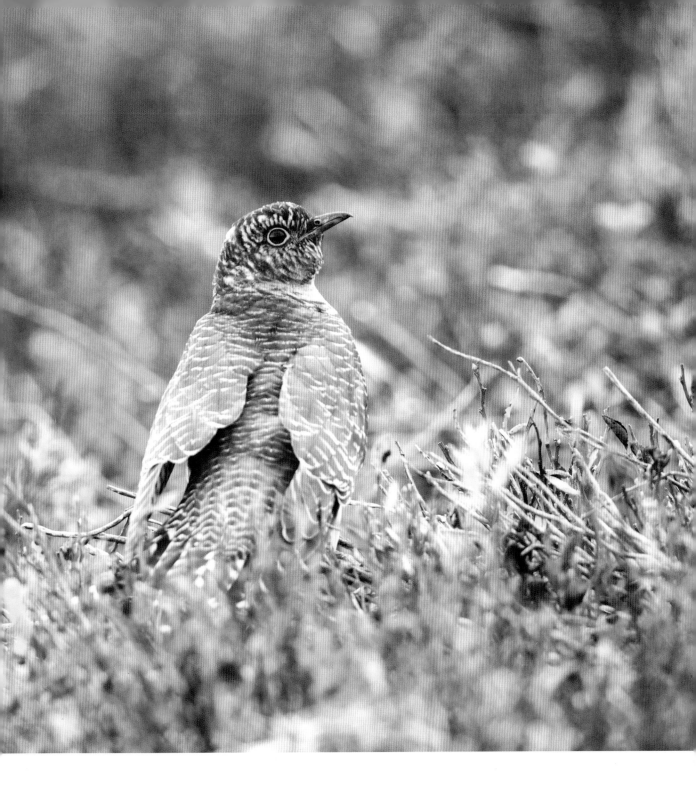

Left: Cuckoo with caterpillar. A warm October means this cuckoo is still able to feed very late in the season.

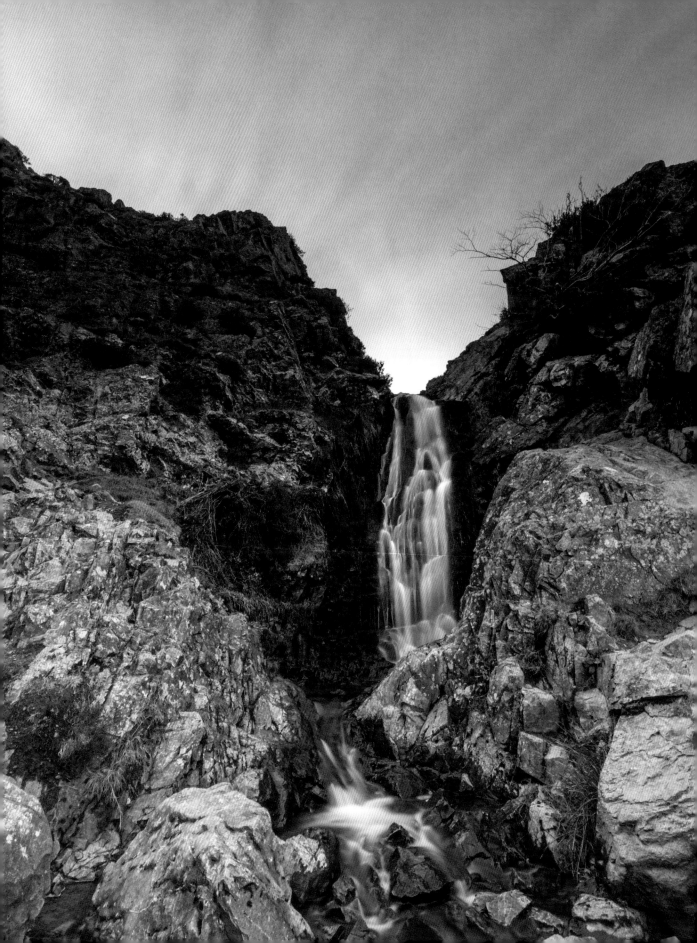

The railway arrived in Church Stretton in 1852 and the Church Stretton Advancement Association decided to rebrand the Mynd as Little Switzerland. Light Spout Hollow waterfall was rather optimistically renamed 'England's Little Niagara'.

Bank Holidays brought thousands of tourists who arrived in specially booked trains. Once they arrived, they could either walk or hire ponies, dog carts or horse-drawn carriages. My mode of transport is a Zafira and a pair of elongated legs. I like the thought of our 'Little' Shropshire water feature duking it out with a somewhat grander wonder of nature.

There are two approaches to Lightspout. Either from above, walking down through the flushes below Shooting Box, or you can follow the path up from Carding Mill Valley. In spring, I prefer the route from the top ridge through the wet flushes, especially to see life returning to these cold, windswept higher valleys. In February, the frogs are first on the scene, and their spawn lies like a bubbly jelly in the boggy pools that feed the stream. The Mynd is silent on these cold days, apart from the crack of ravens, one of which I catch bringing in nesting material. Ravens are early nesters, traditionally relying on the death of live-stock and other animals in harsh winters. Despite the weather, another season already knocks at the door. But the last days of winter hold their own secret. Winter has a vivacious way with sunsets, so I walk between the steepening valley walls, then finally clamber over the volunteer cut steps that enable me to reach the foot of the waterfall. It really isn't Niagara, but it still provides a good sibilant song for a cold dusk. The sky is rich and the last feeble rays of sun are still capable of colouring the air with a hint of purple.

I think of the Reverend Donald Carr who was about his spiritual business in 1865 as he tried to return over the hill from giving the service at Ratlinghope and got lost in a snowstorm. The highest snow for 51 years did not help. After several plunges down ravines, loss of gloves and boots, snow blindness and putting his hands out

Pages 140-141: As I make my way down to the waterfall, this kestrel comes into land on a rock which commands a good hunter's view of the valley.

Left: Winter dusk puts some rich colour into the sky for this long exposure shot.

Below: Despite an inhospitable habitat this high on the Mynd, the frogs are well adapted for a cold environment.

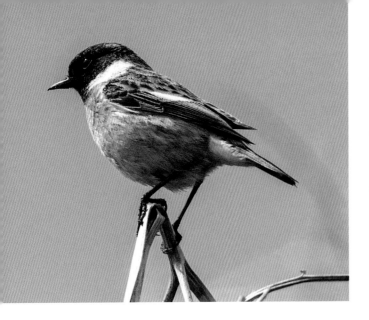

to feel a hare hidden in a snowy hole, he finally passed Lightspout waterfall. Its sound guided him downwards and some children playing found what they thought was a 'bogie in the snow'. He recovered, and went on to write a Victorian bestseller, still in print, and a good reminder that winter is not to be messed with on the Mynd.

As Pete Carty reminds me, the winter fair in Church Stretton used to be called Dead Man's Fair for a simple reason. Farm hands would come over the Mynd to the fair, get drunk and try to walk back.

In the dead of winter many succumbed to frostbite or died. There were no cars with heated seats back then.

When I return to Lightspout in May, it is to an utterly altered landscape. The flushes are decked out with reed buntings and stonechats are declaring territory on any bit of old bracken they can find. The kestrels are out and about and it is quite rare to get close enough to photograph one on its rocky perch. The stream provides me with opportunity to play with my new waterproof set up, sticking my lens half in and half out of the water. Suddenly, a small dark gap at the back of the stream looks like a person-sized cave opening. Miniature has turned massive – maybe the Church Stretton Victorian version of a tourist board had it right. At Lightspout itself, blue sky goes about its business, glorifying water and land and lending a particular brightness to the pair of grey wagtails that nest here most years in the overhanging rock next to the tumbling waters.

Many years ago, I portrayed Donald Carr for a piece on Heart of the Country. The crew had me

Left: The male stonechat uses last year's bracken for a perching spot.

Below left: There are fish below Light Spout Hollow, but above the falls only hidden, miniature caves.

Right: The grey wagtails have found the perfect, inaccessible nesting spot right by the side of the waterfall.

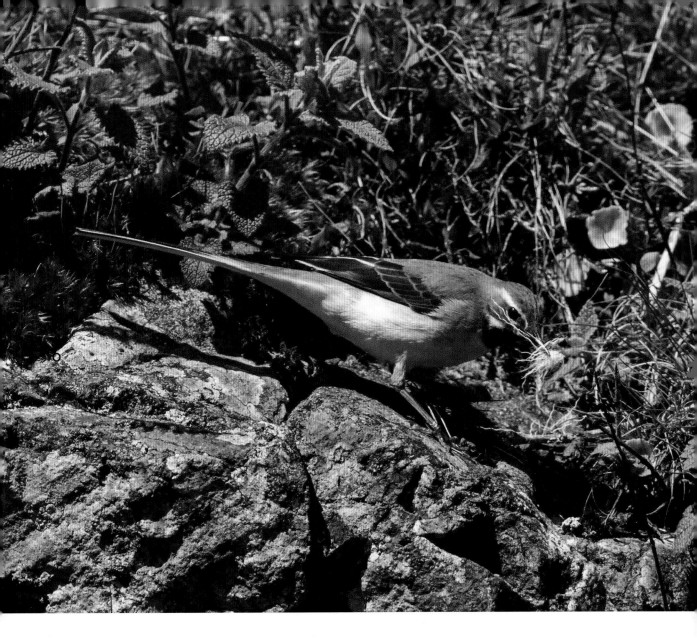

tumbling down slopes, dirtying my hired Victorian costume. It was bruise-making work but I was glad we filmed in summer, and that nobody noticed the seasonal inaccuracy of my portrayal. I do believe we step along paths that were trodden long ago. My joy at Lightspout as I pause to sip coffee from my thermos and bite into a rather good salami sandwich is that I am far from the first to pause at England's Little Niagara.

'It is also a favourite place for picnics, and we had gone fully provided for an emergency of this latter description. With an appetite sharpened by our long ramble over the beautiful moorland, we seated ourselves joyfully on the bank partly surrounding a beautiful clear spring of water, the source of one of the many streams which water the gutters to the south east,' wrote Thomas Wright in his aptly titled book *A Picnic On The Long Mynd*, in 1877. I found this little faded paperback deep in the Shrewsbury Archives, the source of a fascinating historic stream, which finishes this chapter with a nice thought – a day out on the Mynd was so memorable, one visitor turned it into a book. Good on him, I say.

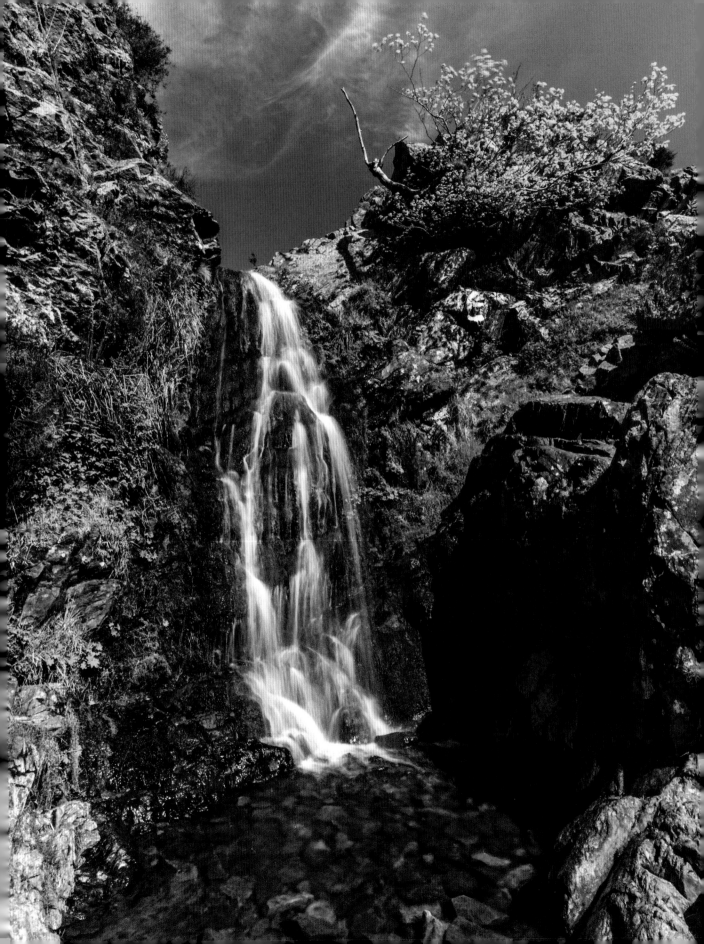

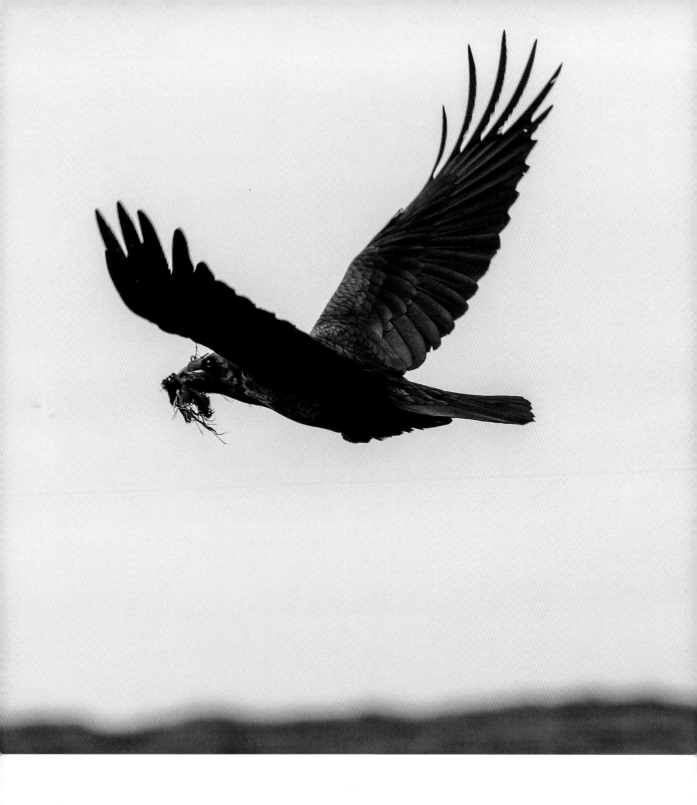

Left: In May, the waterfall is alive with greenery as the precarious hawthorns that sprout from steep crevices are coming into leaf.

Above: Raven with nesting material. Ravens are one of the earliest birds to start nest-buidling in February.

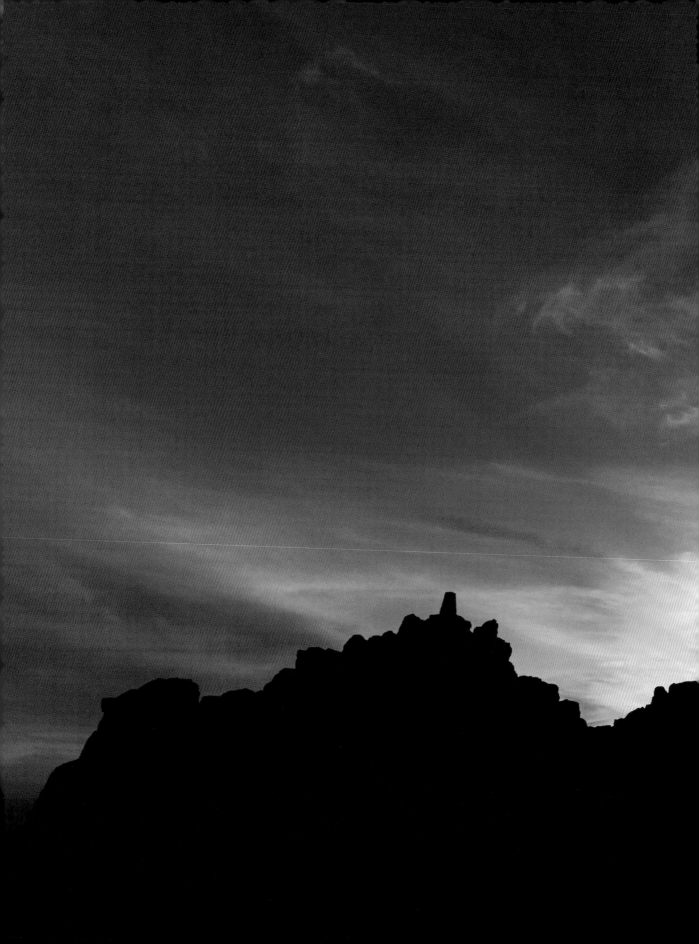

MANSTONE ROCK

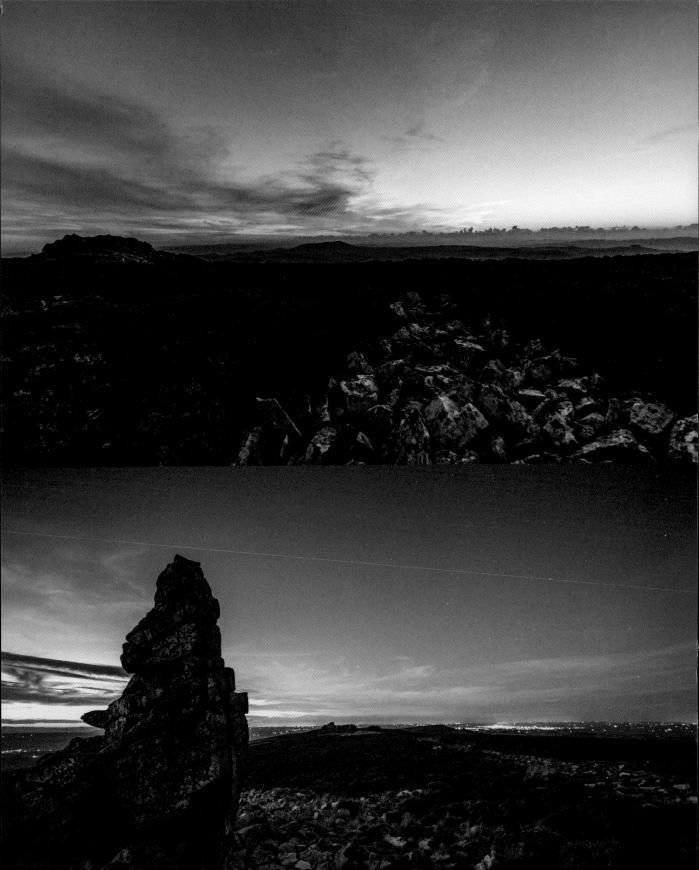

I have had three visits to Manstone rock on the Stiperstones in the last three weeks. Last night the sun was setting in a single cleft between the rearing tor that gives Manstone its name, with a face like that of an ancient from Easter Island furrowed into quartzite and the main crag itself, which is the highest point of the Stiperstones.

On Bank Holiday night I make my way up from the car park. It is the height of the season, but there are few people about. By the time I make the ridge, the ankle-biting path requires use of my LED headlamp as I gingerly cut my way between sunset and night. I am alone aside from the odd cackle of a red grouse, stirred from his nightly slumber.

On this first visit, I have decided to bypass sunset, kicking myself as the orange peels back night for a brief and sweet flare. But I am after more distant silver, and I want it in quantity, the bullion of night. I reach behind the glacially eroded pile that supports a single concrete trig stone indicating the second highest spot in Shropshire. Behind this outcrop, forever on watch, is my main man, the sentinel. Perhaps he is a proper figurehead, a proud prow, chained to the earth, heaving this raised ship through the tectonic waves of time, one inch a year.

The way this hill works is like a magician. First, you are shrouded in the evening, the last rays and their effects hidden behind the upland bulk. Then, as you straddle the ridge at the top, Wales is given to you in all its glory, a flourish of impossible peacock feathers atop its dusky hills. It's no bad view. But the man sees it all. For, whatever the attractions of wilderness, here is a little, angular Buddha who sees the far lights of Shrewsbury twinkling in their earthbound constellations. He meditates, as pilgrims and poets give offerings of purple heather, then smiles, for as night claims ancestral rights, the sky is punched through with distant messages, a morse code from literal light-years past. I take his cue and also marvel, for this is the first time I have seen rising above me like some dug up, vast-curving Viking boat, the whole panorama that is the Milky Way.

I am both confused and greedy. The camera wants it all. The way the far light pollution of Shropshire's capital plays on the rocks behind me gives me both close detail for foreground while the Milky Way itself leads off on a diagonal. This is my spot to capture the movement of the stars. I have studied and worked hard for this, and must now dial in settings and trust camera and rock-steady tripod to go about its business of gathering light. Or rather, harvesting the trail of stars – 100 thirty second exposures, tied together in an embrace

Pages 148-149: Exposing for the sky turns Manstone Rock with its trig point at the top into a perfect silhouette. At 536 metres, this is the second highest point in Shropshire, only topped by the far Clee Hill.

Left top: On the way back down, this glacial scree metamorphoses into an eerie road leading to the night.

Left below: The rock stands sentinel over the Shrewsbury plain.

which shows that everything is in flux. Nothing stands still.

I have prepared for this night of shooting, and understand that the month of August holds no truck at this apex of Shropshire. This means gloves, hat, neckwear and layers. After all, my camera is doing the work, and I am doing the waiting, here in the far dark. For a while, I lie on surprisingly comfortable, springy heather. The stars are overwhelming. I close my eyes and breathe. What disturbs me? A nearby flickering. I sit up and follow its progress up the hill. There are more and more night walkers, runners and cyclists in these parts, stretching the boundaries of exercise and exploration with their LED headlamps and sturdy legs. Fair play to them. But not tonight, when I need this mass of rock to myself. A single beam from their torches and my sequence of photos will be interrupted, the smooth line of the stars will stutter and my work will be for nothing. I am confused. There appears to be more than one. Maybe they are wild camping for the night, or holding an impromptu party. The nearest is getting pretty damn close. I stand up, unsure how to present myself, whether to ask them to step back.

Then the light is gone. I am shivering, but not with the cold. I can work out distant car headlights crawling down in the valleys below, and individual farmhouses, smallholdings and hamlets. This fits none. I look up at the arc of the Milky Way, know I can fit in this whole panorama in 12 photos, but it will take another hour. Instead I pack up in haste. The lights have freaked me out. I want to get off this hill, even as my brain tries to dissect what it saw. My own headlamp shows no pairs of eyes nearby, no grouse to mistake. I lose my way down. The short scramble is achingly long and I am desperate for my car and safety. I finally breathe when I am in my car and driving out of the car park, the whole thing too alien for my liking.

I ask all sorts of local people about it in the following days. Gwyneth Owen grew up in the shadow of this ridge and remembers the tale of her aunt and her nan out walking one night. 'Good evening,' said her nan as they sauntered through the old mine workings. 'Who are you talking to?' said Gwyneth's aunt. Nan said: 'Did you not see the old man just now?' I even think of Wild Edric who is said to live deep in the old mines dotted round the Stiperstones. He will ride out with his horsemen when England is in trouble. With all the political upheavals this year, I would say this would be a good time for him to come and rescue us.

Websites about mirages say: 'If it weren't for atmospheric extinction, an ordinary 100-W light bulb would be barely visible to a dark-adapted eye at about 100 km distance.' The jiggling lights that I thought was an approaching walker could have another explanation. 'People easily become disoriented in the dark, and imagine that a perfectly stationary light is "moving" or even "jumping" around', the websites say. Reason, in this instance, suits me. I really did believe there were other people on the hill. There were not. But there were plenty of cars and distant houses and the dark played good tricks. No wonder it is a place of myth and legend. What I do know is that Manstone changed before my 'dark adapted' eyes.

What I do not know, is if my evening's work has paid off. Forget sleep. The moment I get home, I grab a bite to eat and upload the pictures – over 100 thirty second exposures aimed at rock and sky. Finally, after hours of processing, blending, following a software recipe that squeezes a time-lapse into a single instant, I have found Manstone to be an icon of both movement and stillness, where the journey of the stars suddenly comes to life in front of my eyes.

The strange wispy clouds, lit by light pollution, appear to adorn the distant Milky Way.

Pages 154-155: Over 100 blended 30 second exposures show the movement of the stars above Manstone Rock.

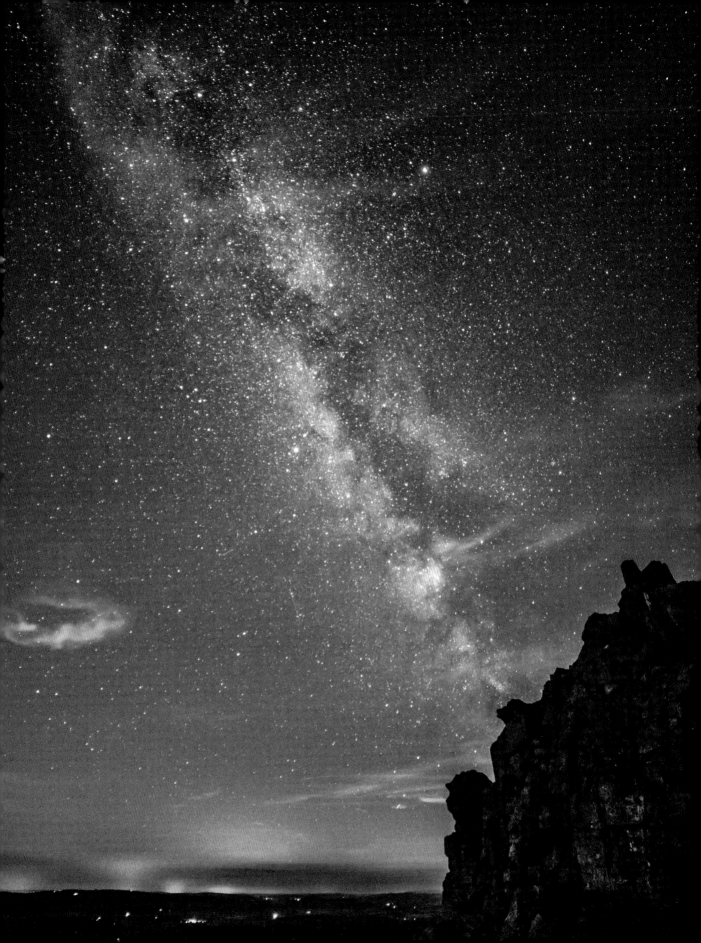

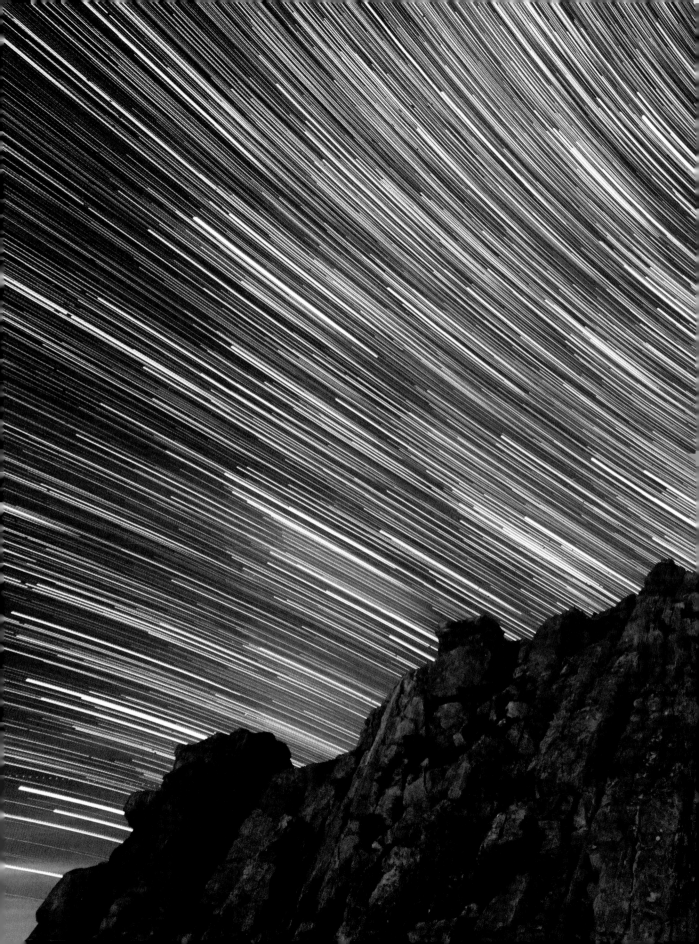

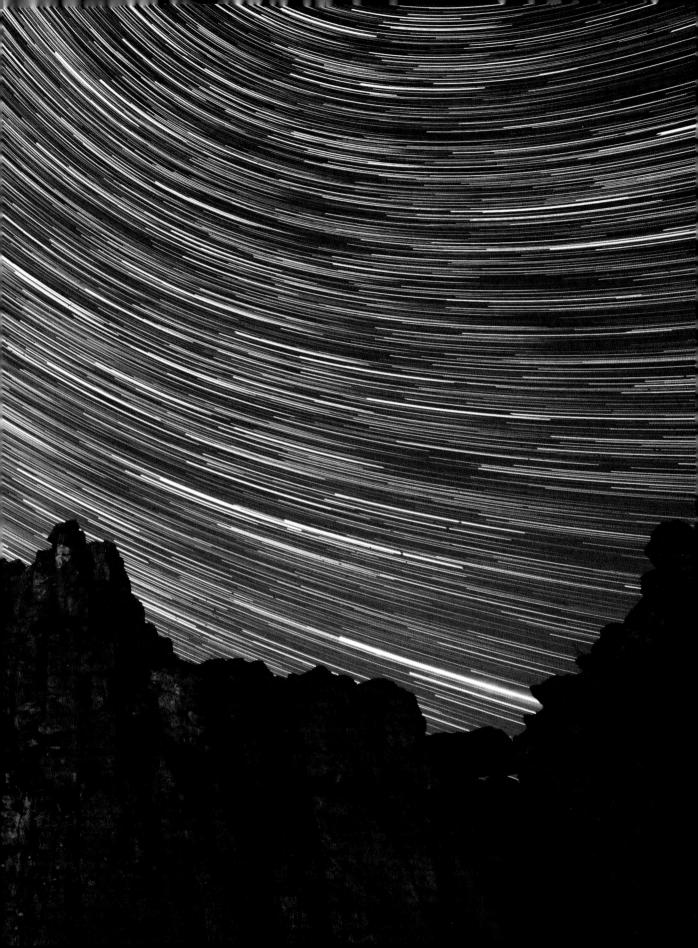

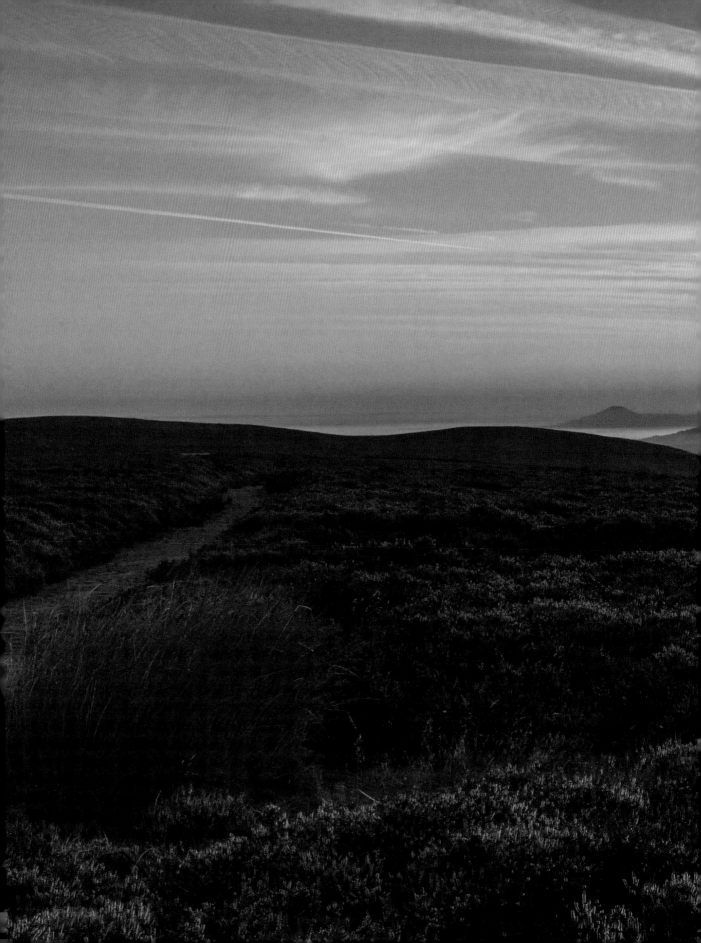

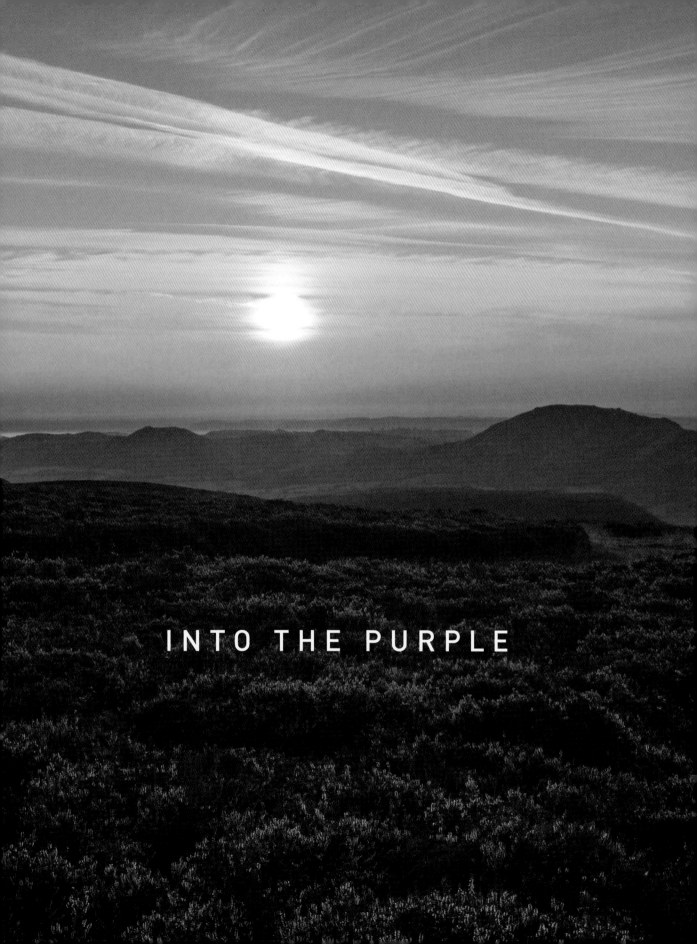

INTO THE PURPLE

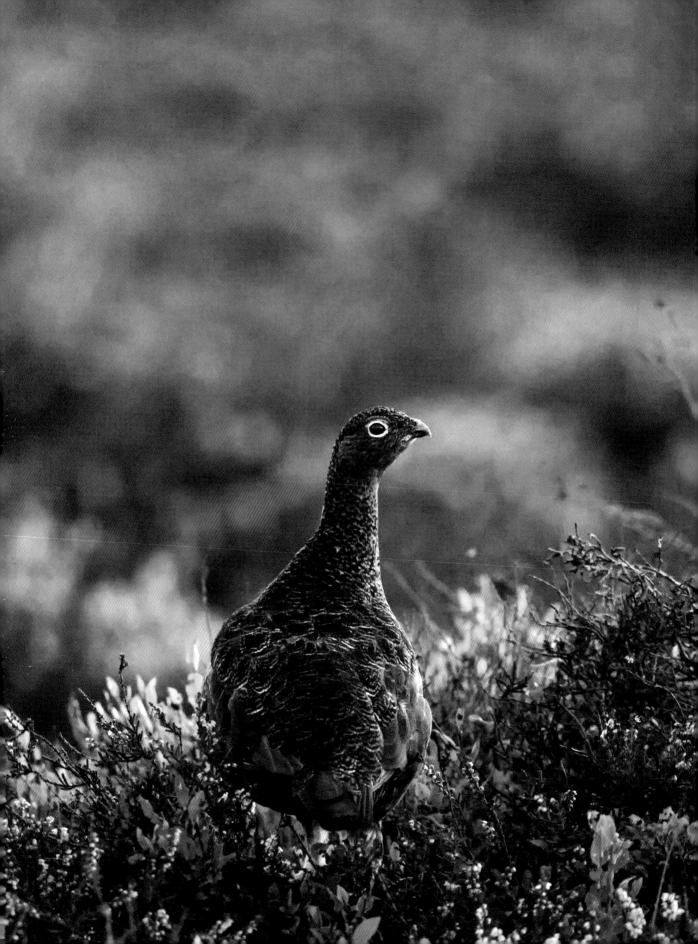

From the end of July through August and sometimes even into September, heather, also known as 'ling' or 'scotch heather' bursts into bloom and a brown landscape is transfigured into something almost holy. The views one can gain or see wildlife set against are only relatively recent.

By 1965 the privately-owned Mynd was in poor condition. Under the recently enacted Commons Registration Act, commoners claimed the right to graze nearly 25000 sheep, 150 cattle and more than 1000 ponies. If exercised, this level of grazing would be unsustainable. A local campaign raised the then huge sum of £18500 to enable the Manorial rights of Stretton-en-le-Dale to be purchased by the National Trust. The Long Mynd had been saved.

At the time, this fantastic landscape we enjoy today was a shell of its former self. Perhaps the sea metaphor is accurate as the hills were drowning in bracken, the heather was in decline and grouse numbers were down to 24 pairs. It took a further 35 years to come to a new agreement with the commoners to graze more sustainable numbers of sheep alongside a small group of ponies.

It is for this reason, alongside other management input including controlled bracken cutting and burning, and thousands of volunteer hours to maintain paths and give wildlife a chance to breathe, that we have this moment of seasonal magic. The hilltops are filled with heather mixed in with bilberry and grasses, which support good numbers of grouse, pipits, Emperor moths and hawks such as merlin and peregrine, who have nested successfully for a number of years.

All this work means that when I rise at stupid-o-clock, wake my daughter, pack bacon sarnies and a thermos of tea ready to head out and up the Burway, I am in with a chance of wonder. At 5.36am, dawn is at its best, showing off the sky and filling it with remarkable vibrance as it hovers over the far Wrekin. My foreground is both rich and royal, a spreading bed of heather.

The purple backcloth is also a great setting for wildlife. There is a very prolific and butterfly-friendly patch of old mine workings near the Bog tea-rooms. Strange to think of miners digging and blasting out barytes, the flower of the earth. Now, we have graylings and a green-veined white, which uses its hollow proboscis to suck up nectar from the heather flowers. An uncurling and uncoiling tongue with good taste, helps the butterfly live off the sweetness of the season. Another visitor to Upland at this time of year is the Bilberry or Bleaberry bumblebee. It likes the cooler air at this elevation, and it is quite the looker with a bright orange-striped abdomen and a gorgeous ruff of yellow about its neck. I found one right under the Devil's Chair a few years ago, and they are often seen among the whinberry bushes that make up the ground cover up here along with the heather.

At the other end of day, I am lurking behind the trees of Pole Cottage as only a sad, bird-spotting middle-aged photographer can do. Rumours of a short-eared owl have spread, but that is all

Pages 156-157: A summer sunrise on the Mynd.

Left: This male red grouse has no idea that he is posing with a perfect purple backcloth.

they are tonight, the distant echo of a hopeless dream. However, a fellow birder took pity on me and pointed out the red grouse who has flown into a patch of heather only yards away. It is near darkness, a hush now fallen on the Mynd as most human visitors are long gone.

The male is keen to protect his territory and turns to me with that red-flecked eye, proud of what he is. As I lift my lens and catch his glory, the red, the purple, the blossom and late summer, all of it framed in a single click of the shutter.

There are other moments to savour during my repeated upland visits, hoping to squeeze the best that I can from these short weeks of flowering. The humble meadow pipit, another indicator of heathland recovery finds that heather is the perfect hunting ground for grubs and caterpillars. A sudden summer mist softens intense tints into pastel hues as grouse flare from the ground and fly past a bemused ewe. Finally, I chase the light after sunset above Wildmoor Pool. Here is the perfect match between the last pink of sky and the rich lushness of August heather, newly in bloom and proudly showing off its territory.

Left: Grayling butterfly.

Above left: Green veined white butterfly feeding on heather at the Bog.

Above right: The bilberry bumblebee is only found above 300m. Sadly, climate change is causing a sharp decline.

Pages 162-163: At dawn on the Mynd, a red grouse skims the carpet of heather.

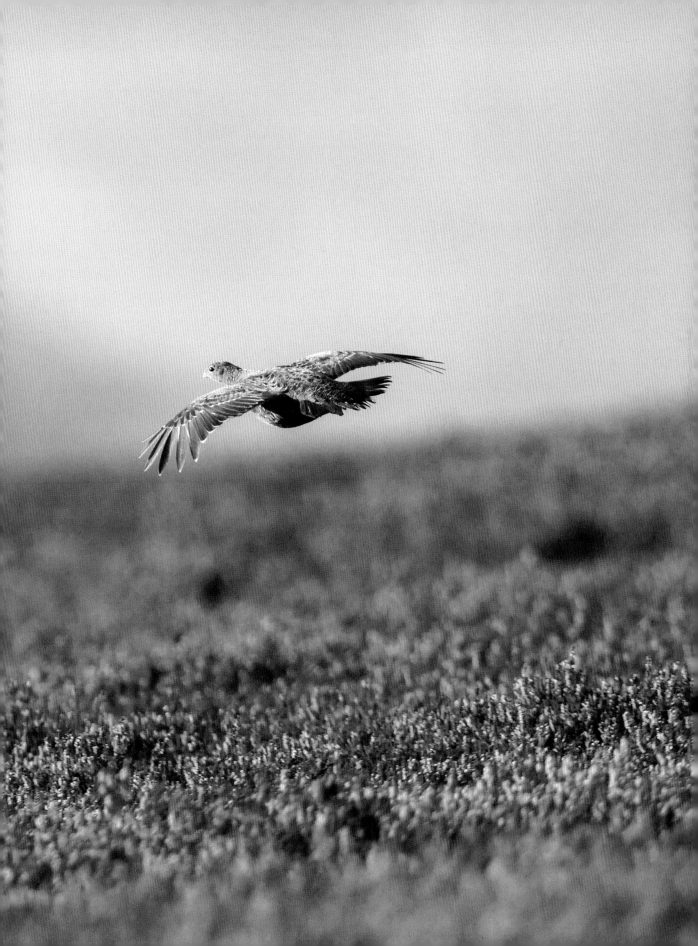

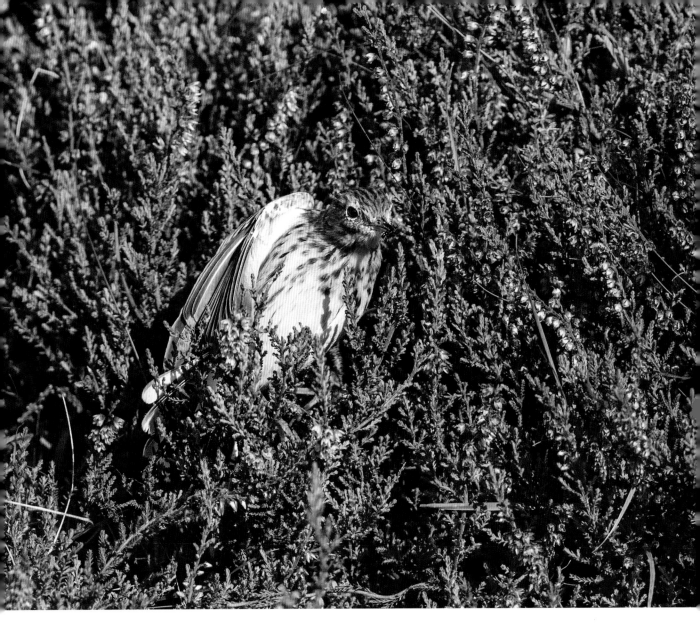

Above: Meadow pipit feeding on insects on the Mynd.

Right: Above Wildmoor Pool at dusk, the heather mirrors the colour in the sky.

Pages 166-167: ICM or Intentional Camera Movement shows the incredible colours of heather and dusk light.

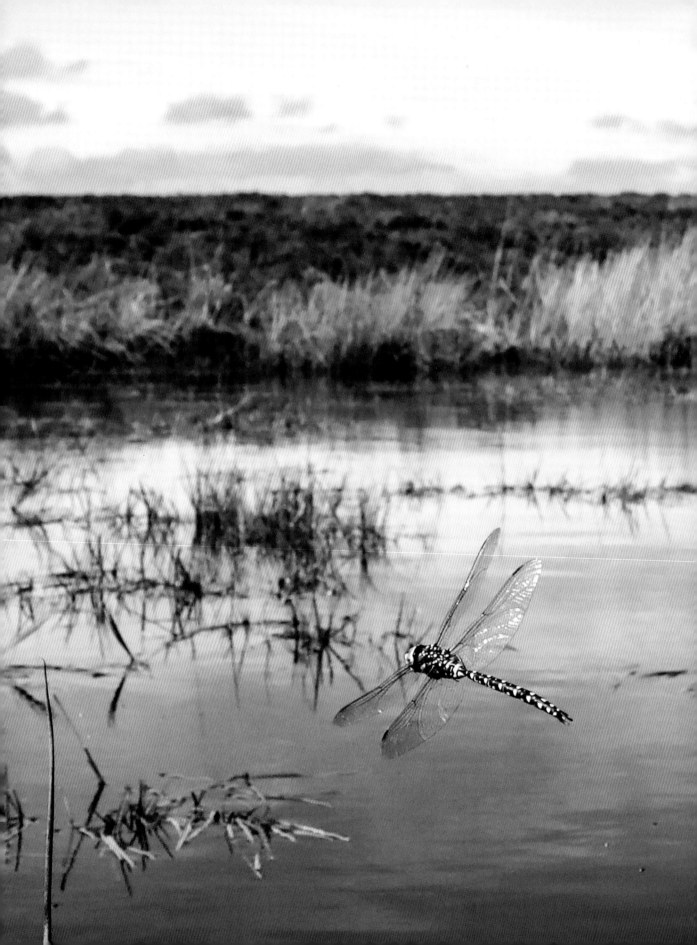

LATE SUMMER

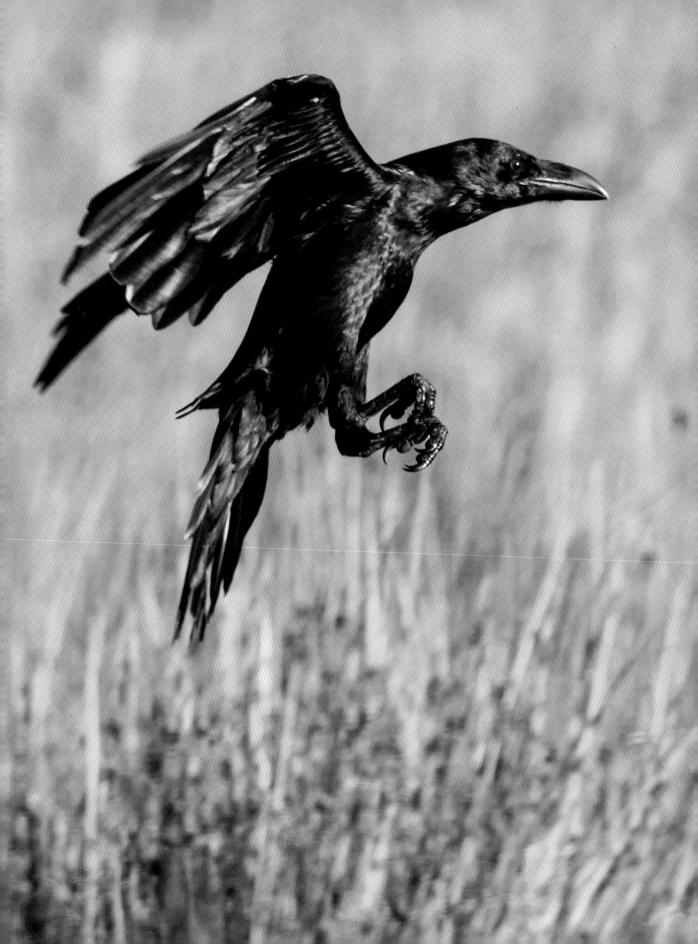

Late summer can be surprisingly quiet in these lifted up lands. Breeding and fledging of birds are over and done. The purple heather is beginning to lose its lustrous purity and once again becomes home to meadow pipit, grouse and a few hawks.

But dawn is still worth the effort for clean, sharp light, and whatever activity may be about. The ravens are normally fastidious in keeping their distance on the Mynd, but occasionally I have been able to walk in and share a quick sort of intimacy.

It's not often in life that I crave being ignored, but when a raven lands in front of me, invisibility transforms into grace. My quiet approach has gained me claw, eye, and such a perfect black sheen it reminds me of the boot polish I smoothed on my winkle-pickers in the 1970s.

Another mating game is underway and the pools around Pole Cottage are the perfect viewing platforms. There is a buzzing in the clear air on hot days and a fluttering of shiny-veined wings brushing up against the heather. The dragonflies are out in force. Migrant hawkers pair up to create strange looping flights as they come together in unparalleled aerial feats before landing high up in an overhanging beech tree. They do me the honour of taking their time, so that I can take my time to frame their slow-motion amatory embrace. One of the bog and heathland specialists, the black darter, lands on an old seed head that sways out over the pool. It is the only fully black dragonfly in the UK, the yellow tones on abdomen and thorax set against the richness of glittering pitch.

Flight is harder. They really do zip around and though I have several times managed to freeze motion at 1/4000 of a second, I am interested in telling a more relevant, contextual story. The more time I spend around dragonflies, the more I

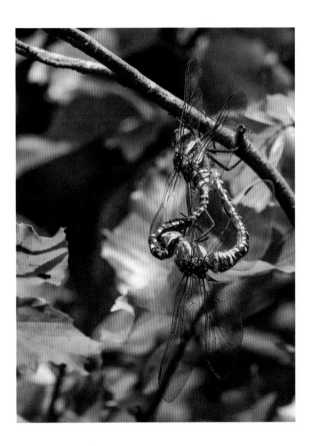

Pages 168-169: With a wide-angle lens pre-focused, I can show the darter in its habitat.

Left: Ravens are a rare success story in the UK, with their range extending west and south and even nesting on the cliffs of Dover. They are the biggest corvid and I am always thrilled to catch them in flight.

Above: To fly while attached is an extraordinary feat, the very act of new life giving lift and buoyancy.

Pages 172-173: The view west from the edge of the gliding station on the Mynd.

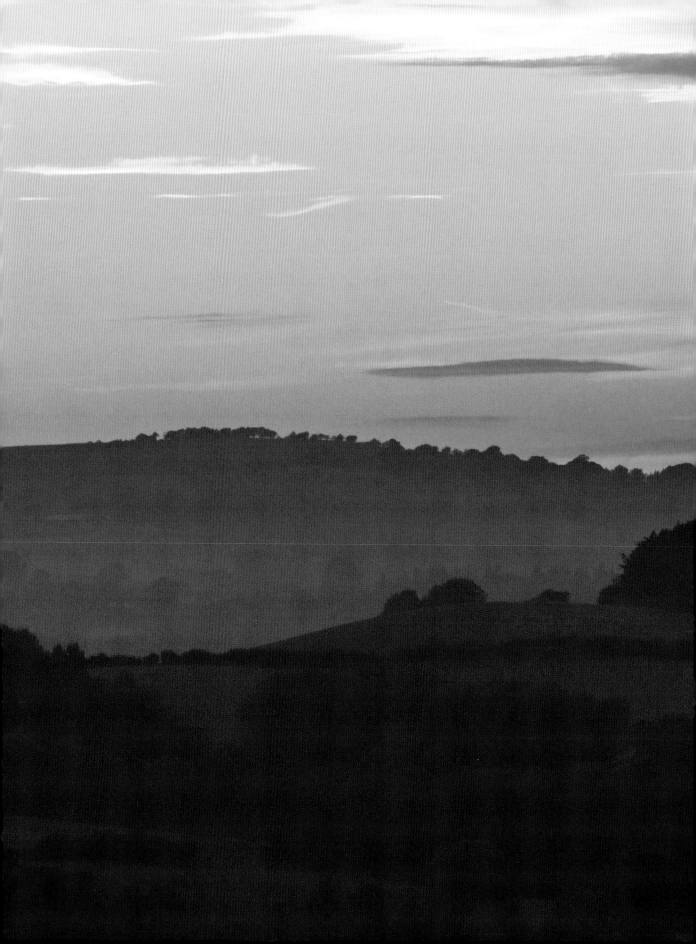

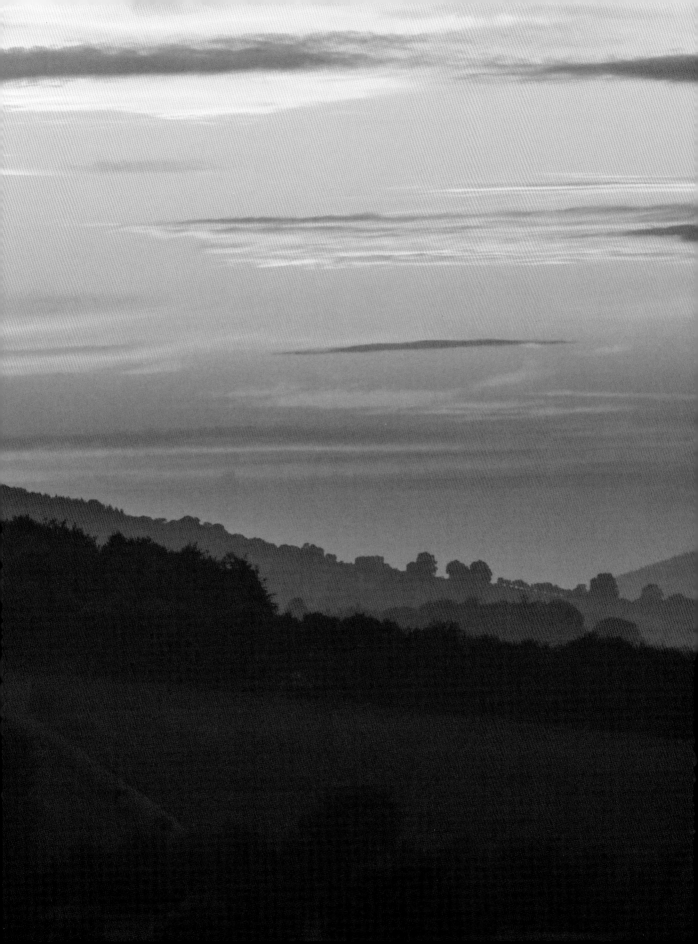

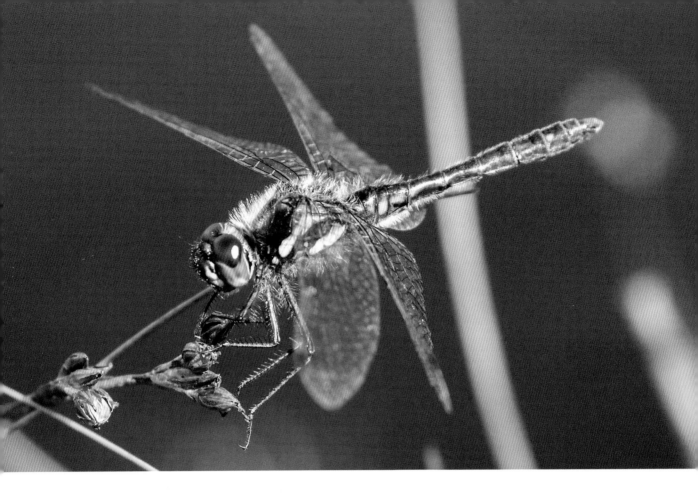

Above: The black darter can be found on moorlands, bogs and heaths and is the only dragonfly that is almost entirely black.

Left: Mating common darter.

Right: Male red grouse.

understand that they too, like birds and mammals, have a set of repetitive behaviour.

For this pool, it means a patrol that zips in and out of the reeds over and over again. I set up with tripod and manual focus at one spot that frames the pool and far edge leading to sky. Then, it's a matter of waiting with remote controlled trigger for the hawker to fly in front of the camera. It's a great moment, looking almost as if I have pasted the dragonfly into another picture.

These pools were part of a hunting picture. The falconer Ronald Stevens, who owns Walcot Hall, rented the Long Mynd both for the shooting and the rearing of his hawks. The pools behind the original Pole Cottage were dug out by the Earl of Powis in 1900 as duck decoy ponds. So, I am hunting dragonflies at the very spot where a different sort of hunting happened a hundred years ago.

Many pools on the Mynd are man-made; some to ward off the effects of incendiary bombs in World War 2, some for hunting and some to water livestock. Wildmoor Pool, where I catch the common darter, was dammed in 1850. This darter is not even mating, but gripping the female brutally by the head to prevent other males mating with her. Studies show that females can end up with terrible wounds from such exclusivity.

The days are turning. On the Stiperstones a preening red grouse peers from heather that has already lost its purple. The vibrancy of summer has moved up into the sky and one night my daughter and I race out to catch the western tip of the Mynd. As we accelerate up the single track road towards the gliding station, I experience a moment of vertigo. To my left lies a drop of impossible steepness that no car should attempt. It's no issue for the kestrel, or the paragliders who loll around on fair and not too windy days. Tonight, we leap from the car, cameras at the ready.

We have not been there more than a minute, when a police car comes from the Stretton direction, makes a sudden turn and screeches to

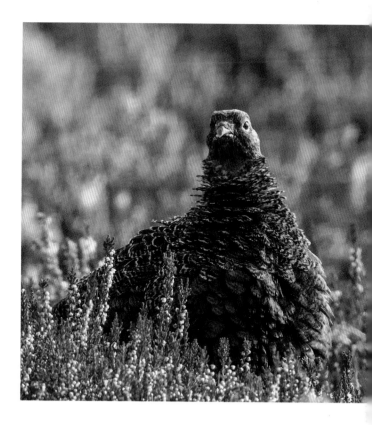

a halt right by us. My heart rate speeds up as I wonder what crime I might have committed. Two officers leap out. Instead of handcuffs, they have phones; the only arresting sight is the view they are keen to capture. Not only that, but one tells me how much she admires my photos. I am both relieved and chuffed. To be recognised on the Long Mynd at sunset is a perfect end to the day. We all set to, grabbing this rich and orangey hue as the sky turns sweet as caramel.

COLOUR, LIGHT AND
FINAL DELIGHT

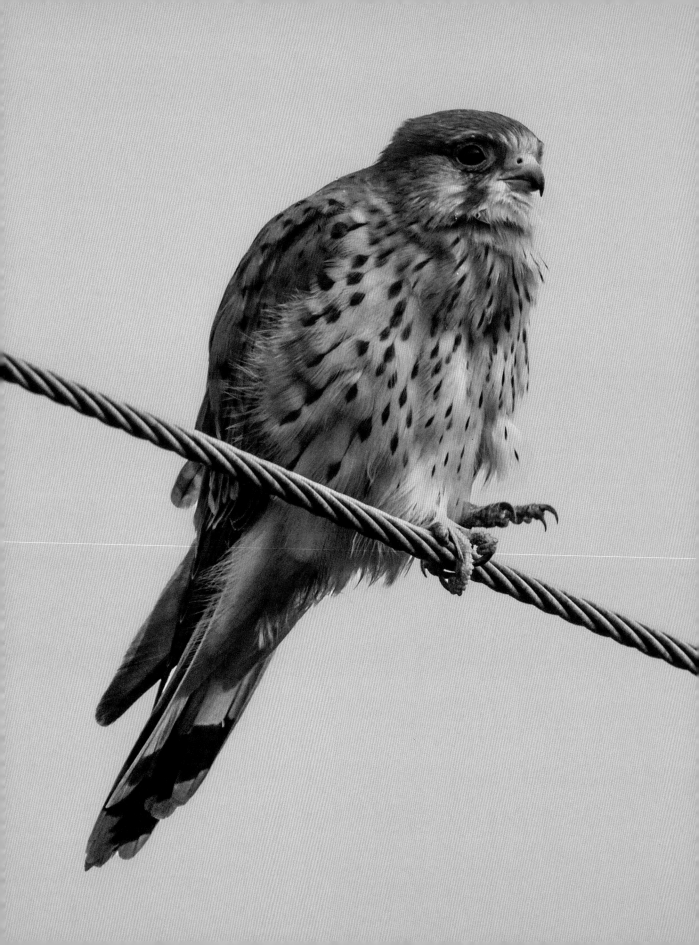

October brings further dry weather, that cleaving unto the season that we must admit is finally over. Summer has been banished and, in its wake, low-lying mists rise from the land and hover like autumn's angels. At dawn, Church Stretton could be a city sighted from a far off vantage point, the hills behind that lead to Clee, lost still in the swaddling fog.

From this elevation, I can feel the end of this journey is near. It is appropriate to finish on my favourite time of year, when storm light renders clouds a yellow that matches the preening telegraph-wire perching kestrel. Though this stopping off point in entirely man-made, the hawk is relaxed as I peer through my car window. Storms are no issue, and the downpour that comes suddenly, a fact of life.

There are a few more goals on my Upland tick-list. For the last two years, the fieldfares and redwings have done their best to avoid me. They hop from tree to tree, evading all closeness. But I have a good session with Simon Cooter and his faithful steed, the seemingly-camouflaged land rover. As we bump along rutted tracks near his office, there is one spot that looks promising. Hawthorns, rowans and hollies on either side, and whole migrant flocks stripping the berries. The holly is red-resplendent and untouched, left until later in the season when the birds have no choice. Maybe there is a trip advisor for autumn feasts and holly only gets single stars. I exit the car quietly, using the door as a lens balance, waiting for that old birding instinct to bring the flock back in. Patience pays off as a fieldfare flies in to perch right above me. I like the way that fieldfares, redwings and starlings will form a single flighty warning system, the flock reacting instantly if a predator comes in on the hunt.

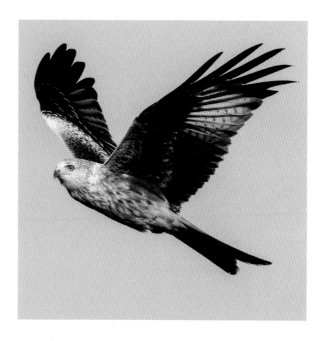

Somehow, this is turning into the season of portraits. A kite shows off the perfection of feathered streamlining on a cold, but perfectly blue October day. I return to Wildmoor pool, hoping the weather report is correct.

Pages 176-177: Dawn from the Burway towards Church Stretton and Clee Hill.

Left: Kestrels have declined since the 1970s and though their habitat is widespread they are listed as Amber status.

Above: Red kite in flight.

Pages 180-181: Mistlethrush at Carding Mill Valley.

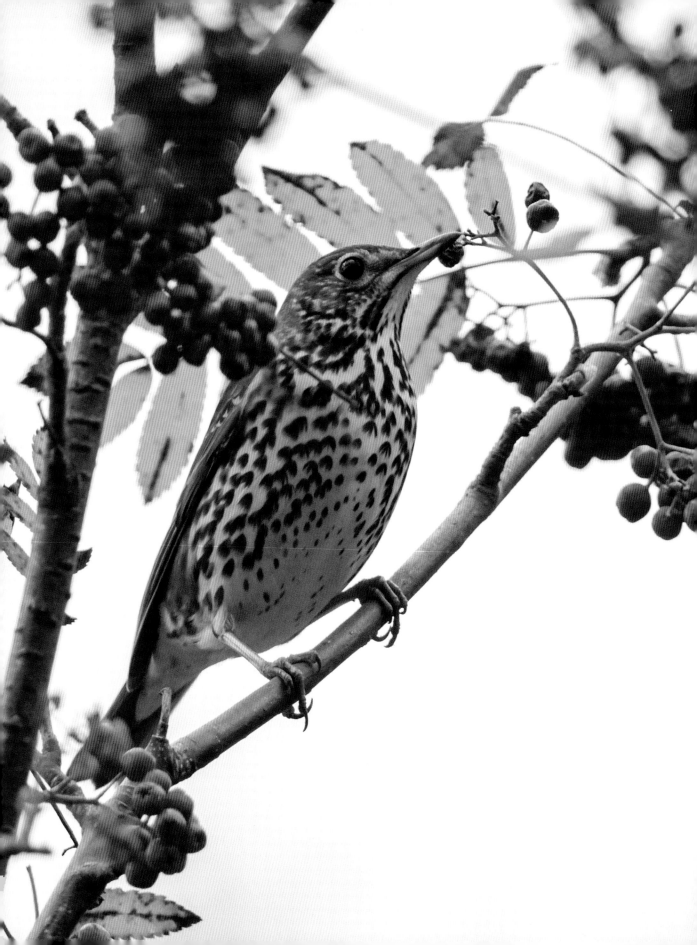

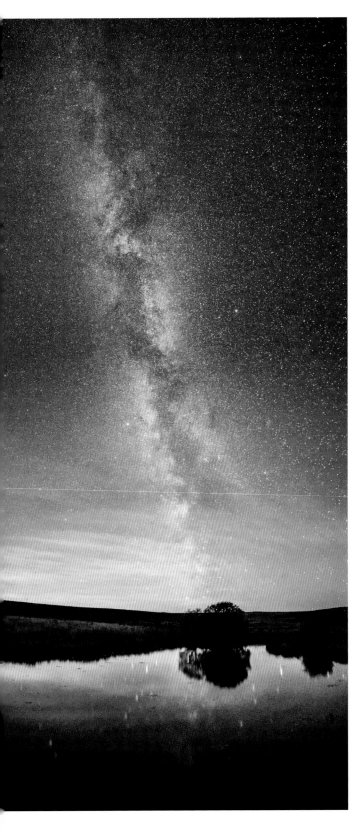

The sky is dazzlingly clear beyond astronomical twilight, though a sharp wind ripples the surface of the pool, blurring the reflected constellation I was after. Instead, I crank up the geared head on my tripod, pointing my lens vertically until I catch the Milky Way both on the horizon and directly above my head in a three-picture panorama that I stitch together later on my computer. The Shropshire Star uses it on the front cover, though I think this should be printed six foot high to show all those stars, all that hugeness compared to which my ambition is a tiny flicker.

I am almost there. On my last visit to the Mynd, I chase a sighting of a November juvenile cuckoo. This sounds like a record, though Pete Carty says it could easily be a migrant blown off course. Anyhow, the spot behind the tea room only yields a robin. On the way in, I spot a thrush in the valley trees. This is often the way of it, as I want one thing, but get another. However, it is a mistle thrush, whose population is a tenth that of song thrushes. Like the fieldfare and redwing, the mistle thrush is on the red list for conservation. So many declining birds. The small hope is that this book will show what we might lose if we are not careful. In my local singing group we sing a song with the lines: 'Better light a candle than curse the darkness.' I don't know, but if I gave in to despair, I would not take another picture or write another word. All I can do is express and reflect the beauty of this world, symbolized by my time in Shropshire's Upland.

There is no better way to close the pages than this. Mist layers up the far hills one early morning from Cranberry rock on the Stiperstones. I have used the metaphor of painting for some of my pictures and this is no cliché on a dawn like this.

Left: Milky Way above Wildmoor Pool.

Right: Fieldfare; Redwing; The starlings have started to come into uplands and the fields below in large numbers. I love the way they share their space quite calmly with the resident sheep.

Here is landscape writ large with the possibility of travelling further. It's a good spot to pack up my kit, and make the trek out of Upland back to a damn good breakfast. But I can't finish there, as all the talk in town and country is of a supermoon, at its closest to earth since 1948. This was the year my family fled Prague after the communist coup, skiing over mountains disguised as ski tourists with nothing but a few gold coins wrapped round their ankles. My grandfather, Eduard Fusek, was brave, determined and resourceful. From millionaire MP to janitor, he started again in America and built a life from scratch. It is his spirit that inspires me as day after day I hunt out the moon, and try to place it exactly where I have been dreaming. Clouds say no and I am knackered and numb with cold from hanging out on windswept ridges with heavy kit. However, on the supermoon night itself, I drive past other photographers also keen to catch this phenomenon. There is a collective sigh as the actual rise on the horizon is obscured. Same old British weather. Oh well. I get in my car, cold and dispirited. Yet as I cross the cattle grid that demarcates the Long Mynd from Church Stretton, the sky opens up and I spy the moon peeking above the knobbly ridge of Caer Caradoc, the hill that cradles the eastern side of Church Stretton. I pull up and jump from the car, throwing my lens onto a suburban hedge and praying my settings are good to go.

For a moment, the clouds clear enough to see the supermoon bitten into by the rocks. The shape of this outcrop is almost arthritic, which makes sense later when I realize the formation is called Three Fingers Rock.

Pages 184-185: As the moon rises, it often appears indistinct, almost blurred. This is because there is more distorting earth atmosphere between you and the moon than when the moon has risen higher in the sky. In this case, it creates another kind atmosphere that then brings the picture to life.

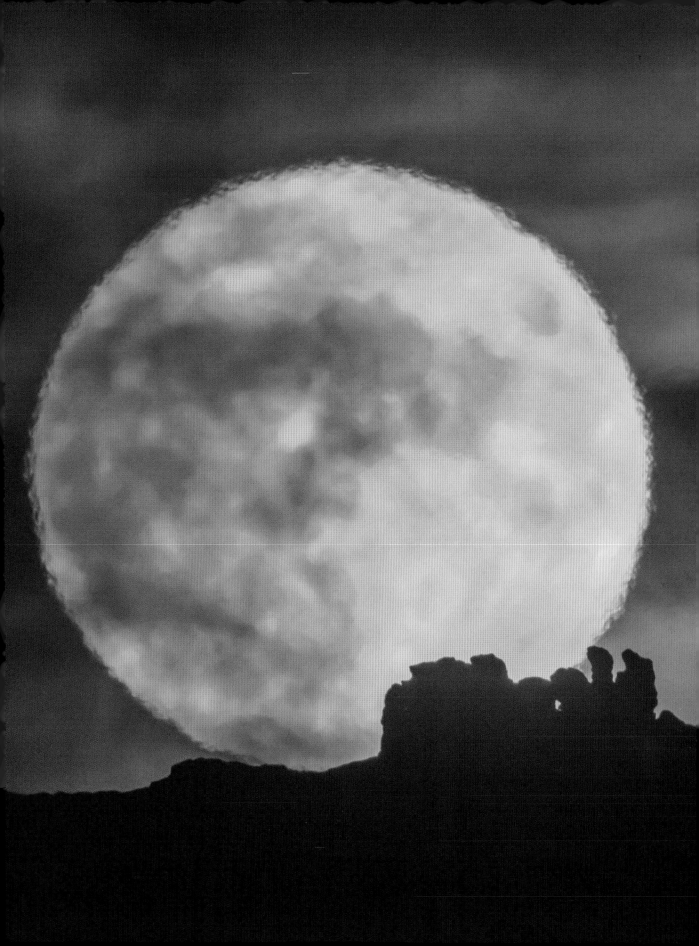

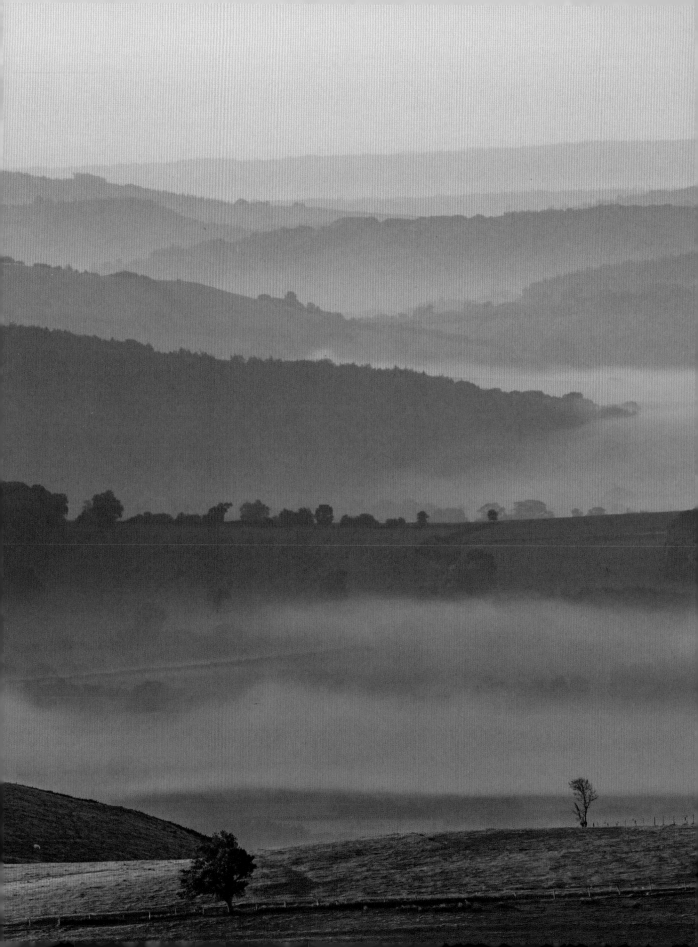

Here, clenched upwards into the sky and framed by the outsize moon is a remnant from 560 million years ago, when this area was dominated by volcanoes. This hardened volcanic echo of flow and thrust has weathered over the last 10,000 years, fracturing history into fingers, the aeons compressed into a millisecond that now gives me the perfect silhouette.

My heart thrills as I drive home, knowing that my press agency is keen to get stuff quick. After a quick edit, I look at the image on screen, unhappy with how shimmery and unsharp the moon is, until I finally decide that maybe it's not so bad after all. I send it down the wire and dreams come true as it is used on the front of the Times and four other national papers. There is glory in Shropshire, and in these uplands. I am honoured to live here, to write about it and to witness such elevated wonder.

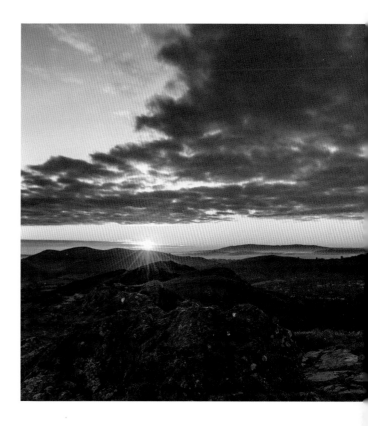

Left: From Cranberry rock at dawn. A long lens compresses the landscape to show the misty layers.

Right: Dawn above the Burway as the first sun catches the rocks; Dusk on the Stiperstones with a small conifer plantation on Linley in the foreground.

Pages 188-189: At dusk, looking down on Cranberry Rock and the distant hills.

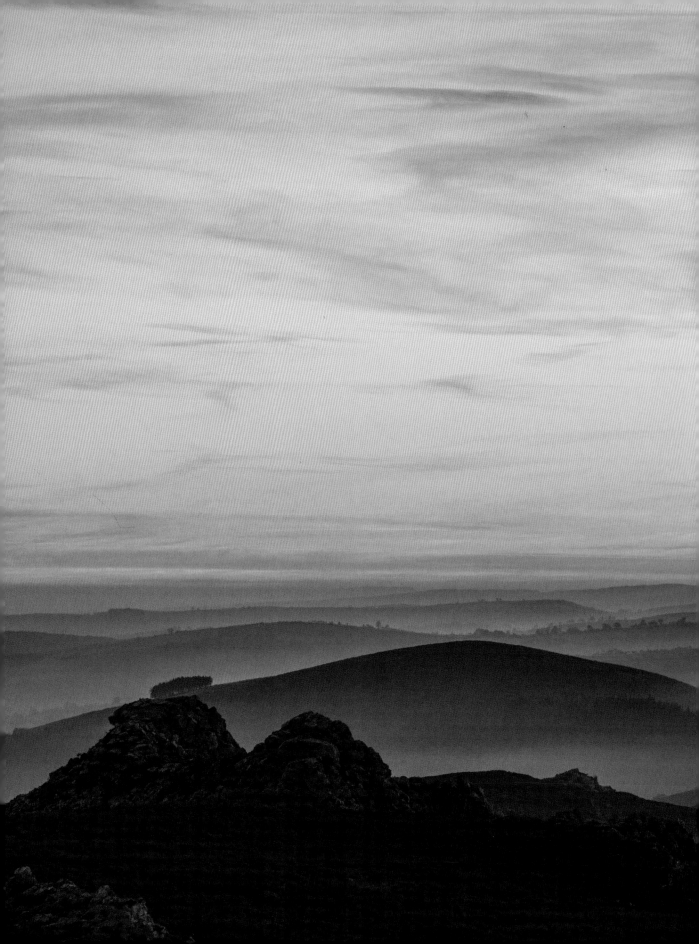

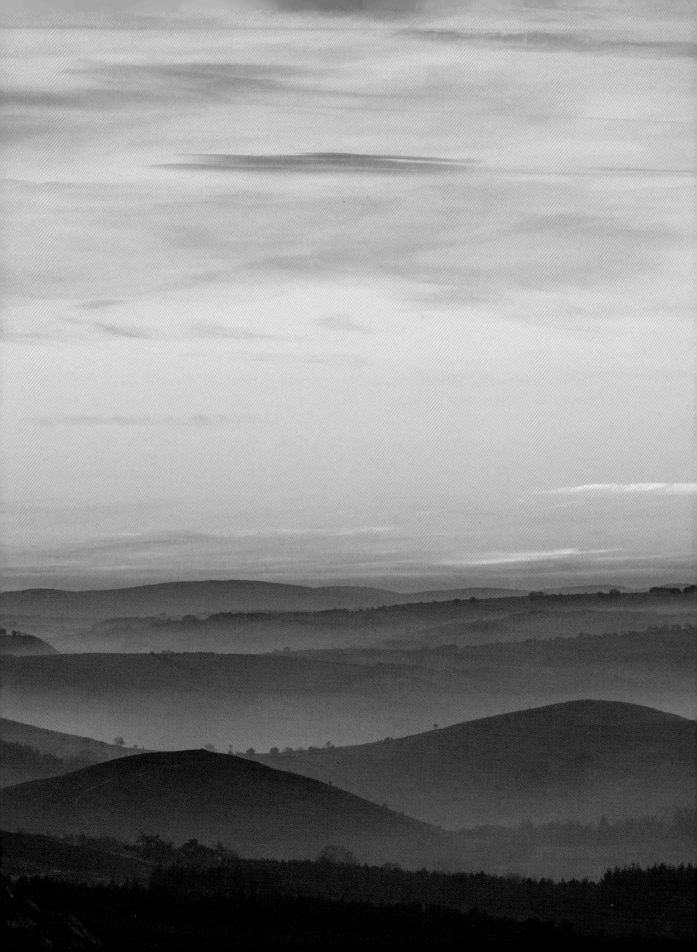

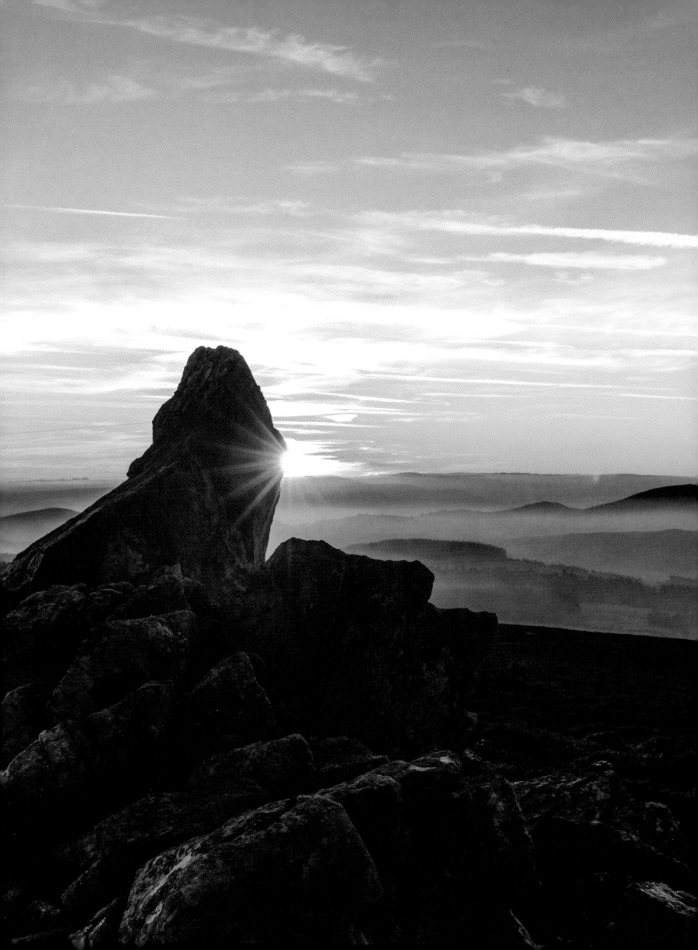

POSTSCRIPT

I keep trying to end this book, but Upland has a hold over me and will not easily relinquish its grip. The end of November brings a spell of clear weather after days of deluge. Suddenly, the forecast on my phone shows sunny, beaming icons. I have an instinct that this one night could be spectacular – clear, cold and clarified with colour.

My return to the Stiperstones is fraught with inner voices telling me that going back to the same spot over and over again is somewhat sad and pointless.

But I brush this negative lint off my shoulders and make for the hills. Already, the light is falling, throwing whole valleys around the back of Wentnor and Cold Hill into a forced dusk. I am aiming higher, driving up the eastern flank above Bridges to park under the looming quartzite ridge. I kit up, then begin the walk and scramble up to the main ridge of the Stiperstones. There is a keenness to this time of day that requires layers and gloves. I ignore the cold and find myself quickly out of breath in the rush to capture this last glory. A few walkers and rambling families are already making their way down, despite the fact that the rocks behind them are rich with golden-hour rays. I have a good feeling about this. So what if I have been here countless times at dawn, dusk and straying into the pastures of starry midnight? That's the thing about Upland – every visit is utterly different to the one before. The action of time, season, day is miraculous and transformative.

Left: Diamond Rock

My instinct proves right as I crest the ridge and see that vast swathes of inverted mist are creeping into the valleys. They remind me of the miniature landscapes of dewy cobwebs covering the holly hedges at Walcot. A receding, endless, layered vista is given to me. The sun strikes the formation known as Diamond rock in front of me and shatters into a fiery twinkling star while Corndon Hill floats on a Sargasso sea of indistinct, hazy grey. I later study that same rock on a fuzzy Youtube video during the scene where Jennifer Jones as Hazel Woodus throws her cloak over it in the 1950 Powell and Pressburger film Gone To Earth. Here be film crews and a landscape filled with dramatic echoes.

When the sun dips and finally bows out of her part in this show, the sky fulfills every promise I dreamed of. The air itself is filled with a pale yellow remorse, a grief for that brightness too soon gone, as flecks of wispy cloud catch the last echoes of day and paint them into the red of hawthorn berries. As I make my way back down, a couple stand at the edge of night, kissing. Despite the darkness that moves in the world now, here is a little piece of harmony and hope.

FURTHER INFORMATION

Natural England
www.publications.naturalengland.org.uk/
file/8649105
This is the current leaflet on the Stiperstones.

National Trust
www.nationaltrust.org.uk/carding-mill-valley-and-
the-long-mynd
The National Trust tea room at Carding Mill Valley
is open all year round and provides excellent food
and refreshments.

The Bog Visitor Centre
www.bogcentre.co.uk
A wonderful tea room and resource centre for the
Stiperstones.

The Bridges Pub
www.thebridgespub.co.uk
Nestled between the Mynd and Stiperstones,
a great place to eat, stay, and start your
exploration of Upland.

CAMERA INFORMATION

Because I work in both landscape and wildlife,
I shoot with a variety of bodies and lenses. I am
always simply looking for the right tools for the
job and as a result my kit is very bashed and
scratched but I don't mind as long as it works.
The main bodies are Canon 7d2, 6d, 5d4 {which
has now replaced my 6d and increasingly my
7d2} and less and less these days Canon 1dx
due to weight and shutter noise. Lenses include
the 500mm F4 and extenders, 100-400L mark2,
24-70 f2.8, 16-35 f4 and for astro the excellent
Samyang 14 2.8.

PRESS AND MEDIA

First published Canon Photo Plus and Outdoor Landscape & Nature
Curlew in flight, brown background, page 49
Male red grouse in flight, pages 162-163
Wheatear portrait, page 88
Male skylark with worm, page 126
Male red grouse in heather at dusk, page 175

Amateur Photographer
Male skylark with worm, page 126

Shropshire Star
Dawn on Cow Ridge, page 28

Shropshire Star front pages,
Milky way above Wildmoor Pool, page 80
Leucistic Kite, South Shropshire, page 23

The Guardian, Daily Mail, Daily Express & Digital Rev. Shortlisted Amateur Photographer of the Year
The stars reflected in Wildmoor Pool, pages 72-73

Metro, Amateur Photographer
Surprised kite and crow, page 96

The Guardian
Sunset over Devil's Chair, pages 112-113

Daily Telegraph page 2, Times page 5, Daily Express, the Guardian
Full moon over Devil's Chair, page 122-123

Countryfile picture of the day
Milky way above Manstone rock, page 153

The Times front page, Daily Mail half-page splash, Daily Mirror, the Sun, Daily Express
Supermoon rising over Caer Caradoc, page 184